VISUAL STORYTELLING:

THE ART AND TECHNIQUE

TONY C. CAPUTO

WATSON-GUPTILL PUBLICATIONS
NEW YORK

Senior editor: Candace Raney
Production manager: Hector Campbell
Design: Leah Lococo Ltd

First Published in 2003 by Watson-Guptill Publications,
a Division of VNU Business Media, Inc.
770 Broadway, New York, N.Y. 10003
www.watsonguptill.com

Library of Congress Control Number: 2002115387

Printed in the United States
First printing, 2003
2 3 4 5 6 7 8 9 / 10 09 08 07 06 05 04

Dedication

To my family, for putting up with the hundreds of hours it took to write and create this book.

Acknowledgements

Thanks to:

Mathias Nastos (comics artist, storyboard artist, director and filmmaker) for his wealth of information; to Harlan Ellison, for his contribution to this book and all of visual storytelling; to Jim Steranko for his special contributions and enthusiasm; to Will Eisner, for having believed.

Sylvia Warren, Candace Raney, and Ali Kokmen for their editorial and professional guidance.

Barry Peterson, Scott McCloud, Kerry Gammill, Jeff Smith, Mark Smylie, Terry Moore, Jackie Estrada, John Byrne, Brian "BMAN" Babendererde, Chester Spiewak, Chris Gabel, Alisa Lober, Eric Nofsinger, Tom Smith, Mark Manyen, Eugene Evans, Terry Kaney, Arlen Schumer, David Spurlock, and everyone else who went that extra mile to make this book an exceptional learning tool.

Table of Contents

Foreword **5**

Harlan Ellison
With the Eyes of a Demon:
Seeing the Fantastic as a Video Image **6**

1 Storytelling:
The Universal Language **23**
The "Seeing Place": The Evolution of Theater **25**
Telling a Story Through Visual Imagery **26**
The Visual Storytelling Media **29**

2 From Frame to Frame **33**
Panel to Panel **35** Scene to Scene **39** Level to Level **41**
Cross-Pollination: Frame/Panel/Level **46**

3 Behind the Scenes **49**
Film and Animation **51** Comics **55**
Interactive Games **57**

4 The Visual Storytelling
Design Palette **63**
Clarity **65** Realism **72** Dynamism **75**
Continuity **77** Total Immersion **80**

5 The Drawing Board **83**
Art and Technology **85** Using Reference **87**
The Question of Style **90** Figure Drawing **91**
Perspective and Relative Proportion **94**

6 The Camera in the Mind's Eye **97**
Distance **99** Camera Angles **102**
Depth of Field, Focus, and Movement **104**
A Miscellany of Shots **106**

7 Lighting and Color
Lighting: The Invisible Character **111**
Light and Color **114** Radiosity in 3D **116**
Steranko Cover Art Gallery:
 Storytelling in a Single Image **119**
Illustrating for Film **122** The Silhouette **125**
Planes and Light **126**

8 Timing and Pace **131**
Who Runs the Time Machine? **133** Style in Motion **134**
Dynamic Timing in a Static Medium **141**

9 Tricks of the Trade **143**
Xtreme Techniques **145** Specialty Line Work **147**
Multiple Images and Morphing **150**
Framing **151** Tilt **151** Some Effects to Avoid **152**
Wally Wood: The Master of the Dynamic Panel **153**

10 An I for an Eye **157**
Words with Pictures **159** Designing from a Script **162**
Communicating Through Design **165**
Mise-en-Scene and Montage **165**
Page Layout **166** Panel Composition **168**
Panel Borders as a Design Element **169**

Jim Steranko
Harnessing Mythology:
Reflections on Narrative Theory **172**

Index **190**

Foreword

Great visual storytellers communicate their inner visions—the things that they alone see and hear—by presenting them for others to experience through the powerful and universal language of imagery. That language is rich and complex, yet whatever medium the artist is working in, the goal is the same: telling the story in the most compelling and cohesive way possible. Years ago, I realized that if a reader of one of my comics had to ask me what was going on, I hadn't done my job as a visual storyteller. The same is true whether the story is for a live-action film, animation, or interactive game. The final package is irrelevant if the story doesn't work. And the story can't work if the tools used to bring it to life haven't been wielded effectively. Style, drawing skills, storyboarding, layouts, timing, pace, color and lighting—these can elevate the audience's enjoyment to a higher level—or kill it! The dynamics are similar in every visual storytelling media, and one of my goals with this book is to show how rich and extensive the cross-pollination has been among them.

Another goal is to pull readers (artists) out of the box (frame) to examine their visual storytelling goals from a different point of view, one that will ignite new ideas and inspiration. Readers will learn about the core foundation of the story itself from award–winning screenwriter Harlan Ellison; building suspense from Alfred Hitchcock; lighting and figure drawing from Andrew Loomis; timing and pace from Mark Smylie, Terry Kaney, and Terry Moore; clarity from John Byrne and Jeff Smith; interactive game design from some of the top names in the field, including Eric Nofsinger, Tom Smith, Cathi Court, and Brian "BMAN" Babendererde; the 22 Panels That Always Work from Wally Wood; drawing movies from Kevin Van Hook; and last but definitely not least, invaluable visual storytelling secrets and tips from Jim Steranko.

Finally, it's not about drawing pretty pictures, dramatic photographic imagery, or using state-of-the-art CGI techniques, but about telling a great story. It's not enough for the audience to read the story, or watch the film, or play the game. They need to *experience* the comic or film or game. That's visual storytelling.

Tony C. Caputo

Visit us at http://www.visualstorytelling.com

Our website contains includes links and email addresses for contributors, behind-the-scenes material, contributor profiles and credits, free streaming media previews and movies, discussion boards, chat opportunities, FAQs and updates, and a bibliography.

Harlan Ellison

With the Eyes of a Demon: Seeing the Fantastic as a Video Image

One afternoon in (something like) 1965, I sat in a little treehouse in Beverly Glen, in Los Angeles, in Hollywood, writing a television script; and I typed these words:

```
The witch rushes down the spiral staircase
and runs wildly through the lavish recep-
tion hall of the mansion. Her cape knocks
aside a candelabrum that crashes to the
floor and spins off a burning candle.
The candle rolls across the floor and comes
to rest in the heavy velvet folds of drapes
covering the wall. The drapes catch fire
and suddenly the entire reception hall
is a mass of flames. The witch is trapped
and burns to death.
```

I wrote these seventy-eight words, only seventy-eight words, for a tv series called *Burke's Law*. It took me possibly one minute to type those lines. And three weeks later I stood wide-eyed in wonderment as they set fire to sound stage #11 at Four Star Studios. I stood stunned with amazement as one of the most beautiful actresses I'd ever seen, Janet Blair, in the role of the witch, Purity Mather, ran down a spiral staircase and through the posh reception hall of a mansion with only three walls. I stood staring open-mouthed as she knocked aside a silver candelabrum, as a sausage-thick candle, specially made not to go out on impact, rolled across the parquet floor (drawn on an invisible thread), settled among swagged drapes, as the fabric actually exploded with flames, and half a dozen firefighters, a fire marshal, sixty-odd studio grips, gaffers, electricians, propmen, studio personnel, extras, stars, producers, associate/assistant/executive/ and hemisemidemi producers, the director and assorted others fell back before the awesome spectacle of that mansion dissolving in flames while Purity Mather writhed in pain and terminal anguish.

And when it was all done—because they could only do it once and they had to get it right the first time—the director yelled, "Okay, that's a take! Let's wrap for the night!" And everyone applauded like crazy, and I was hooked on writing for television.

Seventy-eight casually written words, one minute of the time I spent on that one-hour-long script, and they had called out half the population of the civilized world to put my dream on film.

Until you've been there, don't talk to me about power.

I begin this discussion of writing fantasy and science fiction and other forms of magic realism for films and television with the previous comments and memories for a good reason. As we go forward in this essay, I'll be saying, again and again, that working in the visual media is very much like the old story about the moron who enjoyed being beaten across the belly with a sawed-off ballbat because it felt so damned good when they stopped. I'll be saying that in no other creative medium is there such an attack on the writer's sensibilities (and often his or her life) than in the tv/film arena. It is an art-form by committee, a cobbled-up Frankenstein's Monster of arbitrary rules, imbecile decisions, cowardly rationalizations and tasteless pandering to the lowest possible common denominators of public mass taste. I don't know what you have read about working in the Industry, I don't know what nonprofessional beliefs you hold about how things are done "on the inside." And I don't know what myths you believe or lies you've swallowed. But I would be a liar and a hypocrite if I didn't tell you precisely what it's like from the git-go. Bear in mind, of course, that everything I'll say here is drawn from almost forty years' working in the Industry, and the conclusions are based on where I've been and what I've seen. It's as responsible and accurate as I can make it; but it is an upfront subjective position.

So when I start with that story about "Burke's Law" and then instantly badrap the Industry, you're bound to ask, "If it's such a cesspool, why do you do it? Why should any sane, talented writer choose to indenture him/herself in a medium where the work itself is manhandled and corrupted and amputated, to be used, finally, as the come-on for selling trashwagons and paisley asswipe?"

The memory of that day at the Four Star Studios (now CBS Studio Center) is thus presented as partial explanation and rationale for a writer suffering attacks on his creativity

which should never, under any other circumstances, or in any other situation, be tolerated. This "explanation," this "rationale" for a writer enduring attacks on his creativity is, of course, that working in visuals is exciting and, when you can connect, when you can slip past them, when you build up enough clout or somewhichway steal enough good karma to purchase some luck, it can be artistically rewarding in ways not even the print medium can approach. It's a deal with the devil, a rock-and-a-hard-place trade-off. (How heady it is to envision that witch and that fire, write those few words, and see them actually bring the vision to life. It is the closest contemporary paradigm for Aladdin's Magic Lamp. Merely rub the distended belly of a studio executive and whoosh! You get your wish.)

That's part of it. The other parts are two.

One: if those with talent opt for sanity and peace, and refuse to fight the fight necessary to getting good writing on the big screen or on the tube, if they bolt and desert the arena, forfeiting the medium to the no-talents and the venal businessmen who conceive of themselves as creators *manqués*, then we abrogate our artistic responsibility and surrender without bloodshed the greatest medium for the dissemination of information and individual imagination the world has ever known. I work in television, *nemine dissentiente*. With a dissenting voice.

Two: as I mentioned, when you do manage to get something produced that you've written with craft and skill and inventiveness and honesty, it is a thrilling experience; it reaches more people than those who usually read the printed word; and it vindicates the anguished times you've invested. But more, writing a script—as opposed to a short story, a novel, a quatrain, a play or an essay—is a complex technical undertaking. And learning to do it to perfection, so you develop a "voice" that marks your work and sets it apart (and, one hopes, above) all scenarios written by others, fills you with pleasure, pride and the knowledge that you have expanded yourself as a writer. Because writers should write in all forms, should not limit themselves, should constantly strive to enlarge the scope of their abilities.

Add to the foregoing, the financial rewards. If we're to be utterly honest here. The going price for a one-hour teleplay, between one month and three months' work (depending how speedily and carefully one works), is about $24,000.[•] That is about four times what a new writer can expect as the current average advance for a novel in the sf category. And if one is serious about one's writing, that kind of money can provide security and freedom to spend the year it takes to write a novel properly. (Well, let's say two scripts could provide that time.) So a writer invests three or four months' writing time to buy seven or eight to do what he/she wishes. And the time one invests is spent writing, not waiting table in a diner or working for some cold-call "boiler room" telephone solicitation company; so it is *invested,* not *spent.*

And that is the reason I've taken these pages to tell you why one works in a medium that can be terribly crushing for all but writers with stamina and a highly developed sense of their talent and direction. One labors in the House of the Dead to buy passage into Heaven for one's immortal soul.

I knew you would ask, so that's the answer.

And, of course, because it is a collaborative medium—where one's brainchildren are taken away and altered by producers, directors, cinematographers, editors and actors—the working conditions of the Industry, and the writer's mental attitudes, cannot be avoided as pivotal elements in the equation of creativity. I'll deal more with those conditions later in this essay. But at this point, let's get into the specifics of actually how to write a script for television, and by extension, for movies, using the special tool of sf/fantasy.

It is essential to understand, not just superficially, but all the way down in the creative core of your thinking, that writing for a visual medium is quite different from writing for the printed page. The form is different, of course, but more than that, the intellectual set is very different. If I were to write:

```
Simonson sat across the memory-pool
table from her, staring silently at the
expression of hate in her lovely face.
He knew what she was thinking: this is
the man who caused the death of my family.
He wanted to tell her that it had been
her own father who had done it; her father
```

[•] *As of June 2001, the new Writers Guild Minimum Basic Agreement (MBA), with new fees, has been ratified with the industry's Producers.*

who had destroyed himself and his wife and
his son because of a sense of duty less
courageous men and women could never com-
prehend. Less courageous men, like
Simonson; less courageous women, like the
grieving, hating daughter seated across the
shimmering blue surface of the memory-pool.

I could get away with it perfectly in a story, because the printed page demands participation on the part of the reader. Unlike television, films, football games and WWF Wrestling, wars in underdeveloped nations and the execution of Timothy McVeigh, which are spectator sports, a book requires the activation of its words by the eyes and intellect of a reader. As Isaac Asimov once said in an article postulating the perfect entertainment cassette:

A cassette as ordinarily viewed makes sounds and casts light. That is its purpose, of course, but must sound and light obtrude on others who are not involved or interested? The ideal cassette would be visible and audible only to the person using it. . . . We could imagine a cassette that is always in perfect adjustment; that starts automatically when you look at it; that stops automatically when you cease to look at it; that can play forward or backward, quickly or slowly, by skips or with repetitions, entirely at your pleasure. . . . Surely, that's the ultimate dream device—a cassette that may deal with any of an infinite number of subjects, fictional or non-fictional, that is self-contained, portable, non-energy-consuming, perfectly private and largely under the control of the will. . . . Must this remain only a dream? Can we expect to have such a cassette some day? . . . We not only have it now, we have had it for many centuries. The ideal I have described is the printed word, the book, the object you now hold—light, private, and manipulable at will. . . . Does it seem to you that the book, unlike the cassette I have been describing, does not produce sound and images? It certainly does. . . . You cannot read without hearing the words in your mind and seeing the images to which they give rise. In fact, they are your sounds and images, not those invented for you by others, and are therefore better. . . . The printed word presents minimum information, however. Everything but that minimum must be provided by the reader—the intonation of words, the expressions on faces, the actions, the scenery, the background, must all be drawn out of that long line of black-on-white symbols.

I've quoted Isaac at length because he summed up precisely the difference between writing a narrative and creating a screenplay. All of the things your imagination provides without effort as you read—intonations of words, expressions on faces, actions, scenery, background—all of that plus an exterior point of view, must be invented by the scenarist.

Watching television is a spectator sport. Writing for television is the most involving participation sport in the world of literature. Most people who sit plugged into the box like a patient with acute irreversible coma plugged into a respirator, don't realize that a scenarist not only has the initial dream—the subject matter, the story-line, the approach to the work—but he writes all them funny words them funny little actors—"Electronic Lilliputians," one commentator has called them—say to each other. The scenarist puts in what angles you'll see a scene from. He writes the moves and attitudes of the characters within a scene and the flow of the scenes as a totality, act by act, crisis to crisis. It is visual poetry, as carefully structured as the flow of words into lines and lines into paragraphs and paragraphs into chapters of a novel.

But unlike the written narrative, the script has to show all that. From the outside. Unless you use a voiceover technique (V.O.), everything that goes on in a character's mind must be either spoken or shown in the actions of the character! For many writers, that is a handicap, a tether too short for them to endure. For others, it becomes a kind of challenge, to see how cleverly and visually one can interpret the interior monologue, the irrational impulse, the anguished moment, the inexplicable action.

So, from the very start, the writer of a screenplay must understand that everything will be shown. Or if not blatantly conveyed, at least clearly indicated through the use of camera angles, misdirection, point of view (POV) and electronic techniques.

(I'm wandering from my original point in this section, and in just a moment I'll get back to that paragraph of story I created a few pages ago. But the suddenly discursive tack this piece has taken demands I illustrate the preceding paragraph with some examples. Please bear with me, it'll all come right in the end.)

What I just said, about indicating by misdirection and camera angles, and so forth, is the essence of using film as film. Film is not a stage production, it's not a printed page, it's not the "talking head" mode that one finds employed on television newscasts. It is a realization that the actual movement of the camera, the POV, can convey what would be pages of explanation in a story. For instance:

Let's say the character I introduced in that story paragraph, Simonson, has discovered that his enemies have developed a way to kill him by use of a remote control device keyed to the telephone. . . . No, hold it! Let's make it an even better example than that. Let's say we, the audience, have discovered that fact. That Simonson can be killed when his telephone is picked up. But he doesn't know it.

So there he is in his apartment, nervous, unsettled, knowing that the enemy will be making an attempt on his life, but he doesn't know when or how. In a story, in a book, we'd have to write all manner of interior monologue and observations from the viewpoint of the Omniscient Author. But in a teleplay, it can be done like this.

```
56   INT. SIMONSON'S APT.—NIGHT—ESTABLISHING
     LONG SHOT in UP-ANGLE PERSPECTIVE from
     telephone on modern writing desk LARGE
     IN F.G. across room to Simonson, pacing
     in the b.g. HOLD PHONE LARGE as he
     lights a cigarette, takes two hurried
     puffs, then comes to ashtray on writing
     desk in f.g., snubs the cigarette.

                                  CUT TO:

57   REVERSE ANGLE—PAST SIMONSON—HIS POV
     As he walks into f.g. and we SHOOT OVER
     HIS SHOULDER. The phone RINGS. Simonson
     turns FROM CAMERA to stare at phone.
     CAMERA ZOOMS IN on phone. HOLDS SEVERAL
     BEATS. CAMERA ZOOMS BACK to include
     Simonson in frame. As he moves toward
     phone the CAMERA GOES WITH. He reaches
     for the receiver as CAMERA COMES IN
     TIGHT on his hand posed above the phone.
     He hesitates. Phone RINGS AGAIN,
     seemingly louder, more tension in its ring.
     Will he pick it up or not?
```

Okay, now do you see what I mean? Not a word has been spoken; no one has had to announce in that cornball V.O. that Simonson is nervous—the action with the cigarette and the pacing says it all—that he is in danger from the phone—the angle with the phone dominating the foreground (f.g.) makes that clear—and all the suspense you need is built with camera movement—zoom in/zoom out, Simonson's hand poised above the receiver. •

Thus, we have our first lesson in using film as film; an absolute must if one is to be a good scenarist, an inventive script writer, something more noble than a hack or the hundreds of, well, call them "creative typists," who fill most of the endless hours of prime time with dreck.

Another, perfect example of the use of film as film—that is, film used to tell a story without the words or even the use of actors—is the ending to Francis Ford Coppola's extraordinarily brilliant motion picture, *The Conversation* (which is, for my money, one of the dozen finest motion pictures of the last thirty years, and utterly stunning in its sense of filmic movement).

The ending of the film in case you haven't seen it—or even if you have seen it and didn't catch the subtlety of what Coppola was doing—is this: his protagonist, a professional wiretapper and bugger, has discovered something he was never intended to find out when he was hired. Now he knows a secret that is dangerous to a group of powerful people, and they have to bring him under their control. Rather than killing him, they make him paranoid by using his very own trade against him. They call him and tell him he's being watched. They call him on a private line he has gone to extreme lengths to keep secret. So he knows they're on to him. Now his innate paranoia takes hold. He has to de-bug his apartment. He begins tearing it apart. The phone, down to its parts, like an eviscerated animal. The furniture, stuffing yanked out. The frames of pictures, broken apart, scattered around the room. The walls, savaged to the stanchions, banged open like an empty rib cage. The baseboards ripped out. The ceiling fixtures yanked down. Everything a

• *You've got to be chary in your use of "indicators" such as the phone large in f.g. It draws attention where you need it drawn, but you damned well better pay it off and ring that phone before very long. It ties in with what Chekhov once said: "If, in Act One of a play, you show a duelling pistol hanging on the wall, you* must *fire that pistol before the end of Act Two." Otherwise, you're a cheat.*

shambles. Nothing there. Nothing at all.

And the final shot is of the wiretapper, Gene Hackman, sitting amid the ruins, mournfully playing his saxophone. But. Where lesser directors—and Coppola is one of the heavyweights—would have either pulled up and back for one of those teddibly teddibly meaningful master shots, showing the hunter now crushed and broken, or given us the ho-hum standard freeze-frame, Coppola has done something absolutely original. He has made the point of the film subtly and artfully by doing this:

The camera is already moving right as the shot begins. It pans right slowly, a medium shot with a modified fisheye lens that shows the entire room as the camera sweeps past Hackman, going the full width of the room to the right-hand wall. The camera stops, holds a beat so we think that's all we're going to see, then begins panning back left at the same mechanically steady pace as before. The pan carries us back and we think it will stop when it holds Hackman centerframe. But it keeps going, past him all the way to the left-hand wall, showing the debacle that we have now seen thoroughly from one side to the other. Camera holds a beat. Then starts panning back right again. All the way across. And if, by that time, the viewer does not realize what Coppola is doing, he or she should not have gone to a film that is intellectually beyond his or her capacities.

Had Coppola taken one pan right or left, and finally held on Hackman, it would only have been a grace note. But the steady back-and-forth movement of the camera, it abruptly dawns on us, is Coppola's way of saying, "We are watching this man through a spy camera, the kind they have in banks, that scans across the interior of the lobby, that feeds its image to the watchers who now have Hackman under their thumb." Coppola has not permitted Hackman to find even the slightest trace of bugging equipment in the apartment, though it's stripped to the outer walls of the building, so we cannot know whether this spy camera observation is actual, literally happening, or if it is a subtle clue that they have driven Hackman totally into paranoia, that he will always feel he is being watched, and is therefore no longer a threat. It is an artful fillip added to the final point, made by camera movement alone, permitting us to plot for ourselves. It is the use of film as film.

And it sends a final shiver up our spines.

· · ·

Having illustrated what I mean about seeing film visually, not merely as the translation of, say, a stage production, with everything static and set out in long, medium and close shots, I'll return to that snippet of story I wrote many pages ago. It's almost entirely an uneventful segment, from the outside. (Go back and re-read it if the digression has flensed all memory of it from your mind. Go read; I'll wait; come back and we can go from here.)

All right, you're back. Now. The story as written from techniques that would be acceptable in a novel, would be unacceptable in a script. How the hell do you lay in the backstory about the woman's father and her family? How do you show what he's thinking, or what she's thinking? How do you illustrate her hatred of Simonson, or his innocence? How do you show that he knows what she's thinking, and how does he convey to her the true story?

Well, there are many ways for a scenarist, but they all involve thinking visually. Here is the way I would do it, in script form, using videotape, not film.

25 INT. MNEMOSYNE—EXT. CLOSEUP ON MEMORY-POOL
CAMERA CLOSE on the shivering aquamarine
radiance of one of the memory-pools set
into the center of every dining table at
the famous Mnemosyne. Strange colors
flicker and dance through the liquid and
in b.g. we HEAR strangely compelling
music, like the songs of the Sirens.

CAMERA PULLS BACK to show Simonson and
Klara sitting across from each other.
They stare into the pool. CAMERA BACK as
we see the rest of the dining spa, a
futuristic restaurant all angles and
planes of metal and plastic, with colors
flickering inside the walls. From time
to time we CHROMAKEY the walls of the
Mnemosyne so they change subtly from red
through violet to blue and on through
the spectrum. CAMERA PULLS BACK to ESTAB
LISH the scene,then moves again, TRUCK-
ING IN SLOWLY on Simonsom and Klara.

26 MED. CLOSE—SIMONSON
 as he stares across at her.

27 MED. CLOSE—KLARA
 as she looks up, registers
 acknowledgment of his presence and his
 attention. Her expression is as cold
 as the surface of the memory-pool.

28 MEDIUM SHOT—ARRIFLEX—ON SIMONSON & KLARA
 As they talk, the CAMERA MOVES AROUND
 THEM, first holding Klara past
 Simonson's shoulder, then circling
 to give us the REVERSE ANGLE.

 KLARA
 (coldly)
 I don't like this place. I've never
 liked it. Why did you insist?

 SIMONSON
 The Mnemosyne specializes in more
 than good food.

 KLARA
 I don't have any memories I'd care
 to let you see.
 (beat)
 It ought to be enough that I agreed
 to meet with you in the first place.

 SIMONSON
 (earnestly)
 What if I could prove to you that
 you don't need to hate me?

 She reacts to the suggestion with a
 tenseness that fills her face with even
 greater animosity. She draws herself up
 and looks around as if expecting someone.

 KLARA
 I'd like something to drink.

 Simonson presses his hand against a

transparent plate set into the arm of
his chair. Light shines up.

 SIMONSON
 Klara, what if you've read all the
 signs wrong? What if . . . just what
 if . . . I had nothing to do with
 the death of your family?

 KLARA
 (levelly)
 You'd remove the only reason I have
 left for living: hating you.

 CUT TO:
29 SHOT WITH WAITER MOVING TOWARDS TABLE
 CAMERA CLOSE ON WAITER'S BACK as we
 SHOOT PAST HIM to Simonson and Klara at
 the memory-pool table. He comes to their
 table and they stop talking. She looks
 up, speaks very quickly, in a manner we
 might take to be imperious.

 KLARA
 String martini, over bubbles.

 The waiter looks at Simonson. We have
 not seen any part of the waiter but the
 back of him.

 SIMONSON
 Absinthe and coffee.

 WAITER
 Very good. Thank you.

 Waiter turns DIRECTLY INTO CAMERA and we
 see it is a robot, immobile metal face
 oddly melding with the ornate waiter's
 costume. He moves TOWARD CAMERA and out
 of FRAME to left, leaving us with a
 MEDIUM CLOSE SHOT of Simonson and Klara.

 SIMONSON
 If you're fair, you'll let me see
 the memory.

KLARA

I'm not fair.

SIMONSON

Then, if you're curious.

They look at each other without speaking
for long moments, then Klara nods slowly.

KLARA

Perhaps this is the best way to show
you the depth of my hatred.

She looks down into the memory-pool.

CUT TO:

30 VERTICAL SHOT—STRAIGHT DOWN—MOVING IN
on the MEMORY-POOL. We can see their
hands on either side of the liquid, and
the tops of their heads, bent toward the
circular pool in the center of their
table. As CAMERA COMES DOWN, the liquid
begins to ripple, like a placid lake
suddenly producing wavelets as a breeze
comes up. We HEAR the SOUND of water
hissing through a channel and then what
might be wind-chimes. CAMERA DOWN and
HOLD the pool.

31 SEGUE SHOT—INSERT—MATTE
Preceding shot of pool alters as MEMORY
INSERT shimmers and takes form in the
rippling blue liquid. We HOLD it MEDIUM
CLOSE:

31A INSERT—WHAT WE SEE—SEQUENCE OF MEMORIES

31B ESTABLISHING SHOT of a sleek spacecraft
in outer space. CAMERA MOVES IN on
the ship, passes through hull to
BLACK FRAME.

31C OUT OF BLACK FRAME to interior of
spacecraft. We are in a ship's saloon,
with four people. An older, gray-haired
man, Klara's father; an attractive,
imperious woman of middle years, Klara's

mother; a frightened young boy of
twelve; and Simonson. All three of
Klara's family are ravaged by angry red
sores on faces and hands. Simonson seems
untouched. Still seeing this in the
pool, we HEAR tiny voices SPEAKING.

FATHER

You've got to go back. Before it
passes to you, too.

SIMONSON

There has to be another way.

MOTHER

Please, John, do what he says. You
can't help us.

SIMONSON

At least let me take Kenni with me.

FATHER

Why? To spread it? Take the lifeboat
and go, John.

Klara's mother moves to the side, out
of Simonson's sight.

SIMONSON

I can't just leave you here to
drift, with this thing killing you.
There's a quarantine station on
Ganymede. They can—

Klara's mother has come up behind
Simonson, with a small disc in her hand.
Now she lunges at him, presses it
against the back of his neck. His eyes
roll up and he collapses. Klara's father
looks at his wife, and their eyes meet
with understanding.

31D Preceding SHOT FADES and DISSOLVES THRU
TO shot of the father and mother loading
Simonson into a tiny rescue craft. His
eyes are open, and he's trying to speak,
but he cannot move and cannot articulate.

FATHER

Goodbye, John. Do us this one last
favor. Klara will need someone . . .

They close the transparent hatch and we
see through SIMONSON'S POV the boy,
Kenni, crying, being held by his mother.

CUT TO:

31E EXT. SHOT OF SHIP as the rescue craft is
blown free. DISTANCE SHOT TOWARD SHIP as
it comes TOWARD CAMERA. Suddenly, in b.g.,
the ship silently explodes and at the
same moment of the explosion the liquid
in the pool roils and bubbles and then
. . . subsides to its former placidity.

CUT TO:

32 CLOSEUP—KLARA
with a horrified expression. Her eyes
are filled with tears. We are back in
the Mnemosyne.

KLARA

You bastard! That wasn't my memory!
It was a fake, some awful lie you
dreamed up!

33 TWO-SHOT—FAVORING SIMONSON
He leans across, tries to take her
hands. She pulls them back; and she
is still crying.

SIMONSON

(softly)

You're right, it wasn't just your
memory. It was mine, too. I had to
trick you a little. I knew how you
felt, I knew you thought I'd killed
them, that I let them die; but I
didn't, Klara. So help me God it was
just the way you saw it.

KLARA

No!

SIMONSON

He had more courage than either of
us. I can't tell you I'd have stayed
. . . to catch that . . .
(beat)
But they never made me have to face
the question. They sent me away and
he dumped the pile himself.

KLARA

(with pain)

I can't stand any more of this.

SIMONSON

He wanted me to take care of you.
That's what they wanted, all three
of them. If you don't believe me, if
you don't believe the memory, then
you've killed all of us. Not just
three . . . five.

KLARA

(softly)

What do you want from me?

Simonson looks at her, and shadows from
the changing colors of the room's walls
cast planes of darkness across his fea-
tures. All but his eyes are suddenly hid-
den. They shine with reflected light from
the memory-pool, and his voice comes
across a wasteland:

SIMONSON

Peace. Just peace. I'll always feel
guilty, even if I believe I didn't
do anything wrong. But you can give
me peace.

She stares back at him and HOLD the SHOT
as we:

FADE TO BLACK
and
FADE OUT.

Hmmm. Some day I'm going to have to write that story and that teleplay. I like that scene. A bit wordy, perhaps, but essentially solid. Now, do you see what I mean—and what Isaac meant—when we say that you have to give the viewer everything? What took only a few lines in a story, took many pages of script. Of course, I grant you that I got so involved in my own story that I went on past the point of the narrative segment, but even so it would have been a good deal more complex and a lot longer than what was needed to convey the scene in short story form.

Not only was there plot progression in that scene, but there was characterization, dialogue, camera angles, setting, incidental background, interior tension, conflict, backstory and action. And I wasn't doing anything particularly special just for your benefit here; I'd have written as much for any script assignment.

If there is a sure-fire test you can give yourself, to ascertain whether or not you are equipped with the bare essentials for writing screenplays, it might be this one:

I hope I've established by this point that you must think visually before you write. There can be no scenes of "talking heads" sitting in a bar, telling each other what happened. You must show, not tell; it's a basic rule for any kind of muscular writing, but it's absolutely mandatory when working in films and television. So test yourself by using this secret method I use for writing a script. Pick a bit of a story you want to translate into script, as I did here. Close your eyes. Now run that scene through your mind as if you were watching a movie. Do you see the scene from various angles? Does the camera in your mind's eye move? Do the characters have positions in relation to each other and to the scene as a whole? Can you see what they look like, what they're wearing, the way they gesticulate? Can you hear the inflection in their voices? How are transitions effected: wipes, cuts, dissolves, lap-dissolves, swishpans, fades? Is it all flat or does it have three-dimensional corporeality for you?

If you can see that movie in your mind, and can set it down on paper so the vision is narratively translated employing the directions I gave in that sample script, then you have a chance of becoming a competent scenarist. If you can't translate it, if it's all flat and merely vague shadowy movement without definition to you . . . if you can't *see* it . . . then I urge you . . . forget it. You may be a writer of narratives, but you very likely don't have the visual capacity to write for films and television.

Don't feel insulted; do not pout; don't get cranky: the sensory equipment of human beings varies greatly. Some people hear their memories, some see them in color and wide-screen, some people only have recall of odors or tactile impressions. There are people who are tone-deaf and people who are color-blind. It's nothing to be sorrowful about; but it's something you must realistically assess before committing yourself to the grueling life of a tv/film writer.

Warning: don't ignore these caveats. I've seen very talented writers, in several cases the biggest names in science fiction, who set themselves to become scripters, who simply couldn't write visually, who beat their wings against the Industry like moths against a windowpane, and whose hearts were finally broken after wasting months and years bombing out with one project after another.

It is a remorseless and unsympathetic Industry, and the only thing that counts is ability. You can be the biggest shit in the world and, if you can write the words, they'll hire you again and again; you can be a sweetheart, a charming guy or gal, a pleasure to dine with and share conversations with, but if you cannot produce, they will reluctantly, sadly, helplessly cast you aside and you'll starve before they let you write something as idiotic as a Pauly Shore or pre-*Punch Drunk Love* Adam Sandler flick, or even anything as undemanding as a segment of, say, *Son of the Beach*.

You have been given this warning in all honesty. If you ignore it, don't come crying to me.

Insofar as the rule-of-thumb layout of a tv show is concerned, I've found that each act should have four scenes of major importance. There can be more, such as short linkages between scenes to move the action from place to place, but there should never be less than four scenes per act, or you're going to wind up with a very static, stagey segment. Let me demonstrate what I mean, four scenes to an act, using our old friend Simonson from that earlier snippet of script. Here's a synopsis of, say, the first act of the script.

```
FADE IN deep space. CAMERA MOVES IN on a
shape reflecting back light faintly from the
stars. We approach it slowly, and discover
```

it to be a kind of clear tubelike coffin with a naked man in it. Our POV turns out to be an Earth-bound freighter plying through space toward the home planet. They pick up the coffin and bring it aboard.

On shipboard, the coffin is opened after great difficulty with laser-torches (it is made of some alien substance never seen on Earth) and the man is taken out, unconscious. He is taken to sick bay and slowly, as weeks pass, he's nursed back to health. He confides in the female captain of the ship, HERTA LORAY, that he was the captain of a small space yacht named The Nightwind that has been destroyed somewhere beyond the Asteroid Belt. He tells her he is the only survivor, but says no more. He feigns amnesia, but remembers his name, DEN SIMONSON.

The freighter makes Earth, Simonson is the only one kept by Port Authority officials, and he is questioned closely by representatives of some top-secret Earth government agency. They want to know where he was piloting the yacht when it met its fate, and what has happened to the three members of the BOWKER family who perished in the accident. They put him in protective custody, against his wishes, and take him to a hospital where he is little more than a prisoner.

There is something about him that they find out under examination. That he has almost perfect and total regenerative powers. He discovers this himself, before they do, when he tries to escape one night and tears the skin off his chest against a rough metal wall. As he watches, the skin grows back in a matter of seconds.

He discovers, purely by accident, that he is not the first person to return from space with this linkage to immortality, and that the government wants to keep him in custody forever. He realizes he has some strange

destiny involved with this power, and plots to escape from the prison hospital.

Before he can effect his escape, however, he is permitted a visit from KLARA BOWKER, surviving child of the family that died in the yacht accident in space. She calls him a killer and swears she will see him as dead as her mother, father and young brother.

Simonson knows she has the story wrong, but at that moment decides not to defend himself. First, he must get away from the ones holding him prisoner.

That night, he uses a clever ruse to escape, and flees into the city. As the act ends, the agents of the government discover he's gone and start after him, calling him "the greatest threat to humanity the world has ever known." FADE TO BLACK AND FADE OUT. End Act One.•

Now let's examine that sample portion of the "treatment" for the scenes. 1. Deep space. Simonson found and brought aboard freighter. 1a. A linkage sequence showing him taken to sick bay; time-lapse of him recovering. 2. Simonson in conversation with captain of the ship. 3. Landing on Earth and immediate arrest. 4. Interrogation by government agents. 4a. Linkage sequence; Simonson taken to prison hospital and locked away. 5. Discovery by Simonson of his abilities. 6. Discovery of immortality by doctors. 7. Overhearing of background information Simonson needs to move his future actions and his escape. 8. Visit from Klara. 9. The escape sequence. 10. Grace note; the agents saying he's a menace.

• *Please note that this synopsis has been written in the form of what is known in the industry as a "treatment." The term* treatment *is interchangeable with the term* story *in the parlance of film/tv deal-making. It is the first step in writing a script. It is a present-tense, straight-line description of the entire plot scene-by-scene, with the barest minimum of dialogue and characterization and camerawork. It serves several purposes, most of which benefit the producer: it tells him what your story will be and how it will move, so he can "cut off" the scenarist before the first draft stage of the assignment if he doesn't like where the story is going or he doesn't trust the writer; it gives him an opportunity to force the scenarist back onto the track he thinks the show should have if the scenarist has wandered off the track; and it minimizes the chance of a script going wrong from the start. For the writer it provides the chance to plot succinctly and without holes.*

Now, since it was the first act, and a great deal of background information had to be laid in before-the-fact, the act comes out longer and with more scenes. I'd say it would come out around twenty pages, with heavy set descriptions. You'll notice there are several conversation scenes, which occur in between scenes in which there's movement, some action. That's called pacing. You take the viewer up and down the hills; bring the audience to a peak, give them some respite, then start yanking them up again. In that way you build interior tension. Pacing.

But let me digress for just another moment.

Until Simonson discovers he's immortal, this is not science fiction. Oh, I hear you mumbling, it has spaceships and alla that junk in it, so it's gotta be sf! Nonsense.

Just transpose the setting to the South Seas and make it a pleasure yacht cruising through a chain of obscure, uncharted islands. They pick up a plague, they cosh the stalwart Captain over the head, put him in a lifeboat and set him adrift and then blow themselves up. He's picked up by a freighter blown off the well-traversed seaways, he's brought back home, and then quarantine officials put him in protective custody. See? It ain't sf. Which brings us to one of the absolute necessities if you're going to specialize in writing the fantastic for film and tv.

The fantastic.

It has to be there.

But it has to have internal logic. That is, the plot must fall apart and be untellable without that sf element. This is hardly a fresh concept. It's been said by every sf critic since the genre became a visibly commercial medium. It is what identifies the form. Without the science fictional linchpin that holds it all together, it might just as well be a story that can be told as a western, a gothic, an adventure saga or a mystery. Or to quote the classic comparison, consider the selection below, taken from the back cover advertisement that was featured on the first issue of *Galaxy* science fiction magazine way back in September of 1950.

You'll Never See It in *Galaxy!*

Jets blasting, Bat Durston came screeching down through the atmosphere of Bbllzznej, a tiny planet seven billion light years from Sol. He cut out his super-hyper-drive for the landing . . . and at that point, a tall, lean spaceman stepped out of the tail assembly, proton gun-blaster in a space-tanned hand.	**Hoofs drumming, Bat Durston came galloping down through the narrow pass at Eagle Gulch, a tiny gold colony 400 miles north of Tombstone. He spurred hard for a low overhang of rimrock . . . and at that point, a tall, lean wrangler stepped out from behind a high boulder, six-shooter in a sun-tanned hand.**
"Get back from those controls, Bat Durston," the tall stranger lipped thinly. "You don't know it, but this is your last space trip through this particular section of the Universe."	**"Rear back and dismount, Bat Durston," the tall stranger lipped thinly. "You don't know it, but this is your last saddle-jaunt through these here parts."**

Sound alike? They should—one is merely a western transplanted to some alien and impossible planet. If this is your idea of science fiction, you're welcome to it.

And so, until Simonson discovers he's got the power of regenerating his body, until that moment in the teleplay or film script, all we have is a transplanted South Seas adventure story. But from that moment on, it's science fiction. (Oh, and by the way, while I was plotting act one of that treatment I figured out the entire story. That happens sometimes. Terrific idea for a story or a teleplay. I may just sit down and write it soon. Good thing this piece is copyrighted. Which brings me to the subject of protecting your work against theft. But it's too soon for that. I'll get to it later. I'll be damned if I'll digress off a digression.)

I've detailed how you pace the work in scenes. Now let me take a moment to touch on terminology—industry shorthand—I used in the script pages. (Not all of it, because many terms are self-explanatory; if you need more specificity than space permits here, heaven knows there are walls of published books on screen writing . . . and the lingo.)

The words in caps are the camera terminologies that form the directorial guidelines for setting up shots. There are writers who have been in the business for decades who'll tell you only to write "master scenes" and to forget all the fancy camerawork, that it's the province of the director or the cinematographer. Any writer who says that is a hack and ought to be out honeydipping Andy Gump chemical toilets. "Master scenes" are sloppy donkeywork cop-outs used by lazy and usually untalented writers so they can do ten scripts in the time it should take them to do one. A "master scene" is set up like this:

```
15      THE SMITH HOUSE—LIVING ROOM—DAY—
        ESTABLISHING SHOT
        John enters the room. He sees Martha.

                    JOHN
            So! At last! You're home!

                  MARTHA
        Where was I supposed to be?

                    JOHN
            That's what I want to know!

                  MARTHA
        What are you suggesting?
```

```
                    JOHN
            I'm suggesting you were out with Rick.

                  MARTHA
        I won't dignify that remark with an
        answer.

                    JOHN
            Easy enough for you to say.

        Martha slaps him.

                JOHN (CONT'D.)
            That's what I'd expect of you.

                  MARTHA
        Put 'em up! C'mon you turkey, up!

                    JOHN
            Violence is the last bastion of the
            coward.

                  MARTHA
        How about I bust you one in the
        pudding trough?

                    JOHN
            You don't love me anymore.

                  MARTHA
        I don't love you any less.

        They rush into each other's arms. John
        smears his mascara, Martha's tattoo
        runs; their tears spoil the artwork.

                                        FADE OUT.
```

Etcetera, etcetera, etcetera, ad nauseum. Sorry I had to do that to you, but I wanted to get across my revulsion at the "master scene" philosophy. It's part of the whole corrupt auteur theory that directors have been using to hype gullible film students and cinema critics for years. For those who really believe the director is the author of the film I offer these two direct quotes. The first from George C. Scott, very likely the finest actor this country and its film industry have produced in the last thirty years.

"Directors come in different levels of competency like all of us," Scott said with a look of innocence. "They may be fascinated with technique at the expense of the acting and even of the writing. You can mess with the acting a little but start tearing up a good piece of writing and you're in trouble. Screen writing is an extremely difficult craft; the writer should be applauded and be given the respect of constancy, of having his work done the way he intended it to be done."•

And the second quote is even more on the button. It comes from one of the six directors in the world today whom I consider wholly and totally *sui generis*, with voices so distinctive and powerful that they dominate the directorial landscape like the Colossus of Rhodes: utterly without competition. The other five are Luis Buñuel, Stanley Kubrick, Akira Kurosawa, Federico Fellini and Robert Altman.† But the quote is from Francis Ford Coppola, who said:

I like to think of myself as a writer who directs. When people go to see a movie, 80 percent of the effect it has on them was preconceived and precalculated by the writer. He's the one who imagines opening with a shot of a man walking up the stairs and cutting to another man walking down the stairs. A good script has pre-imagined exactly what the movie is going to do on a story level, on an emotional level, on all these various levels. To me, that's the primary act of creation.‡

The auteur theory denies the (to me) inarguable truth that first came the word. Without script, the director has nothing. Without a solid script, the director and his/her players can have all the charisma and verve in the universe, and they'll wind up standing around the sound stage with fingers up their noses.

The most obvious example of that condition can be seen in the films of the late John Cassavetes, an enormously talented director who, inexplicably, never seemed to learn

that he could not write very well, no matter how muscularly he directed. His schema for making a film, from his first (*Shadows,* 1961) to *The Killing of a Chinese Bookie* (1976), was to sketch out a plot with the barest essentials, and then to permit his players to ad lib their way through the shooting. It is a testament to Cassavetes' talent that there is anything of merit in such films as *Faces, Husbands, Minnie & Moskowitz* or *A Woman Under the Influence.* (It should be noted that these represent his "personal" films, as opposed to projects such as *Too Late Blues* and *A Child Is Waiting,* the former a disaster artistically and commercially, the latter a success in both respects, which were undertaken for major studios and for which full scripts were written. In the case of *A Child Is Waiting,* the script was written by Academy Award winner Abby Mann (*Judgement at Nuremberg, Ship of Fools, Report to the Commissioner*) and has always seemed to me the high point of Cassavetes' directorial career.) In his most representative films—*Husbands, A Woman Under the Influence* and *The Killing of a Chinese Bookie*—Cassavetes ran on like a senile old relative telling an anecdote the punch line of which he's forgotten. The actors posture and mumble, ramble endlessly, bore interminably, and the films come out at twice the length the material will support. I urge you to go see *Chinese Bookie* (a failure in many other ways, as well, but interesting for our purposes here as a startling proof of the contention that without script a director is nowhere), a film that clocks out at two hours and sixteen minutes . . . and could have been done as a sixty-minute film-for-television.

Actors who, puffed with self-importance, tell a director or a scenarist on a sound stage, "I can't say these lines," mean precisely that. Not *these are badly written lines*, but they cannot say them. Yes, it is a scenarist's job to write speeches that are flowing, rational, artful and concise without being tongue-tying, but it is the actor's job to bring skill and soul to the reading. In this way it is collaboration between Art and Life. And when actors or directors fool themselves with tragic little delusions that they are the authors of the film they condemn themselves to the making of a bad film.

If you retain any vestige of doubt that what I say here is core truth, and if neither Scott nor Coppola convinces you, check the credits of those directors you consider the most

• *George C. Scott, as quoted by Charles Champlin in the* Los Angeles Times *"Calendar" section.*
† *Since this was originally published, Buñuel, Kubrick, Kurosawa, and Fellini have died. This does not bode well for the current quality of cinema.*
‡ *Francis Ford Coppola, as quoted by Hollis Alpert in* Saturday Review/World.

innovative, the most daring, the ones with the longest string of successful credits (and I mean not only artistically, but commercially, as well). Josef Von Sternberg, Billy Wilder, John Huston, Robert Rossen, Sam Fuller, Lina Wertmuller, Charles Chaplin, Bryan Forbes, Mel Brooks, Ingmar Bergman, Preston Sturges, Claude Chabrol, Joseph L. Mankiewicz, Sergio Leone, François Truffaut, all of the giants I listed above—each director also writes. And brilliantly. Most of them were writers before they expanded their activities into directing. Even Orson Welles, credited with all the glory for *Citizen Kane*—though the script has been almost universally acknowledged, finally, as being the creative vision of Herman J. Mankiewicz—began as a writer and continued writing throughout his early and mid-career.

These comments are made at this point to invest you with the feeling that writing is a holy chore; that writing for film can be equally as holy, and that even in the face of the massive promotion for directors that permits jingoistic journals such as *Newsweek* to list actors, cinematographers and directors in their reviews, while omitting the name of the scenarist . . . if you decide to pursue a career as a writer of films/tv, you will be the foundation of any production, the cornerstone of the Industry. Take my word for it: you can have Brad Pitt and Reese Witherspoon and Steven Spielberg all signed on the dotted line, but the banks who put up the money to finance films won't give you a dime without a strong script.

When I started writing this essay, I thought I would lightly skim over the basic facts and refer you to other, more detailed studies. But apart from an excellent reference work by Coles Trapnell• there isn't a book on the subject I think worth your time. And as I've progressed through this discussion of translating the fantastic to the visual media, I've found it's very much a case of trying to explain in simplistic terms something that's incredibly complex. I guess it's even more complex to explain than I'd ever considered; even having worked in the media as long as I have.

There were two choices. One was to brush across the surface and touch only a bare few high points; the second was to

give you everything I've got. But that meant a rather extensive glossary of film/tv terminology. And clearly, you won't need it all immediately, nor is there space here to insert forty pages of lingo. There is a wealth of terminology that applies to camerawork, lighting, set decoration and special film/tape technology I have excluded that you won't need unless you become a full-time practicing scenarist.

Trapnell's book can give you the full regatta.

But a general rule of thumb that works extremely well is that the simpler and more direct your language in writing a script, the easier it is to visualize and to shoot. That is, and should always be, a paramount consideration. Also a 20th Century-Fox, Warner Bros. and Universal consideration.

One final thing about form, about what a script should actually look like.

Here is a tip that was given to me by Alex Gottlieb, a producer who was working in the office next to mine at 20th when I was doing the first treatment (never used, but paid for very handsomely) of *Valley of the Dolls* a while ago.

Alex and I got to know each other, and he was a fount of those obscure little tips that, if followed, save you endless hours of wrong directions. One afternoon, having written a half dozen pages of script in which two people have a long exchange of dialogue, I carried the pages in to Alex, to have him read them, to see if he thought they'd "play" (that is, if they'd be fast and perky and easy for the actors to work with). He took the pages from my hand, flipped through them without apparently reading a word, and dropped them on the desk.

"They won't play," he said.

I was stunned. "But you didn't even read them!"

"Doesn't matter," he said, with unassailable *sang-froid*. "They won't play."

"How the hell can you say that?"

"I can tell by looking at them. They don't look right."

I picked them up and leafed through them. "They look fine to me."

Alex pulled a note pad over and began making marks. "Look," he said, "here's what your pages look like."

• *Coles Trapnell,* Teleplay: An Introduction to Television Writing *(revised edition), Hawthorn Books.*

They all looked like this:

The short line in the upper left is the shot sequence information, the short line in the upper right is the page number. The short lines centered on the page are the indications of which character is speaking, and the long lines (which are, in reality, as you can see from the script portion earlier, much shorter) are the speeches.

"And here," said Alex, drawing on another piece of scratch paper, "is what that page *should* look like to flow and move for film." And here, approximately, is what he drew:

At first, I just stared at him without understanding what I was seeing. But after a moment I began to perceive what Alex was telling me. Do you see the difference?

Of course. You've got it. My script had speeches that were six, seven, eight, ten lines long; very long; too long. Prolonged speeches. Lectures. Alex's version had the speeches broken up, short "leader" lines that prompted the

other character to elaborate . . . but not too much. There were three and four word interrogatives that pulled the conversation forward; sharp dialogue that compressed the wordy messages of my version; the establishment of interior tension in the dialogue because the conversation was now a tennis match, not a series of pontifications. Alex hadn't rewritten my script, he simply showed me that you can tell whether or not a page of dialogue will work from the physical appearance!

I've repeated that tip to professional tv writers—several of whom have even won Emmys—and they were amazed and delighted. Yes, they said, that's right; you can tell just by looking at the page. So check over that script portion and see if it'll work. Except for one thing: there are always exceptions to the rule. Check out Linda's speeches at the close of *Death of a Salesman*. They're long, but they play like a baby doll. This is a general rule that is a good one to follow, but when you have someone speaking intensely, full of emotion, it is often permissible to let the character run on.

Oh hell. Any rule can be broken!

I was going to do a section here on Magicam, computer graphics, matte techniques and miniaturization, which were (when I originally wrote the first version of this essay in 1976) the coming thing in sf on tv, but since that time F/X and headlong tech advances have become so dominant, there are now entire books far more exhaustive and current and helpful than I could be here that deal exhaustingly with what I would have covered.

Let it suffice as my opinion that while these new technological developments can permit a production company or studio to put the equivalent of *2001: A Space Odyssey* on the screen every week for less money than it took to produce a segment of, say, *Star Trek*, these visual techniques are still only ways of telling a story more excitingly. Without a parallel development of sensibility that sf is about people and the effects on people of technology, the future and the fantastic . . . what we'll see on the tube or the big screen will merely be more Technicolor tomfoolery. It is the *story* that counts!

(And for the very best assessment of the state of the motion picture industry today, I urge you to locate the August 5th, 1974, issue of *The New Yorker* containing Pauline Kael's long, absolutely brilliant article, "On the

Future of Movies." It provides a view into the Industry that I can only touch on briefly here; Ms. Kael's perceptions will stun and enlighten you.)

(And for a television market list, featuring every show of the current season; to whom scripts should be sent and the shows that are either staff-written or that will only read agent-submitted manuscripts; *précis* of the plot-lines of the new shows and what material they're seeking, $5.00 ($7.50 Canada and Mexico; $10.00 Foreign) should be sent to The Writers Guild of America, West; 7000 W. 3rd St., Los Angeles, California 90048. Request the latest issue of *Written By*, the monthly slick journal of the WGAw. It's worth every penny; you might even want to subscribe after sampling an issue.)

And now let me tie up all the loose ends I promised to tie up, so we can both sit back and think about all this.

If you're worried about being plagiarized, should you come up with a series format or a screenplay idea, you can use the WGAw registration service ($20 per item for non-members, but only $10 for WGA members) even if you're *not* a member of the Guild. The Guild has many such services. It is, in short, the only writers' organization with which I'm familiar that spends its time and effort and money to protect and better the working conditions for writers. Once you've sold something, you can join for a very nominal fee, and you'll find the Guild a guardian angel of not inconsiderable power.

And this is important . . .

DO NOT SEND ME YOUR SCRIPTS, OR LETTERS ASKING ME TO READ YOUR SCRIPT, OR REQUESTS TO FIND YOU AN AGENT, GIVE YOU SPECIFIC MARKET INFORMATION, A PLACE TO STAY, OR ENCOURAGEMENT. I HAVE DONE MY SHARE BY WRITING THIS ESSAY. IF YOU SEND ME SOMETHING, NO MATTER HOW CLEVERLY YOU WRITE THE COVER LETTER, I'LL ONLY BURN THE DAMNED THING AND CURSE YOUR MISERABLE SOUL!

There. That ought to be direct enough.

A final word. Writing science fiction and/or fantasy for the visual media is a tougher row to hoe than writing a western or a caper film or even a searching, penetrating study of life in America today. It takes great skill, a fertile imagination, and the stamina of an Outback Abo.

Watch what comes across the tube, go to see the sf movies, and study them for technique, not just how good or bad the storyline might be.

And, in an effort to weed out those of you who will be deluding yourselves about your abilities or the toughness of this gig, even after all I've said here, let me close with the words of a great critic, the late Cyril Connolly, who said in his book, *The Unquiet Grave*:

> *The more books we read, the sooner we perceive that the true function of a writer is to produce a masterpiece and that no other task is of any consequence. All excursions into journalism, broadcasting, propaganda and writing for the films, however grandiose, are doomed to disappointment. To put of our best into these forms is another folly, since thereby we condemn good ideas as well as bad to oblivion. It is in the nature of such works not to last, so it should never be undertaken. Writers engaged in any literary activity which is not their attempt at a masterpiece are their own dupes and, unless these self-flatterers are content to write off such activities as their contribution to the war effort, they might as well be peeling potatoes.*

I'm not sure I agree with all of that, but he's right on the most important count. If you aren't prepared to produce work of a masterpiece brilliance, don't come out here, don't try to become a scenarist, don't muck up the water with more inferior work. Be prepared to embark on a writing career whose sole purpose is to refute Connolly's admonitions.

It can be done. I've seen enough superlative screen writing to know it can be done. But if you are arrogant enough to think you can do it, just remember: you have to be a very fast gun, indeed; and there are those of us here already who will challenge you to draw against us.

And when the smoke clears, there won't be any Cisco and Pancho giggling their way into the sunset.

You've been warned.

Harlan Ellison

Hollywood 1974/2002.

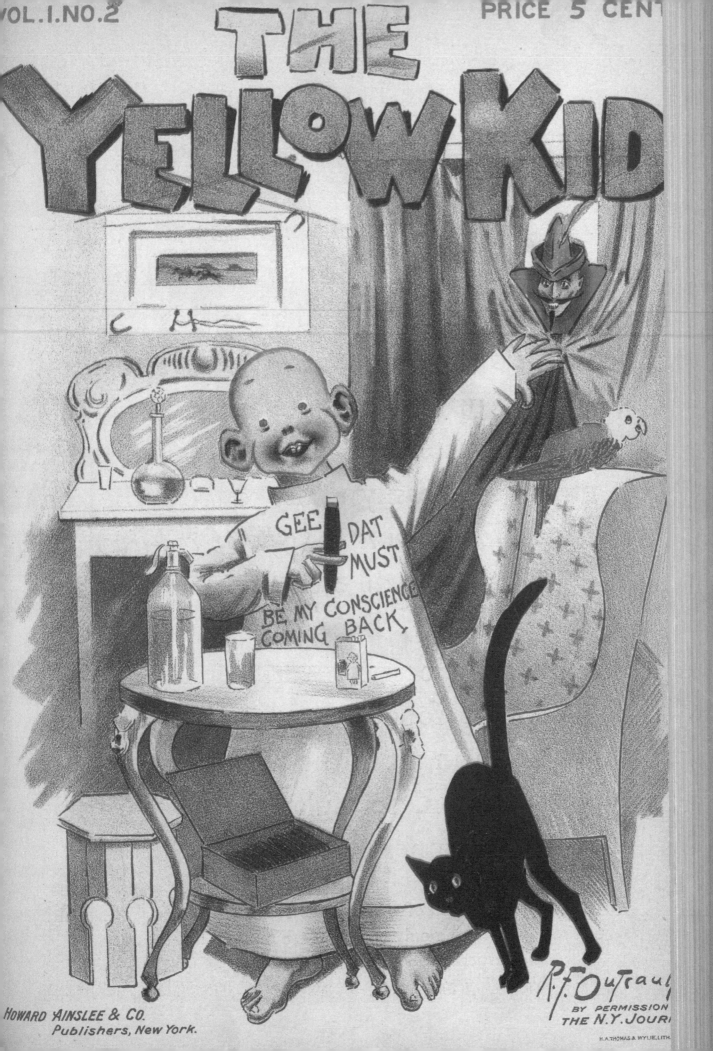

STORYTELLING:

THE UNIVERSAL LANGUAGE

Human beings are an insatiably curious and creative species, and from prehistory to the twenty-first century, a universal way for human beings to express their creativity has been storytelling. And though it may seem that "pure narratives"—that is, stories told without accompanying visual images—are completely different from the visual media that are the subject of this book, their purposes, and hence some of their foundations, are the same. The goal of oral or written narrative is to capture the hearts and minds of the listeners, and effective storytellers, whatever their intention—to enhance the magic of a ritual, to educate, to entertain, or just to tell about the one that got away—rely on many techniques that transcend the medium. This book, however, is for the visual storyteller—the visionary, artist, creator, renderer—who must transcend the words of a story, and create a compelling, unambiguous, and immersive visual experience by making a live-action film, digitally adding elements to a photographic canvas, creating 3D animation, or drawing the panels and pages of a comic.

The "Seeing Place": The Evolution of Theater

Storytellers occupy a different space from the audience—the people they are telling the story *to*—so the first "stage" was simply wherever the storyteller was sitting or standing. The earliest official "script" should be credited not to the Greeks, but to the Egyptians, whose preoccupation with preparation for the afterlife motivated them to create numerous ritualistic performances. One of them, a story about the death by dismemberment of the god Osiris, and his subsequent resurrection, had enough characters and was complex enough to be called a play, and is referred to in theater histories as the Abydos Passion Play. Greek theater evolved from performances at religious festivals connected with the cult of Dionysus (who, not coincidentally, was also killed, dismembered, and later resurrected), the main ingredients of which were choral singing and dancing. According to tradition, the first person to create a drama in which individual characters stepped out from the chorus and involved the chorus in a dialogue was Thespis, in 534 B.C. By the middle of the next century, when Aeschylus's *Oresteia* was performed at the Theater of

Sequential art is deserving of serious consideration by both critic and practitioner. The modern acceleration of graphic technology and the emergence of an era greatly dependent on visual communication make this inevitable.

—Will Eisner, Master visual storyteller

Dionysus at the foot of the Acropolis in Athens, the crowd came not only for the plays, but to see their favorite actors. The spectators were seated in benches in an area called the *theatron,* or "seeing place," and the actors probably performed on a long, narrow platform, in the back of which was a wooden façade, which might be painted to resemble a palace wall, a mountain, or a temple, but could by no stretch of the imagination be called a "set."

Over the succeeding centuries, stagecraft became an art and the "seeing places" of theaters all over the world became immensely popular gathering places. Lighting, with candles and reflectors, was introduced during the 1700s, and gas lamps replaced candles in the late 1700s. In France during the nineteenth century, the first real directors emerged, taking over complete control of production and, increasingly, demanding the illusion of reality. Characters spoke to each other, within elaborately realistic settings created through lighting, sound, "special effects," costumes, and props. At the beginning of the twentieth century, panoramas, painted on large drapes hanging from spools on the ceiling, were added to stage sets, a technique which, much refined, is still used in films.

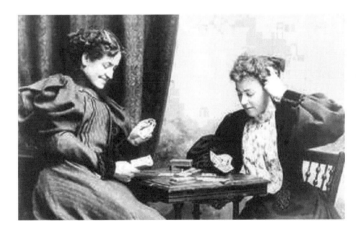

The bare-bones subject of this still is two women, but every detail—the clothing, the setting (the style of the table and chair, the drapes), the expressions and body language of the women—is part of the visual story.

Telling a Story Through Visual Imagery

What is visual storytelling? For the purposes of this book, it is any medium that uses visual images and or graphics, moving or otherwise, to tell a tale in such a way that the whole is more than the sum of its parts. Ten different people reading an unillustrated paragraph in a narrative or magazine article will conjure up ten different mental images on the basis of that paragraph. In fact, any narrative without visual representation, no matter how compelling, leaves the door wide open for as many independent interpretations as there are readers. Adding illustrations to a narrative text, so that all readers have the same pictures to look at, closes the interpretive door to some extent. The story may be as straightforwardly presented as a sequential live-action filmed narrative, such as *The Crocodile Hunter,* or as complicated as, say, one of the third-generation interactive games such as *Metal Gear Solid Two.* The purpose of the storyteller(s) is the same: to use the tools of their trade in such a way that the viewer sees and feels—insofar as possible—what the artist/director wants him or her to see and feel. Whether the final result is primarily shaped by one person or is a true collaborative effort, and what *style* is used, are not, in the end, relevant. The effectiveness of any visual storytelling medium—comics, film, or interactive games—depends on the creative talents of the writers, artists, directors, and technical experts who have a common goal: they want to draw the audience into the story unfolding before their eyes and keep them there.

Animator and Eisner Award–winning cartoonist Jeff Smith, creator of the popular *BONE* comic series, firmly agrees that the visuals are there to enhance the story, not the story to enhance the visuals. "The story is crucial. Presenting the clear story is what the visual storyteller must do." It's true that when we see a trailer for a new movie, it's the quick cuts of dynamic scenes and wild imagery that entice us to go to the theater or rent the movie, but when we finally sit down to watch, it's the story we're after. Bran Ferren, former President of Research and Development and Creative Technologies for Walt Disney Imagineering, has been quoted

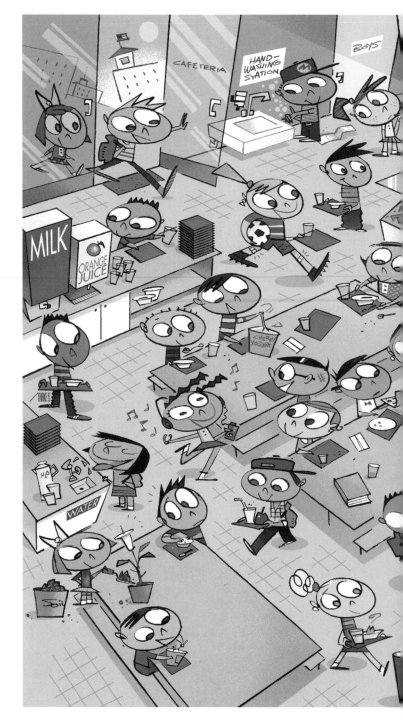

many times as an advocate of storytelling. "The core component of leadership is storytelling," Ferren believes. "Education is a storytelling problem," he insists. "Leadership is a storytelling problem."

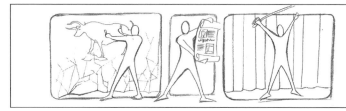

This drawing was created by Bob Staake for the American Museum of Natural History in New York City, for an article about their new cafeteria. Staake says that when he is illustrating an article, his professional role is to *illuminate* the manuscript. But, says Staake, "I've always considered myself more of a carnival barker. My role is to get the reader to go ahead and interact with that story. That's my job. I'm a guy who's standing there saying 'Hey, there's a writer in the big top—come on in!'" This drawing, which has a classic left to right eye path, has many stories unfolding, yet the reader has a choice: check out every detail or take a cursory glance and turn the page.

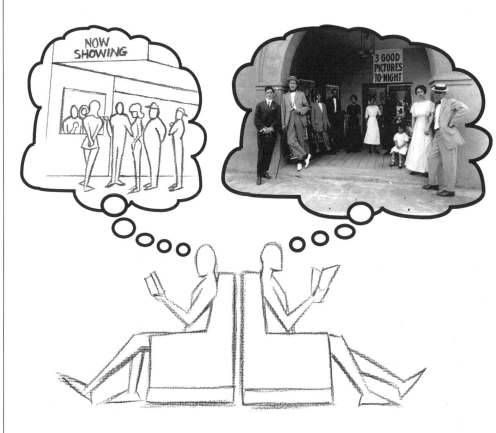

They gathered together at the local cinema. Sam was there, with his lovely wife Judy. Although the event was not formal, the men, in particular, were nattily dressed.

No storyteller can be sure that the way a person reading a text without illustrations visualizes a given scene will match the storyteller's intentions.

A brief visual history of visual storytelling. The last panel looks forward to the day when virtual reality is *the* medium for interactive gaming.

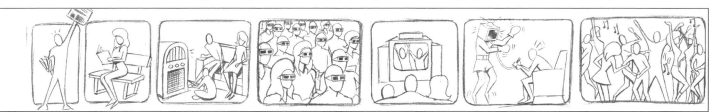

One of the most famous examples of a narrative that achieved the desired effect without accompanying visual images is The Mercury Theater's October 30, 1938 Broadcast of the Orson Welles–Howard Koch adaptation of H. G. Wells' *War of the Worlds*. Although the ultimate impact of the broadcast was to some extent pure happenstance (thousands of Edgar Bergen–Charlie McCarthy fans abruptly switched stations when an unknown singer began the show, thereby missing the prologue to the Mercury Theater's radioplay), the brilliant collaboration that produced the script was orchestrated by Welles. Koch's first draft went through revision after revision, and at rehearsals Welles made numerous changes, demanding that every detail be as "authentic" as possible, right down to using the names of actual places and people. Frank Readick, playing man-on-the-scene reporter Carl Phillips, modeled his emotional tone on that of the reporter who had broadcast an account of the destruction of the *Hindenberg*. And, as the following excerpt shows, the script concentrated on descriptions that would evoke visual—and visceral—responses in listeners:

Ladies and gentlemen, this is the most terrifying thing I have ever witnessed . . . wait a minute, someone's crawling. Someone or . . . something. I can see peering out of that black hole two luminous disks—are they eyes? It might be a face. It might be . . . good heavens, something's wriggling out of the shadow like a gray snake. Now it's another and another and another. They look like tentacles to me. There, I can see the thing's body. It's large as a bear and it glistens like wet leather—but that face! It . . . ladies and gentlemen, it's indescribable. I can hardly force myself to keep looking at it; it's so awful. The eyes are black and gleam like a serpent. The mouth is kind of V-shaped with saliva dripping from its rimless lips that seem to quiver and pulsate.

Martians had come to New Jersey, courtesy of Orson Welles and a radio broadcast that projected maximum realism by way of Carl Phillips's intense visual details. Over a million people—presumably none of them had heard the introduction of the radio show as a fictional adaptation of H. G. Wells's novel *War of the Worlds*—assumed it to be real because it painted the picture of being real. "Pure" narrative can accomplish this, but in good visual storytelling, the instantaneous recognition and understanding provided by imagery replace the narrator.

The astonishing success of the *War of the Worlds* broadcast was one of the reasons that RKO films made Orson Welles an unprecedented offer, giving him total creative control over his first motion picture, which turned into one of the all-time classics, *Citizen Kane*.

Sequential Art and Illuminated Manuscripts

The concept of visual storytelling goes back way before the dawn of history, to the Paleolithic era, some 30,000 years ago, with the earliest recorded cave drawings found in France. About 17,000 years ago, an ancient artist in what is now Altamira, Spain, drew animals with legs with multiple images. When viewed in candlelight, the multiple legs in these cave paintings create the illusion of animation. The 1067 Bayeux Tapestry, a 230-foot-long hand-embroidered, richly colored tapestry is a pictorial narrative of the Norman conquest of England.

Many early examples of sequential art—where pictures and words work together to tell the story—were religious in nature. Papyrus rolls containing an illustrated text of the famous Egyptian *Book of the Dead*, circa 1500 B.C., are an early example of an "illuminated manuscript," a term which refers to any manuscript—whether on papyrus or paper—illustrated with hand-drawn and hand-colored images or decorated with purely ornamental art. Probably the oldest illuminated manuscript extant is a fragmentary illustrated copy of the *Iliad* now in the Ambrosian Library of Milan.

The Yellow Kid and friends.

The Visual Storytelling Media

There are four visual storytelling media covered in this book: film, animation, interactive games, and comics. If there should come a time when all motion pictures are completely rendered with CGI (computer-generated imagery) rather than photographically filmed, the media breakdown may change. Today, however, although a movie like *Star Wars Phantom Menace* may be 75 percent "rendered," it cannot be considered "animated" in the traditional sense. In fact, a new rendered film art has emerged, a new type of animation (or live-action–animation mix) that is only limited by the storyteller's imagination and software tools at his or her disposal.

Two other famous examples of illuminated manuscripts are the Holkham Bible Picture Book, probably created in London circa 1325, which features lavish sequential illustrations of selected parts of the Bible, from the Creation of the Universe to the Last Judgment, and Josef Franz von Goez's 1783 "Lenardo and Blandine," a *melodram* with 160 illustrations. Although "Lenardo and Blandine" can be found on a German website called Platinum Age Comics, the closest relatives to today's comics are probably Wilhelm Busch's illustrations in *Max und Moritz,* which were published in the United States in 1870 and were the inspiration for Rudolph Dirks' *Katzenjammer Kids* in the 1890s. This was around the same time that *The Yellow Kid* evolved from a single-panel cartoon into a multiple-panel comic strip and was then collected into what was the first real comic book. *The Yellow Kid* became a successful merchandising property, gracing buttons, cracker tins, and cigarette packs. It was even turned into a Broadway play, which at the time was the equivalent of one of today's major motion pictures.

As the illustration shows, one way to classify visual storytelling media is to start with two major subcategories: the Static (without motion) media (magazine narratives, accompanied by photographs or drawings, illustrated books, and comics) and the Active (with motion) media (movies, television, multimedia, and interactive games). Luminear, one of the two static media, is a coined term combining "illuminated"—from *illuminated manuscripts*—and "linear"—your typical "this is what I have for you so sit back and watch" experience. One crucial difference between these media is the dramatic variation in what the viewer brings to the experience of the story being told. As visual storytelling media moved from the static page to the screen (either in the movie theater or on the television screen or console), the possibilities for different kinds of illumination and imagery led to increased use of cinematic techniques, even in the static media, and, finally, to the very real player participation in today's interactive games.

Visual Storytelling																
Static						Active										
Luminear		Interpersonal				Linear				Interactive						
Articles		Illustrated		Comics		Movies		TV		Multimedia		Games				
Newspapers	Magazines	Picture Books	Childrens Books	Periodical	Graphic Novels	Manga	Silent	Talkies	Serials	Live	EnhancedTV	Internet	DVD	Role Playing	First person	Strategy

The visual storytelling continuum.

Comics

As comics have evolved, they have increasingly relied on cinematic techniques to achieve desired effects. But comics are a static medium, so readers must supply their own timing and pace, dwelling on a single panel or page as long as they want to. Artists can direct readers' responses (for example, by creating a page with so much information that the reader will want to slow down, or by using "extreme" graphic techniques). Yet in the end, the experience of the comic book reader is an interpersonal, active, one.

Silent Films

The first of the active visual storytelling media were "silent" films. Although the viewer no longer supplied the timing and pace, the accompanying music was often unrelated to the story, and so the experience of a cinema-goer watching a pre-"talkie" film was, like the experience of a reader of a comic, an interpersonal and active one. The ele-

Although the first motion pictures had no soundtracks, and the black-and-white photography was anything but crisp by today's standards, the imagery could be very effective in creating a desired response. The cinematic representation of an oncoming train shown here, accompanied by dramatic music, frightened some moviegoers out of the theater.

In an "interpersonal" medium, such as comics, the visual storyteller requires contributions from the audience (reader or viewer).

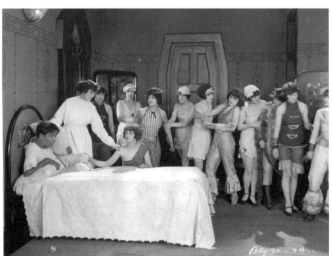

"Silent" films are a more interpersonal medium than today's films. When films consisted of pictures and music, viewers could imagine what the dialogue and sound effects might be, thus becoming a participant in the storytelling experience.

ments that must be supplied by the viewer of a silent movie are the same elements that must be supplied by the reader of a comic: voices (is the voice baritone or bass? a slow southern drawl or Brooklynese?) and sound effects. That is why comics are closer to silent films on the visual storytelling continuum than they are to the talkies.

The Talkies and Beyond

Films with real voices, sound effects that match what is taking place on the screen, and state-of-the-art special effects all foster the illusion that what the viewer is seeing is "real." Whether the intention is to mimic photographic reality or to create an internally consistent but impossible world of cinematic magic, the best of today's films are realistic in ways that could not have been predicted even ten years ago. There is, however, a trade-off. The more effectively rendered the illusion, the more passive the role of the viewer. Viewers' emotional reactions to a particular film are still shaped to some extent by their life experiences, and by their previous experience with other visual storytelling media, but overall, watching a film is a passive experience.

Interactive Games

Interactive multimedia, and specifically interactive games—either for game consoles such as PlayStation or for personal computers—represent an entirely new visual storytelling medium, a hybrid that shows just how fertile the cross-pollination of different media can be. Multimedia games, like films, are an active medium, but unlike films, they are a lean-forward, interactive, rather than a lean-back, passive, medium. The best of the games, in which story, sound effects, graphics, 3D effects, and high-tech game control mechanisms work seamlessly together, offer a unique level of immersive complexity, for both the developers and the players. The available technology takes ideas from widely diverse sources, including out-of-this-world comics and popular novels and real-world scenarios involving historical characters and sports stars, and turns them into dynamic visual storytelling.

• • •

Although comics in America have waned in popularity since their introduction (selling millions of copies in the 1940s vs. hundreds of thousands today), this is not because other media

Linear storytelling media, which have a structured, unchangeable story and path, offer a "sit back" experience, while the interactive media offer a "lean forward" experience. The players of interactive games are not just members of a passive audience. They are part of the story. The experience is more like real life, which is both active and interactive.

"can do it better"—they're just different. History has demonstrated that a really popular medium never dies. When television proliferated, people believed that there was no future for radio, but television didn't kill the radio—it changed it. Home video didn't kill the movie industry—it changed it. At a recent interactive gaming conference, Scott McCloud said, "The art of the moving image is the most common way of coming back and seeing our world, but through another one's eyes. It's hard to triangulate our environment unless we see it from more than one viewpoint at a time and that's why I think a diversity of media is always going to be important even if one is most popular."

FROM
FRAME TO
FRAME

A frame in the world of visual storytelling consists of margins, or borders, which contain the images and/or words the storyteller has used to illustrate a particular point in a narrative. In all media which are shown on a screen—movie screen, television screen, or computer monitor—the frame is usually the screen itself, and the images have been designed to be shown to best advantage on a screen. In comics, the frames are the panels. In one sense, a frame is a window, but what we see when we look out of a window depends on the position of our head and eyes. In contrast, what we see when we look at one shot in a film or one screen in a game or one panel in a comic depends on how the creators of the shot have arranged the objects that will appear in the frame and the position of the "camera" on the stage. In all visual storytelling media, it is the *sequence* of frames that moves the story forward, drawing the viewer, reader, or player along.

You can do a little bit of this story, a little bit of that one, but everything's happening sort of at the same time. You have to empower the player to interact with not only the environment, but also the story. You have to invite them into the kitchen as another chef, otherwise, they can just go watch a movie or read a comic. —Brian "BMAN" Babendererde, Game designer and comics artist

Comics: Panel to Panel

Although they are in a sense a variation of the illustrated narrative, or picture book, comics are the only printed visual storytelling form with truly sequential cinematic qualities. One of the first newspaper comic strips, *The Yellow Kid*, appeared on July 7, 1895 and became popular almost overnight, creating, according to Stephen Becker in his book *Comic Art in America*, the "first, gentle wave of mass hysteria which accompanies the birth of popular art forms."

The terms "comic book," "comics," and "comic art" are misnomers which stuck. The word "comic" generally refers to something humorous or funny, and is aptly applied to strips like *The Yellow Kid* or *Krazy Kat* or *Little Lulu* or *Archie,* but there is nothing funny about the story content of most of today's comic books. Comics can be about anything from superheroes to war stories to serial killers, and if you travel to Europe and Asia, you'll find comics about golf, soap operas, rock stars, and even truck drivers.

In his book *Reinventing Comics* Scott McCloud makes the point that the actual product is not the physical comic book, but the visual story told within its pages.

Reading a two-page comics spread (Western style). 1. The reader takes in the spread as a unit, absorbing a "summary" of the action and characters. 2. Looking at the left-hand page, the readers focuses on the overall design, but subconsciously tracks the flow through shapes, contrast, characters, word balloon placement, etc. 3. Moving from left to right, the reader starts with the panel in the upper left corner, then follows the action flow from the first to the second panel. 4. Next, the eye moves down and left to the left side of the horizontal panel on the next row, and so on. As the dotted lines indicate, at all times the reader is conscious of the layout as a whole.

Eye Path

Eye path can refer to the movement of a viewer's eye from one part of a single picture or panel to another part of that panel or, in the case of the linear sequence of a comic book, from panel to panel. When a reader opens the pages of a comic book, the eye registers the whole page (or two-page spread) at once, but the brain cannot process all of the details at once. Thus the artist must focus on a sequential path, from one panel to another. A superbly designed page will include elements that will assist the reader in following the story. If page design and panel layouts are not easy to follow—if the confusion of the page kicks readers out of the story, they will naturally pull back to try to figure out the mechanics of the sequence—the order in which it is supposed to be read. They might even give up on the story altogether, or, at the least, miss an important plot element.

Watching a person reading a comic is a great way of witnessing firsthand how the comics-reading process works. The action flow of a panel can be based on the natural eye path of the reader, a cinematic technique that emphasizes any action the artist/writer wants to emphasize, making it seem as big or "fast" as desirable. The converse is also true: drawing the action flow so that it goes against the reader's natural eye path can bring things to an abrupt halt, or even make the reader subconsciously feel an impact.

There are many different techniques used by comics artists to lead a reader's eye through a sequence of pages and panels, including variations in panel size, shape, and angle, as well as within-panel design that focuses attention on that panel or uses directional design elements (as in the page from *Artesia* shown opposite). In general:

* A figure or object that is larger or smaller than everything else in the panel/page will show the reader that that figure is most important.
* A reader will generally assume that the largest panel on a page is the most important.
* An oddly shaped panel will stand out on a page, forcing the viewer to focus on that panel.
* Dramatic use of the "frame-within-a-frame" draws attention to the panel.
* An unusual shot angle in a single panel will naturally attract a viewer's eye, and can also add drama, suspense, and excitement to a page or a spread.

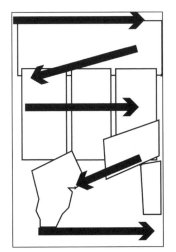

A page from the original *Alias* comic book, written by Chuck Dixon and illustrated by Todd Fox and Enrique Villigran. On the left is a facsimile of the page; on the right, a schematic showing the eye path.

The character's movement from left to right in this panel helps the reader's eye move from left to right, rather than straight down to the overlapping panel. In the overlapping panel (panel 2), the reader sees the piled-up papers; the eye then moves naturally across to the third and fourth panel. The reader sees the note—held by an ornate magnet—before the character, who is moving from right to left, does. A nice touch. The dramatically angled slope downward to the left both foreshadows and literally points to a close-up of the character's hand holding the note. The character drops to the floor, covering his face, and the reader doesn't have to read the note to know the person who wrote it is long gone.

This stand-out panel is designed to call attention to itself. The general is looking right, at Lt. Dahl, and in case the reader's eye would be tempted to stray, the cigar also points to the right. The lieutenant is dramatically framed in black *and* silhouetted. Finally, the word balloon at the upper right is a sure sign that Wood intended the reader to look first at at the upper left of the next panel.

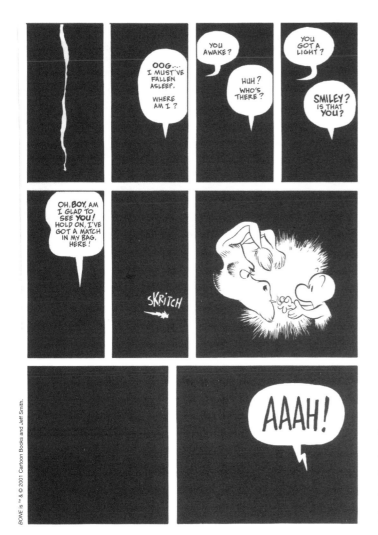

The shape and placement of word balloons—and sound effects not contained in balloons—can be just as important as the words within them.

Eye path design can be very subtle. In the first panel of this page from Mark Smylie's *Artesia* the crossed swords held by a band of off-camera soldiers creates a direct line to the towering knight in the second panel, and the downward directional is reinforced by the word balloons. In the third panel, the first word balloon leads the eye to Artesia's word balloon, which is positioned just above the close-up of the enemy knight's horrific face. In case that's not enough of a guide, Mark adds the sword that drops off panel just below the word balloon.

Word Balloons

Most comic panels contain captions and/or "word balloons" and sound effects, so when drawing a comics page, an artist should try to design panels with the space for the words. This is done during the thumbnail and layout stage of design (see Chapter 10, page 162). There are two theories of copy placement: (1) to butt captions and balloons against borders to get them as far away from the central art area as possible and (2) to draw the balloons recessed within the border of the panel, leaving the outside border or gutter intact, so even without pictures, the word balloons, words, sound effects, and panels move the story forward. In the page shown at the left, the eye

is drawn to panel seven, where Bone is lighting the scene with a match. That single image gives the reader the information needed to visualize the characters while reading the word balloons.

When planning for word balloons, the artist has to consider the overall look of the panel. For example, if an artist wants significant negative space in a panel that will eventually contain a lot of copy, the artist will need to design for "extra" negative space so that after the copy is added, there will still be enough room for the images plus space. As with every element of panel and page design, a logical and clear eye path for all copy is very important. To ensure that the reader doesn't have to stop for even a fraction of a second to figure out what caption or balloon is next, the artist must design balloons, captions, and sound effects with the desired action flow and eye path in mind.

Western Style vs. Manga Style

The pages and panels of Western comics are drawn and read left to right, top to bottom. Japanese manga comics, in contrast, are read right to left. Another major difference between the two styles is pace. The standard 32-page Western-style comic tends to provide more narrative and dialogue, necessarily slowing the reader's pace (otherwise the slender comic wouldn't be much of a read). Manga comics sequences have less dialogue, and a highly specialized visual vocabulary which is readily understood by Japanese readers. They are also a lot longer, and so can afford to include many more panels that are examples of "pure" design, and don't necessarily advance the story.

The opening two-page spread for this chapter shows a *Soul Chaser Betty* sequence, drawn Western style. The characters flow off the panels, and the overall page layout and eye path are more important than the individual panels themselves. The tattered cloth from a flowing cape draws the reader's eyes from the upper right corner (after reading the second word balloon) down through the second, third, and fourth panels. The screaming letters then guide the reader to the flowing cape at the bottom right and up to the villain. Shown here is a *Soul Chaser Betty* page, manga style. The sequence is cut into quick "snippets" of images, none of which holds the viewer's eye for long or resembles the previous panel or image. The technique is reminiscent of

The one overall design element that *does* guide the reader's eye here is the flying beast's tail swooping down and through the bottom three panels in the order they should be read.

how a pivotal scene in an action movie would be cut, with the heavy use of speed lines, rather than page design, guiding the reader's path.

Leap of Faith (Between Panels)

The frames in films are temporally continuous. All the audience has to do is sit back and pay attention to the action on screen, following the characters as they walk across a room, commit murder, or just look out of a window. Comics panels, in contrast, are *not* continuous in the same way, and there is no actual motion. For example, readers will fill in the "dots" between panels at their own pace; some people may experience a fight scene in slow motion, while others see it as lightning-fast.

Film: Scene to Scene

Motion pictures—a new paradigm of visual storytelling—emerged around the turn of the 20th century, but the earliest makers of moving pictures might more aptly be referred to as film "manufacturers" than filmmakers. There was very little acting in early silent films; individual characters in the film were used to move the story along or for scene transitions. Screenplays—and hence any attempt at cohesive structure—did not exist, and the camera operator used short descriptions of the action to set up shots. The early, industrial-age films had an assembly-line, mass-produced feel to them.

In the United States, the two recognized pioneers of films that were directed rather than manufactured were Edwin S. Porter for Edison films and David Wark Griffith of Biograph films. Porter's best-known film, *The Great Train Robbery* (1903), set up a formula for the "Western" (crime, pursuit, and capture) that is still being used today. Griffith's directing debut was *The Adventures of Dollie* (1908), a film involving a kidnapped girl whose father is in relentless pursuit. She is hidden in a barrel, which falls into a river and over a waterfall, then into her father's arms. For this film, Griffith devised one of the first "blueprints" of the visual storytelling climax (or punch line). As a director, Griffith focused on symbolism, dramatic imagery, camera angles, lighting techniques, and placement to tell his visual story scene by scene, everything that filmmakers do today, and his Biograph films became the yardstick by which subsequent films were measured for many years.

In his film *The Country Doctor,* for example, the scenes involving the doctor's house were shot on one of only two sets, one inside of the doctor's home and one outside of the home, and the entrances and exits of actors from these sets were shot from the same point of view (that is, if the camera was placed at the curb at eye level when an actor went into the house, it would be in the same exact place when the actor came out of the house). This did save money because it allowed Griffith to shoot multiple scenes in one session, but his motive wasn't economic, but rather a desire to establish the house as being stable and consistent. In his masterpiece, *The Birth of a Nation* (1915), he introduced

D. W. Griffith, 1875–1948. As a young man, D. W. Griffith acted in films for Edison Film Co.. Fortunately for the filmmaking industry, he didn't fancy himself an exceptional actor. He almost single-handedly created the language of modern cinema.

No, this isn't an unfinished comic book page, but one of the storyboards used to establish the scene-by-scene sequences for the film *Species II*. Although storyboards are only one step in the long and complex film production process, they are just as important as if they were a final product—only the audience is different. The images here were drawn by comics and film storyboard artist Kerry Gammill.

both the close-up and the moving camera. The art of film—the "seventh art"—might have continued to imitate the stage had it not been for talents such as Griffith, who saw beyond what others could see and developed a new art form.

Drawing Movies

In his 1959 book *The Cinema as a Graphic Art,* Vladimir Nilsen says that what the moviegoer sees on the screen is not what actually happened in front of the camera, but rather "its optical interpretation, as fixed on film." Today, with the advent of computer graphics imagery (CGI), screenwriters and directors are no longer limited by the laws of optics, by what a camera can "see." Movie cameras will always be able to take photographic images of "real" people, places, and things ("real" in quotes because much

Yes, this is an unfinished comic book page, and notice how much more dynamic the images are than the ones in the *Species II* storyboards. Here Kerry Gamill was not limited by the knowledge that the scenes he was creating would ultimately be filmed, and used extreme foreshortening and impossibly exaggerated positions and stances. Even if an artist is doing the storyboards for a film that will make extensive use of CGI, he or she must consider that when the sequences are made into film, if the results are too different from photographic reality, the audience may reject the scene.

of what seems real in pre-CGI action films was created using models), but CGI has added a new stage to film-making—a *rendered* stage, where an artist can take film footage, digitize it, and enhance it to achieve the desired effect.

Digital special effects can also be used when the safety of human actors needs to be to considered. A recent addition to the digital effects stage is the use of digitally rendered flashes with blanks, instead of filming real gun-fire. "I tend to not use blanks all the time in my films," says animator and filmmaker Kevin Van Hook. "I feel it's vitally important, especially in small rooms. I just don't personally feel comfortable with that risk, because it's still a charge; it's still an explosion. So, we do digital flashes, shell casings discharging. It works out actually a little cheaper, and we can make it more dynamic, especially if we're dealing with lots of shell casings. The real ones follow the law of gravity, so you can't expect much added dynamics from them, but when we add them digitally, we can almost ignore that for better effects. We still include interactive light with the flash, so the people's faces light up when the gun fires, so there's no loss to the reality in the storytelling experience."

At the climax of the film *Miss Congeniality* Sandra Bullock tosses a beauty queen crown through the air to a Statue of Liberty stage armament. Upon hitting the statue, the crown explodes into a giant blast of smoke, fire, foam rubber, and confetti. The crown itself, the exploding statue, smoke, fire, and the confetti were all rendered in Newtek's Lightwave 3D, Adobe After-Effects 4.1, and Photoshop 5.5. Van Hook comments, "In real life, because of the way they wanted to film the crown flying through the air, she [Sandra Bullock] couldn't really throw anything. There was too much risk—hitting the camera equipment or people—so we put the crown in digitally."

Van Hook says that with CGI you can adjust the composition, change the lighting, color, and backgrounds. Ten years ago filmmakers might have looked at a scene that was in many ways spectacular but was unusable for some reason—the lighting may have been off, for example—and said, "Wow, that's wonderful; I wish we could use that, but we'll have to reshoot." Today, they might say, "Wow, that's wonderful; have the CGI guys fix it." Suppose two actors

give the performance of their lives, but someone forgot about the 1990 Chevy in the background of a movie set in 1960. Traditionally, they'd have to move the car out of the way and reshoot the scene, possibly losing that original energy. Today, they can have the CGI guys change the car to a 1959 Olds or just erase it. "No matter how good you are or how focused you are as a filmmaker, you can still make dumb decisions, like having an African American man walk around at night in a black jumpsuit. Now they don't have to go back and reshoot it. It's like the comic artist at the drawing board. The layouts become the film footage; you sit there and go, okay, is there anything I can do to fix this?"

Duane Tucker, Chief Technology Officer for Dynamic Media, has followed CGI for years and believes that the future technology will focus on faster, cheaper, and better. In the beginning of James Cameron's film *Titanic,* when we see Leonardo DiCaprio standing on the bow as the ship heads out to sea, the camera flies past him, up toward and through the smoking smokestacks, then turns around and looks backward toward the rear of the boat. Tucker says that 60-second scene took 18 months to produce in CGI, because the smoke was so difficult to render. "They had to hire hydrologists just to help them create special software to realistically animate the water."

One question often asked about filmmakers' increasing reliance on CGI is, Will the use of digital effects make possible hitherto unexplored means of artistic expression, or will it lead to a new kind of cookie-cutter approach, where filmmakers use a library of outrageous canned effects just because they can? Wayne Hanna, the Academic Director for Visual Communications at the Illinois Institute of Art, believes the availability of CGI doesn't make much of a difference on how creative people approach things.

Creativity is something apart from technology. . . . All the wonderful things that we can do technologically are still falling into the familiar patterns, where everybody runs the same way, everybody looks the same way, and everybody thinks kicking dinosaurs is cool. So, part of what we try to do is to kick them outside of that box and find something different. How do you develop your personal style? In that process, we tie one hand behind their back and dictate that they can't do dinosaurs, now what are you going to do?

Interactive Games: Level to Level

In pitching his proposed film of Joseph Conrad's *Heart of Darkness* to RKO executives, Orson Welles wrote that it would be "a completely unprecedented experience for the audience since it will see a story told in an entirely new way." He wanted to manipulate the "frame" of reality by making the camera itself the protagonist, a visual pun which would equate the "eye" of the camera with the "I" of the character. By making the camera a character that framed reality, he would give the audience the opportunity to "walk into and through" the narrative. Although Welles never made the film, his description of it presaged the first-person interactive game.

The latest 3D interactive games seem light-years away from their earliest arcade ancestor, *Pong,* but for most of the 1970s and some of the 1980s, arcades were *the* venue for interactive games. Cartridge-based home video systems (and hand-held games) came next, paralleled by the development of games that could be played on personal computers. A milestone in the history of interactive games was the Apple II version of InfoCom's *Zork,* where the action took place in a fully realized environment. *Zork* wasn't just about scoring points: It was an adventure. In the 1990s, giant leaps ahead in microchip technology made it possible for developers to create ever more complex games in which the graphics were as much a part of the experience as game play (*Myst*), multiple-player games where every prop and character were designed for maximum realism (*DOOM*), and even games where players had access to the source code (*Quake*).

It is impossible to say exactly what interactive games in 2010 will look like, but one thing is certain: they will be immersive and entertaining, and the most important "character" will still be the player.

The Eye as I

The "eye as I" may have been ahead of its time in the year 1941, but it is commonplace in the world of interactive gaming today. In interactive games the player, who is both viewer and navigator, not only sees the graphics (the "eye")

The Name of the Frame

The way a designer composes the objects within any frame in a visual storytelling medium depends in part on the dimensions of the frame—the height and width of a movie screen or the height and width of a comics panel, for example. The composition of images to be contained in a square frame will be very different from the composition of images to be contained in a long, narrow frame. In film, the ratio between the height of a film image and the width of that image is called the *aspect ratio.* The aspect ratio of films up until the 1950s was about 1.33 to 1, which meant that for every 4 units of width there were 3 units of height. It is no accident that when television came along, the screen was designed with the same 1.33 to 1 ratio. Thus when "classic" movies (e.g., *The Wizard of Oz*) are shown on a television screen, they look pretty much the way they do on a movie screen.

During the fifties, Hollywood started making movies for wide-screen formats, ushering in Cinemascope and Panavision, among others. Today films can be made in one of any number of different aspect ratios, but the two most common are called academy flat (1.85 to 1) and anamorphic scope (2.35 to 1). Hitchcock's *The Birds* was shot in academy flat; Lucas's *Star Wars* in anamorphic scope. When films shot in one of these widescreen formats are shown on a TV screen, if the original width to height ratio is preserved, there will be ribbons of black both above and below the screen images. When widescreen-format films are "modified to fit your TV screen" the ribbons of black disappear, but at a huge cost: the composition of the shots, which were meant for a relatively long, thin rectangle, is lost completely. The plot line is the same, but the visual images that tell the story are far removed from what the filmmaker intended the viewer to see. This happens whether the film is a live-action movie or animation. In *Jimmy Neutron: Boy Genius,* there's a scene where Jimmy and his friends are captured by aliens. On the wide screen, you can see their captors floating beside them, armed with spears. On the television screen, the armed captors are nowhere in sight.

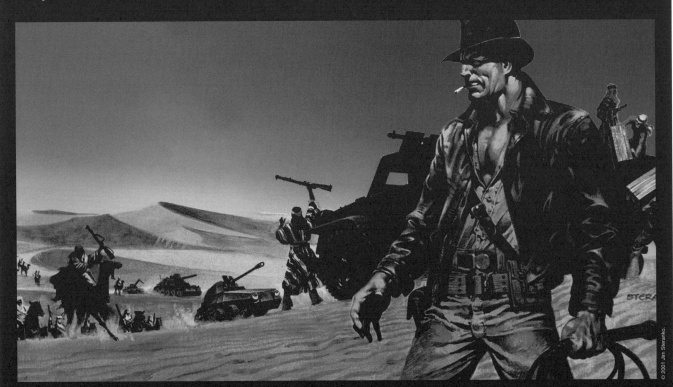

When Jim Steranko was doing the concept art for *Indiana Jones*, he used the 2.35 to 1 scope ratio.

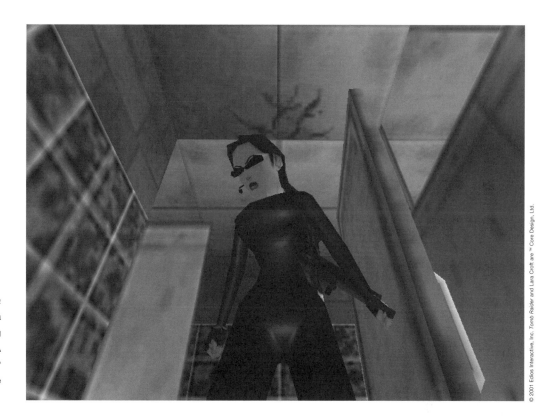

A screen capture from the game, *Lara Croft: Tomb Raider,* showing Lara about to . . . Do what? A standing jump? A standing jump and grab? A running jump, twist, and grab? Maybe the player should save the game, again, before doing anything.

but participates (the "I") in shaping the way the story unfolds. Of course, the experience is programmed, with every facet of the player's interaction manipulated and tweaked by software. But unlike films, interactive games are not a linear medium: no two players will have the same experience. And unlike comics, they are an active medium.

One of the biggest of the blockbuster 3D games—the one that helped catapult the Playstation system to the top of the industry—was *Tomb Raider 2*, where the game's protagonist was a buxom female character named Lara Croft. In the trial version that came with the Playstation console in 1996, she was immediately dropped into a pit from a helicopter, where she slid down the side of a cliff and landed with catlike grace on her feet at the bottom of an enclosed canyon. There she stood, awaiting instructions from the player, who was empowered by the controller to make her jump, run, climb, walk, swim, back-flip, side-flip, and leap tall buildings in a single bound. The player could also change Lara's point of view and examine the details of her 3D world. The television screen was suddenly more more than a display medium for linear visual storytelling. The game drew the player in—pulling rather than leading. When Lara died, the player died too. When the player got lost, Lara was lost. It was intoxicating.

Hollywood multimedia guru Jim Banister says that what the player does in an interactive game is *storyforming.* At a game developer's conference in 2000, game designer Doug Church presented a related concept, which he called "abdicating authorship." The most compelling game experience, Church believes, is when the player makes a substantial contribution to the storyline. He says, "Our desire to create traditional narrative and exercise authorial control over the gaming world often inhibits the player's ability to be more involved in the game world." Under the storyforming concept, the contributions of programmers, designers, and artists must mesh together seamlessly to give the player/author the feeling that he or she has genuine control over how a story will play out.

In all interactive games, there are specific parameters necessary for the flow of action, such as entry from a particular area, but the game designers have a lot of control over the actual details of the environment. Often, artists will also add personal details to the interactive play, such as dramatic reactions by the characters upon meeting or seeing other characters, which all help in providing a unique and realistic experience (for an example, see the discussion of the bar scene in *Septerra Core,* the sidebar on page 47).

Multilevel Complexity

In first-person shooter games, the interactivity is primarily of the "they'll kill me if I don't kill them first" variety. Designing games in which the player is a sort of coauthor is far more complex. The more decisions the game allows a player to make that will affect the subsequent course of action, the more programming and design layers there must be. For example, in Enix's *Star Ocean: The Second Story,* there are 80 possible endings depending on the actions the player takes and how the player interacts with the characters in the game. In *Resident Evil 3: Nemesis,* there are a number of points at which a player has to make a choice, and some choices significantly affect the way the story progresses— which means the game designers need to provide as many realistically rendered paths as there are possible choices. *Lara Croft Tomb Raider: The Angel of Darkness* has three parts, and in the first, some of the choices made by Lara

affect how other characters treat her. Throughout the game, different scenarios are available in certain locations, and players can either find and try them all or play the game in a straight line. In *Sherlock Holmes: Consulting Detective,* the player has access to multiple sources of information that provide file or newspaper data on all the people directly or indirectly involved with three different murders, or you can interview the characters in person. Some clues are meaningless unless correlated with some seemingly insignificant fact, and some are simply red herrings.

I, Character

In third-person interactive games, including *Super Mario Brothers, Lara Croft: Tomb Raider,* and *Sonic the Hedgehog,* the player explores the environment as a character created by the game's designers. In first-person games, such as *Half-Life* or *Quake,* the action is seen through the eyes of the

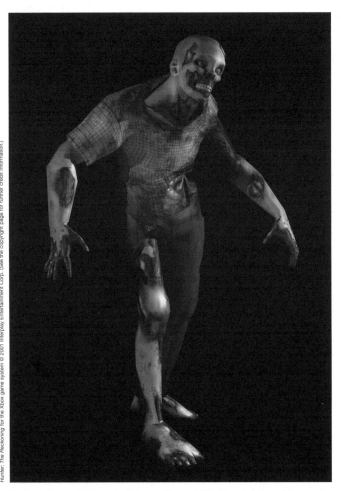

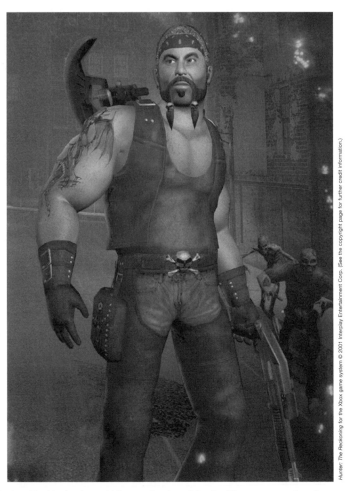

Both of these characters—Spenser "Deuce" Wyatt and the zombie—are from *Hunter: The Reckoning,* which was developed for the Xbox game system from Microsoft and is based on the popular role-playing games from White Wolf Publishing, Inc. The use of motion capture (see Chapter 5, page 88) and a very high polygon count made the characters seem very real, and added to the game's intensity.

player (the eye as I as camera). The best of the first-person games are immersive enough that the player comes to feel that the character is an extension of him or herself. The player is actually *in* the game; he or she *becomes* the armed space marine shooting wicked monsters in a gothic world gone mad, not just the butt of a gun. But when the camera follows an actual on-screen character, the focus becomes the person on the screen. If *Tomb Raider* were developed as a first-person game, like *Quake,* players would lose the sense of Lara Croft as a fully developed character in her own right. Croft is a complex character, with a home, butler, history, and a set of opinions that contribute to the interactive epe-rience above and beyond you and your gun.

On the left is a storyboard for a climactic cut scene for the interactive game *Septerra Core.* In the center is a filmstrip showing how the three major storyboard images were "translated" into sequences in the game. On the right is an attempt at transforming those cinematic images back to a single image to represent each sequence of frames in the filmstrip. However, on the right, without the element of dynamic motion, those moving pictures become static, almost stagnant. The accompanying six-panel comics page (top right) shows how a comics artist would "render" the same sequence, using the "cheats" that comic's artists have mastered to create the illusion of dynamic motion on the static page.

Cross-Pollination: Frame/Panel/Level

One of the major theses of this book is that filmmakers, animators, renderers, comics artists, and interactive game designers regularly borrow techniques from one another, creating a cross-pollination among the visual storytelling media that enriches each genre. In an interview with Jim Steranko, J. David Spurlock said, "You've used photographic techniques in comics, comic techniques in film, film techniques in illustration, and illustration techniques in your animation work," and these words, or similar ones, could be said of many of the most creative visual storytellers. European comic art legend Hergé has said many times that his internationally distributed comic strip *Tintin* was heavily influenced by the films of Charlie Chaplin, Harold Lloyd, and Buster Keaton. He employed many framing techniques from film. In 1942, when he was asked about his unique comic strip language, he said that he considered his stories as films: "So, no narration, no description. I give precedence to the picture, but of course, it's 100% about talking pictures. The dialogue comes graphically out of the characters' mouths."

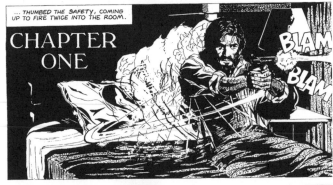

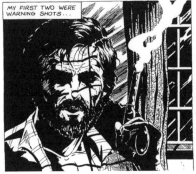

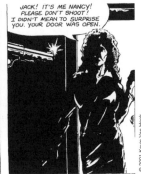

Kevin Van Hook, filmmaker and special effects wizard, having done effects and storyboarding for films such as *My Favorite Martian, 13th Warrior,* and *Miss Congeniality,* recently completed a film called *Frost: Portrait of a Vampire,* starring Jeff Manzanarez and Gary Busey. "It was an interesting experience to write a screenplay, then make a movie based on the comic book I did when I was 21 years old. I wanted to stay true to that story, but film has a different formula, created to attract and keep, but fit within two hours. In the comic book series, I had more time and visual techniques to develop those characters." This page from the original *Jack Frost* comic book was used as the concept storyboard for an identical scene in the film version.

Spider-Man is one comics superhero who made a spectacularly successful jump from comics to film. Director Sam Raimi, like the Marvel writers and artists who created the character, set much of the action in New York, a city immersively familiar throughout the world. Raimi says that everybody from the storyboard artists to the actors came up with material that contributed to the film. Some changes were made specifically to enhance cinematic realism. "When it came time to talk about the webshooters and Peter Parker having the technological ability to create such a mechanical device and chemically engineer this new substance in his little Queens bedroom," Raimi says, "we felt that organic webshooters would be better for the movie."

The Making of Septerra Core

The role-playing PC game *Septerra Core,* developed by Valkyrie Studios, has an average tested 120 hours of game play. Fifteen people worked on the game for about two years, and the budget was over $2 million. (These days, $2 million is small potatoes. *Final Fantasy* had a budget of about $35 million, and it took hundreds of people to develop the game.) *Septerra Core* has 200 different locations that are open to gamers. There are 35,000 words of spoken dialogue (for a total of about 5 hours of audio); 154 speaking parts—everyone that the character walks up to has something to say that can advance the story; over two dozen animated creature-combatants; and 15 separate "chapters" or "acts" that the player experiences.

Some role-playing games, for example, the *Hero Quest* series, give gamers a choice of characters to play. In *Septerra Core,* although players can only be the main character, Maya, they can choose up to eight companions. And, although the game's designers felt that the resources that are involved in creating realistic environments are too valuable to be wasted on designing a multiplicity of roads "less traveled," there are three different paths you can take, with different experiences, that don't necessarily connect during play. Brian "BMAN" Babendererde, the visionary behind the game, decided to leave things open-ended in the sense

© 1999 Valkyrie Studios.

© 1999 Valkyrie Studios.

Uncle: "Mayor, what's the meaning of this!??"

Whenever the clan approaches a speaking character in *Septerra Core,* a window in the upper right corner appears, with a close-up of the character, and the dialogue is printed in the lower menu bar. The medley of words and pictures offers multiple ways to engage the player.

Lobocity. Lobo, the gun-toting combat cyborg turned pirate, was repaired by an old mechanic after being lost in battle and reprogrammed for free thought. Lobo is just one of the many nonhuman chacracters given a "real" personality.

that the player experiences various "mini" adventures, but then moves on along the main story path.

An example of the kind of dramatic encounter that makes *Septerra Core* such a good game is an exposition scene, in which all the main characters converge on a bar and discuss various story elements. As the player meets each new character, the character provides information that will be useful as the game progresses. One of the possible components of the outcome of the story is a romantic involvement between two of the nine main characters. There are subtle hints (e.g., thoughts, eye contact, comments to other characters) of this potential romance, but unless the player notices the hints, and takes action, the characters will not get together. Although this kind of "background" design detail—where something becomes important to the plot only if the player sees its significance and takes action—is unique to interactive games, the best directors and comics artist plan every background element of every shot. Viewers or readers who aren't paying attention can still follow the story, but the experiences of those who do notice such details will be much richer.

BEHIND THE SCENES

> **"Vision does not come by inspiration. It comes from knowledge, intelligently cultivated."**
> **—Robert A. Weaver**

Every film, comics, or interactive game has been created by a unique mix of people and technologies. In a perfect visual storytelling world, writers, editors, producers, and directors (including art directors) would give all artists on a production team enough freedom so that they could be true participants in the creative process. The value of a collectively realized aesthetic would be recognized. Depending on the medium, however, the extent to which any product is the result of a genuinely collaborative process will vary.

I don't believe in standard storyboards. Video storyboards are more practical. You're going to make mistakes, so make them cheaply. The story and characters will come through, regardless.

—Filmmaker Robert Rodriguez

Visual Storytelling in Film and Animation

The production process for both live-action and animated film usually begins with a story, written in an outline form, which is turned into what is known as a *treatment.* A treatment (which is also used in comics and interactive gaming to pitch a concept) can be written in either descriptive prose or extended outline form, and documents (in the present tense) a full account of the story, characters, and scenes, but most often without dialogue. Next comes the screenplay, which adds dialogue and, depending on the screenwriter, more or less detailed guidelines for how a scene should be shot. Sometimes, a "shooting script" is produced, adding the actual camera positions and angles (for an excerpt from a screenplay with detailed shooting instructions, see the Introduction, page 9), but most screenplays are considered as a foundation only. As with every collaborative art form, changes happen at every step of preproduction, which, as the diagram shows, includes writing the shooting script, storyboarding, casting, and designing and building sets, monsters, and props.

During the production stage, the initial version of the film is shot and edited, or, in the case of animated films, the animation is developed (either through traditional hand-drawn, or 2D, means or rendered in 3D). The postproduction "stage" is, in reality, several stages (see the diagram), and involves the addition of digital enhancements and special effects. After each postproduction step, including test screening, more changes are made, and changes can be made right up to the time of theatrical release.

Today, the widespread use of digital equipment means that the term "film" used to describe a full-length live-action feature may be a misnomer. For *Star Wars Episode II—Attack of the Clones* live-action scenes were shot with a high-resolution camcorder, sent to a computer for editing on the Avid system, and later combined with CGI "footage" and digitally captured sound. During the shooting Lucas and his director of photography could watch the action simultaneously, and reshoot on the spot if necessary. All final editing and color correction were done on the com-

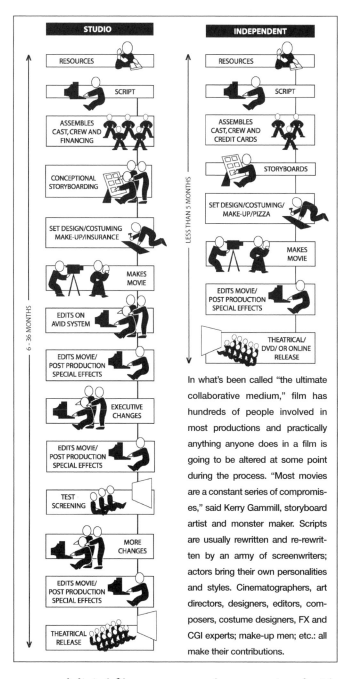

In what's been called "the ultimate collaborative medium," film has hundreds of people involved in most productions and practically anything anyone does in a film is going to be altered at some point during the process. "Most movies are a constant series of compromises," said Kerry Gammill, storyboard artist and monster maker. Scripts are usually rewritten and re-rewritten by an army of screenwriters; actors bring their own personalities and styles. Cinematographers, art directors, designers, editors, composers, costume designers, FX and CGI experts; make-up men; etc.: all make their contributions.

puter, and digital files were sent to theaters equipped with digital projection equipment, where the files were loaded into their systems. Actual celluloid was used only at the very end of the production process, when the digital movie was transferred to film so that theaters with conventional projection equipment could screen it.

Film production, whether of a "live" or animated feature, is a complex, time-consuming, and extremely expensive process. *The Lord of the Rings* film trilogy, for example, director Peter Jackson's cinematic "translation" of J. R. R. Tolkien's epic masterpiece, took three years to make and required the combined efforts of hundreds of people,

including four-foot-tall "scale doubles" for the actors who played dwarfs and hobbits; the staff of WETA Limited, New Zealand's premier physical effects house, under the direction of Tania Rodger and supervisor Richard Taylor; two language coaches; and a swordsmith. "I started with one goal," Director Peter Jackson says. "To take moviegoers into the extraordinary world of Middle-earth in a way that is believable and powerful. I wanted to take all the great moments from the books and use modern technology to give audiences nights at the movies unlike anything they've experienced before."

Every trick in the special effects and CGI lexicon was used, including elaborate scale models (covering a huge 24,000-square-foot WETA warehouse) and completely computer-generated creatures. Over 48,000 items were specially created for the films, among them 900 suits of handmade armor; 2000 "stunt" weapons (that is, weapons made of plastic or rubber); 20,000 articles of everyday life; and over 2000 pairs of prosthetic hobbit feet. *The Lord of the Rings* was published in 1954 and 1955 without illustrations, but artists all over the world have since created elaborate drawings and paintings of the characters and locations in the book. As a perfect example of cross-pollination, two of those artists, Alan Lee and John Howe, were hired to conceptualize Middle-earth, and its inhabitants, on the drawing board.

To make an animated feature of a complex narrative like *The Lord of the Rings*—whether in 2D or 3D—might take an army of artists two years to produce; it still can't compare with the scale of such a project in live-action film. In animation, there is no need for armor, weapons, and extras; all are drawn.

Storyboards

Storyboards come in all shapes and sizes, and although they seem very similar to comics, these sequential illustrations are rarely "polished" for final static reproduction in print form, with word balloons as a narrative tool. They are only the beginning: the visual foundation for what will be in a scene, and in what sequence the scene will play out. Storyboards, which can be a series of sketches or sometimes even photographs, are a sort of blueprint, and may include notes on dialogue, special effects, and camera movement.

Storyboards must include critical components for continuity and style, and in that sense they need to communicate the same type of information that comic art communicates. The audience, however, is different. Kerry Gammill, a veteran storyboard artist (*Virus, Species II,* and *Outer Limits*), has also worked extensively in comics and as a "monster maker," designing the creatures seen in film. Gammill believes that when working on the storyboards for a film, the artist can't get too attached to the work, because someone will most likely change it. "The work of a storyboard artist or production artist is to provide visual tools for the director and producers, who make the final decisions about how the film will be shot," he says. "An artist has little influence over what ends up in the finished film, but it's very interesting watching some of your scenes and designs come to life on the screen."

Dynamic Storyboarding

The advent of digital technology has made possible a new kind of storyboarding: during the editing process, the film footage is digitized and added to an Avid Media Composer or Avid Film Composer. The Avid editing system, which was first introduced in 1989, has revolutionized the editing process for film and television. Terry Kaney, an award-winning editor for Avenue, a production studio with offices in Chicago and Santa Monica, California, has done some well-known visual storytelling commercials for McDonalds, Hallmark, and Kraft Foods. With commercials, the agency and client decide on a story concept, and the director and cinematographer (much as in the early days of silent films) will go out and shoot the film that they believe will successfully convey that message; there is no script and usually no storyboards. They'll shoot 10, 15, 20, and sometimes even 30 takes (6,000 to 10,000 feet of film), whatever is necessary to get everybody happy with the visuals. Kaney will then set up his personal favorites on his Avid system and put together the action flow that best tells the story. He spends hours reviewing each take and then editing on-screen to add nuances, like a dramatic lighting effect, that will help convey the story without having to use words. For example, in a scene in which a student is sitting in front of the principal's desk, he might make the sunlight streaming in from the window seem like a spotlight used in a police

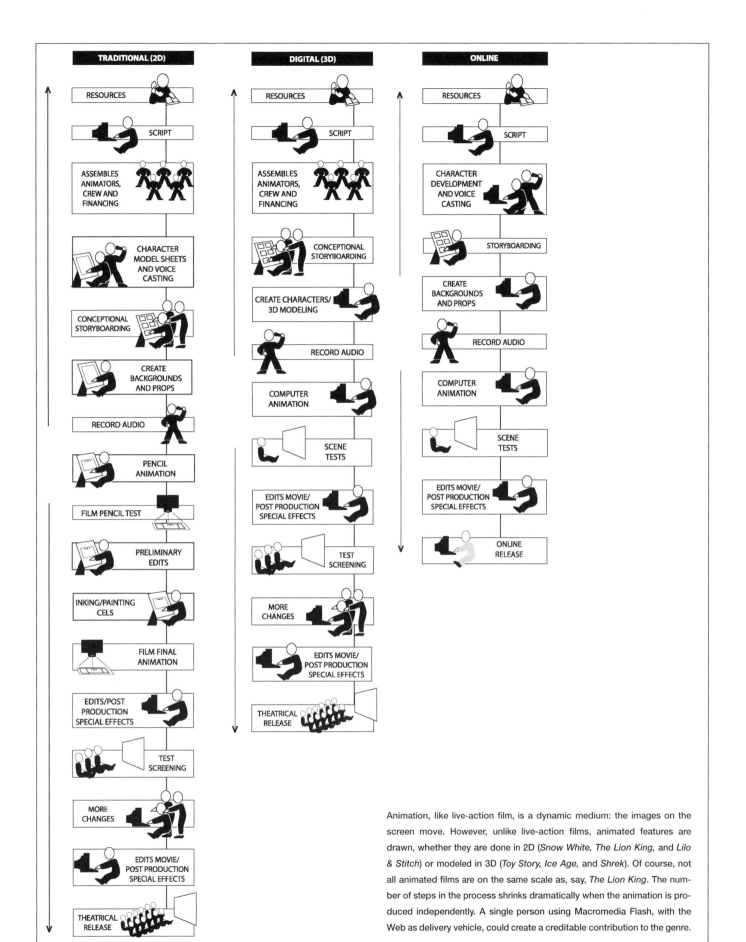

TRADITIONAL (2D)

- RESOURCES
- SCRIPT
- ASSEMBLES ANIMATORS, CREW AND FINANCING
- CHARACTER MODEL SHEETS AND VOICE CASTING
- CONCEPTIONAL STORYBOARDING
- CREATE BACKGROUNDS AND PROPS
- RECORD AUDIO
- PENCIL ANIMATION
- FILM PENCIL TEST
- PRELIMINARY EDITS
- INKING/PAINTING CELS
- FILM FINAL ANIMATION
- EDITS/POST PRODUCTION SPECIAL EFFECTS
- TEST SCREENING
- MORE CHANGES
- EDITS MOVIE/ POST PRODUCTION SPECIAL EFFECTS
- THEATRICAL RELEASE

DIGITAL (3D)

- RESOURCES
- SCRIPT
- ASSEMBLES ANIMATORS, CREW AND FINANCING
- CONCEPTIONAL STORYBOARDING
- CREATE CHARACTERS/ 3D MODELING
- RECORD AUDIO
- COMPUTER ANIMATION
- SCENE TESTS
- EDITS MOVIE/ POST PRODUCTION SPECIAL EFFECTS
- TEST SCREENING
- MORE CHANGES
- EDITS MOVIE/ POST PRODUCTION SPECIAL EFFECTS
- THEATRICAL RELEASE

ONLINE

- RESOURCES
- SCRIPT
- CHARACTER DEVELOPMENT AND VOICE CASTING
- STORYBOARDING
- CREATE BACKGROUNDS AND PROPS
- RECORD AUDIO
- COMPUTER ANIMATION
- SCENE TESTS
- EDITS MOVIE/ POST PRODUCTION SPECIAL EFFECTS
- ONLINE RELEASE

Animation, like live-action film, is a dynamic medium: the images on the screen move. However, unlike live-action films, animated features are drawn, whether they are done in 2D (*Snow White, The Lion King,* and *Lilo & Stitch*) or modeled in 3D (*Toy Story, Ice Age,* and *Shrek*). Of course, not all animated films are on the same scale as, say, *The Lion King*. The number of steps in the process shrinks dramatically when the animation is produced independently. A single person using Macromedia Flash, with the Web as delivery vehicle, could create a creditable contribution to the genre.

Nonlinear editing systems allow random access to any of the scenes within a film; that is, the filmmaker/editor can work on any scene, from anywhere in the film, rather than having to move sequentially through the scenes. It also offers the ability to quickly and painlessly try out numerous edits and sequences. Here, the larger image on the right has been selected from the thumbnail video clips on the left, which together give a digital preview of the footage of the scene, providing the ability to review, interchange, duplicate, delete, or edit. The thumbnail images are analogous to the sequential images on a hand-drawn storyboard, only they are completely manipulatable.

interrogation. In a sense, he's reviewing a dynamic storyboard, "drawn" by the director and cinematographer.

Kaney fondly recalls one McDonald's commercial that he worked on that was very simple storytelling but won awards from Cannes (for commercials) to the Clio (the Oscars of television commercials). The commercial started with a baby swinging back and forth toward the camera. "Eventually, you start to realize that when she swings up close to the camera [you] she smiles, but when she swings back and away; she cries." It's intriguing, yet confusing, until finally you see the reverse angle and the reason for her laughing is she can see the McDonald's sign. No dialogue. "That showed me how much more you could accomplish, with less," said Kaney. "You don't have to say anything when you're communicating with pictures."

Filmmaker Robert Rodriguez, who produced the films *Desperado, El Mariachi, From Dusk 'til Dawn,* and *Spy Kids,* uses the same type of nonlinear editing systems on all his films. "Nonlinear editing systems are faster and more conducive to creativity and make it true to at least one person."

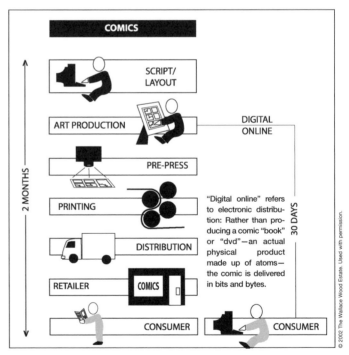

"Digital online" refers to electronic distribution: Rather than producing a comic "book" or "dvd"—an actual physical product made up of atoms—the comic is delivered in bits and bytes.

The production of a comic book involves a smaller group of creative people than film, animation, or game production. An editor's involvement can vary widely, from traffic director to visionary. In the studio model, the final product is a blend of all the talents involved: a showcase for the team.

Visual Storytelling in Comics

The first stage in the comics production process is usually an actual script, rather than an idea that has to be pitched to a studio. If the writer and artist are one and the same person, the "script" may be a combination of visuals and words. Comics are very different from films or interactive games in that the production process does not involve using technological devices to make final changes. The static page remains a static page.

The Comics Director

One of the significant differences between comics and films and interactive games is that producing a comic need not be a collaborative process at all. Comics that come out of the creator-owned school of comics production, in which the entire product is the work of a single writer and artist (for example, Mark Smylie's *Artesia,* Terry Moore's *Strangers in Paradise,* Mike Mignola's *Hellboy,* Frank Miller's *Sin City,* or Jill Thompson's *Scary Godmother)* are very far removed from the factory/studio model–style products distributed by most entertainment conglomerates. This is one of the main reasons that many successful writers and artists from all of the visual media return to or stay with creator-driven comics: it gives them complete control over their concepts and ideas, without having to participate in the back-and-forth, evolutionary process that a collaborative setting demands. Comics provide a way for the visual storyteller to work unconstrained by hardware/software requirements, budgets, or the laws of optics.

Brian "BMAN" Babendererde is the visionary (artist to designer) behind the creation of many popular interactive games, including *Road Runner's Death Valley Rally, Phantom 2040* (SNES & Genesis), and *Septerra Core.* As the lead game designer, his broad range of skills includes script writing, illustration, and character design, as well as programming game logic. Currently, while he's still in touch with the game development community, he's

focusing his energy on a new comic book called Soul Chaser Betty (see Chapter 2, pages 32 and 38), which has a strong anime and manga influence. "I'm going back to doing something by myself," said Babendererde. "This is what comics can do."

Mary Jo Duffy, writer and editor of many comics, including *Star Wars, Fallen Angels,* and *Catwoman,* believes that comics have an advantage over dynamic visual media, where the artist is not in control of what the director or designer wants the audience to experience. "You know exactly what's going on and how much and how far, and comics liberates the mind and the imagination, so you have to feel things out; they're not laid out in front of you entirely." She compares comics to shorthand. "If you insist on using eight pictures where one will do, then you're losing some of the shorthand and you're spelling things out a little too much." The comics director—who is writer, director, camera operator, cinematographer, and special effects technician all rolled into one—is in charge of camera angles, lighting, and shot selection. He or she casts the actors, tells them how to say their lines, and puts on their makeup; designs the sets; and provides the props.

Teamwork

Many comics are like films and interactive games in that they are the product of a collaborative team. The editor (the analogous job title in film would be producer) is in charge of choosing the team and approving each step of production. Pencilers work closely with writers, and most writers will polish or even entirely rewrite the dialogue after the pencil sketches are completed. This may be to provide a better flow, or because the art provides so much information that some of the words have become superfluous. Then the pencil art is handed over to inkers and colorists, who will enhance the penciler's work with their own skills. As with all visual storytelling media, the final product represents a blend of the talents of all team members.

In the development of an interactive game, the programmers are responsible for making it work. The artists are responsible for making it pretty. The designers are responsible for making it fun, and the producer is responsible for making it happen.

—Tom Smith, Lead designer, Danger High-Voltage Software

Thumbnails

The artist uses thumbnails to set up the overall look of the page, including the positioning of the characters, and an indication of where word balloons and sound effects will go. If the artist is also the writer, he or she may skip the script stage, doing the writing and layout simultaneously. Notice the evolution of the scream (AAGGRRRG!) from thumbnail to layout to detailed penciling. Ordinarily, a victim's scream might not be such a big deal, but the character here is made of a corrosive alloy, and isn't supposed to feel pain. The words "WHERE'S THE DUDE" (thumbnail) became "MYSTIFIER, WHERE THE HELL ARE YOU" (layout). In the final penciled version (not shown here; see Chapter 9, page 148), the person speaking the words is "off screen," and the line is, "WE'RE NO MATCH FOR THIS THING. WHERE THE HELL IS MYSTIFIER?" The cavalry (Mystifier) does appear, in the final panel, in time to catch the screamer as he falls. Most of the fine-tuning is between the layout stage and the detailed penciled version; for example, notice that the beam protruding from the left knee of the victim of the blast, which doesn't appear in the layouts, guides the reader's eye downward and to the right. It's very important to get the basic layout and design right before doing the final penciled artwork. You *do not* have time to reinvent the design at that stage.

Rough layout

Detailed penciling

Visual Storytelling in Interactive Games

Developing an interactive game is very different from developing a film or comic. The interactive game platform offers the game designers the opportunity to put together a really complex story, including multiple subplots and many fully developed characters.

Collaborating Creative Complexity

The creative opportunities offered by interactive game design are not without drawbacks. The development cycle for interactive games is 12 to 24 months, making it more likely that clashes between team members will eventually cause problems. This usually happens around the 12-month mark, or when the beta version is released. Catherine Court, the Executive Producer of *Septerra Core,* found that her job description included group counseling and providing ways for team members to let off steam. "I bought 50 pumpkins once, took [the team] to a field with a bunch of baseball bats and told them to knock themselves out. It worked."

Court also says that when the team believes in a project (which in turn is a function of their faith in the creator's vision for the game), and are given creative freedom, they will "give everything they have to give." She remembers that the *Septerra Core* team didn't sleep much for nearly a year. "People were living there. They were willing to do it, because they got to do it at their own pace and it was a story and concept that was exceptional enough that these people became very attached to it." Run-of-the-mill, committee-produced concepts, she says, don't get that level of commitment, and the end result usually shows it. "[Septerra Core] looks and feels above and beyond. Everyone who's played the game recognizes that passion."

Art-Centricity

Mark Manyen, Technical Director for Magic Lantern Playware, CEO & President of Wounded Badger Interactive, and a veteran programmer since the days of Atari and Commodore, said, "When you had only four colors to play with, a programmer could easily be an artist. It's not that simple any longer." Recently, Manyen completed the development of porting the Monopoly game onto an interactive DVD. He's seen many changes in the industry, but believes he can predict what lies ahead, at least for interactive games. In the past, the programmers responsible for clever, smooth game play were the most important part of the team. As programming became more of a commodity, and hardware and software limitations were overcome one by one, the art became more and more important. Almost certainly, this trend will continue. The fact that interactive games are now being developed at DVD resolution puts tremendous pressure on the people responsible for creating realistic characters and backgrounds. Manyen says that the sheer volume of art that has to be produced for an interactive game is mind-boggling. "The quality of that art all has to be very consistent, too. You can't just say oh, that's a rock, screw it, I'll do it with texture or something, because people will see that. They'll walk up close to that rock and give a look, because they want to see how it's done or they're looking for clues or secret passages. You have to give a realistic level of detail and continuity to everything." When Manyen says "everything," he means, among other things, the graphics in the interactive segments of a game have to be just as fully rendered as the graphics in the cut scenes.

The mission of Softimage, founded in 1986 by National Film Board of Canada filmmaker Daniel Langlois, is to create 3D animation systems designed for and by artists. Their latest system has been used in many best-selling interactive games, including *Super Mario 64, Tekken, Virtua Fighter* (Virtua Fighter is the character is pictured on the opening page of this chapter), and *Wave Race,* as well as major feature films, such as *Jurassic Park, The Matrix, Men in Black, Star Wars—The Phantom Menace,* and *Harry Potter.*

The Interactive Script

As the diagram for the interactive game production process shows, the process of creating the complex worlds that players move around in is tremendously complicated. The script for an interactive game includes elements of a traditional movie script (for the cut scenes; see below), project management standards, and a software requirements specification (SRS) document. The SRS will include a project Scope

GAMES

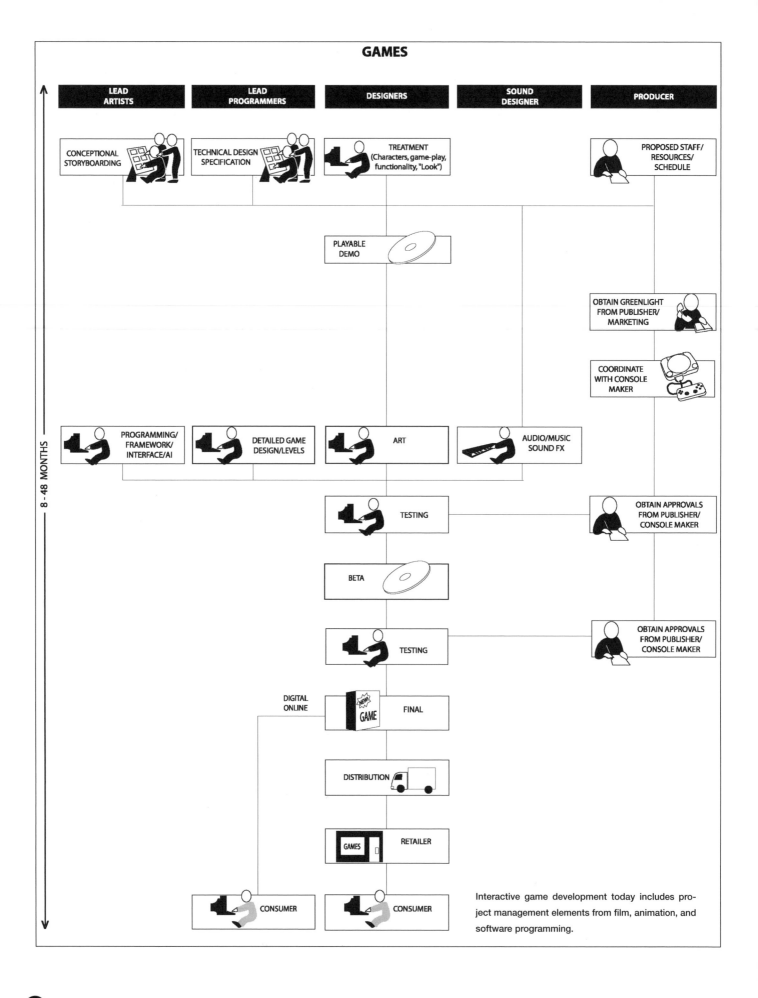

8 - 48 MONTHS

LEAD ARTISTS	LEAD PROGRAMMERS	DESIGNERS	SOUND DESIGNER	PRODUCER

CONCEPTIONAL STORYBOARDING

TECHNICAL DESIGN SPECIFICATION

TREATMENT (Characters, game-play, functionality, "Look")

PROPOSED STAFF/ RESOURCES/ SCHEDULE

PLAYABLE DEMO

OBTAIN GREENLIGHT FROM PUBLISHER/ MARKETING

COORDINATE WITH CONSOLE MAKER

PROGRAMMING/ FRAMEWORK/ INTERFACE/AI

DETAILED GAME DESIGN/LEVELS

ART

AUDIO/MUSIC SOUND FX

TESTING

OBTAIN APPROVALS FROM PUBLISHER/ CONSOLE MAKER

BETA

TESTING

OBTAIN APPROVALS FROM PUBLISHER/ CONSOLE MAKER

DIGITAL ONLINE

GAME FINAL

DISTRIBUTION

GAMES RETAILER

CONSUMER

CONSUMER

Interactive game development today includes project management elements from film, animation, and software programming.

and Overview; a Business Context description, a detailed list of Product Functions; User Characteristics and Objectives; and a complete list of Functional Requirements: what events will happen and where, motion capture for wild animals, etc. Issues that must be addressed early on are preliminary cost structure, schedule, and projected risks, as well as the user interface (between the game and the player), software interfaces (between software applications), and hardware interfaces (what makes the hardware play the game), as well as resource utilization—that is, how many people will be needed and for how long? The hardware limitations of the past are rarely a problem today, as the computing power of today's gaming systems can easily handle programmers' polygon count.

Game designers must also consider the manufacturer: Xbox has more juice than PlayStation 2, but fewer games; PlayStation 2 may not be interested in another racing game whereas Dreamcast may be in the market for one; each manufacturer's disk format is proprietary, so formatting becomes an issue; etc. Finally, there are often general publisher's constraints. For example, the publisher may specify not only budget, but also style ("make it dark and brooding"), storyline limitations (can't have Bugs Bunny shooting and killing anyone); and rating (e.g., for general audiences or for teenagers).

Even before the testing phase, the development process usually involves a constant back-and-forth between artists, designers, and programmers. When a level is being designed, there may be specific notes attached to the section of the script that pertains to it. For example, "If a player turns right, then sees monster squad A and stops to pick up a rusty knife, the knife will turn into a magic weapon." No storyboard sketches will be formally created to picture this action, but at that point artists will be assigned to add visual details to the specific space: shards of gleaming glass, hot lava, exotic flowers, etc. Throughout the creative process there must be constant communication between the lead artist and the lead designer, who will make final decisions, and the rest of the team.

A detailed conceptual description of the game—developed during the course of communication between the designers, artists, and programmers—is the foundation upon which all steps are built. A mutual vision is developed that focuses on the look of the game, scenes, style, and characters. The game play is built around the content, but many different kinds of concerns, aesthetic and/or technical, will send the team back to the drawing board. For example, if a something that has been included in game play results in imagery changes throughout the game world, there will simply be too many polygons for the machine to draw in at one time, and the game will crash.

Cut Scenes

The conceptual descriptions of today's games include the movie sequences (cut scenes), the short film clips between game play sequences which move the story forward and which are the only parts of an interactive game that can be storyboarded. The sheer number of scenes, characters, objects, and artificial intelligence actions (actions that do not depend on anything that the player does)—plus anticipating what the dynamic character, the player, might do—would make it impossible to storyboard all game play sequences in a cost-effective and timely manner. Cut scenes, however, are storyboarded, reviewed, and modified until the game designers and artists are completely satisfied with every aspect of a scene: characters, lighting, camera angles, dialogue, etc. A demo storyboard for a cut scene sequence from *Septerra Core* is shown in Chapter 2, page 45.

Who *really* calls the shots? Students of film apply the term "auteur" to directors who so control every aspect of their films that they deserve to be regarded as sole authors. In the first section of this book, Harlan Ellison refers to auteur theory as "corrupt," and he quotes George C. Scott and Francis Ford Coppola, who both emphasize the crucial contribution of the screenwriter. Certainly few of the films being produced today—live-action, 2D animation, 3D animation, or completely rendered—are the brainchild of one person. Rather, as we have seen, they are the product of the collaboration of a multitude of people using a variety of extremely expensive pieces of equipment. Similarly, interactive games require such a complex mix of talents—from writer to artist to programmer—that it would be impossible for one person to do it all.

However, behind most films, interactive games, and comics that achieve the status of classics is usually a single visionary, one person whose passion drives a project from start

to finish. It could be the artist, writer, director, cinematographer, or even producer. That is not to say that the hundreds of people working on a film or interactive game do not contribute their personal strengths and inspired expression. But the vast majority of the really great films (eg, *Citizen Kane*, *Vertigo, Raging Bull, Star Wars, The Godfather*) or games (eg, *Myst, Final Fantasy, Quake, Septerra Core*) have been guided by the work of one visionary genius—a person who was driven by the need to tell a story, to create a fully realized world into which the audience can escape.

Location Name: **C316-Graveyard1**	Hot Spot: **023** **Drax's Tomb**

Description and Dialogue

Status

New Menu
Tomb Icon Appears in Beggar
Tomb Icon in Carver
Tomb in Head Monk
Tomb in HHead
Bartender(Friendly)
Tomb Icon in SF Bar
Patron3 (M)

Reference Number

023LC316

(Action)

Additional Character Dialogue

Maya:"What a big Tomb. Whoever lies inside must have been important."	023LMya
	Maya Dialogue
Grubb:"This structure is old, that's for sure. I don't know much about the history of local architecture, but this tomb has got be several hundred years old, at least."	023LGrb
	Grubb Dialogue
Runner Generic Response	RnnrGen
	Runner Dialogue
Corgan:"The Tomb of Drax. Self made sorcerer and the stuff of children's nightmares." Maya:"You know his story?" Corgan:"A little. But I am not one for tale forgeing. Ask the Carver in SouthFarm. He knows much about the old days."	023LCgn
	Corgan Dialogue
Led:"I think it looks creepy. Lets get outta here..."	023LLed
	Led Dialogue
Selina:"Some seem to spend more money and time on death than life..."	023LSln
	Selina Dialogue
Araym Generic Response	ArmGen
	Araym Dialogue
Badu Generic Response	BaduGen
	Badu Dialogue
Lobo Generic Response	LoboGen

Every segment of dialogue in the script for an interactive game must be referenced to a specific "hot spot" (in this case, 023, Drax's Tomb, which is located in Graveyard1). At the right of this page, which is just a tiny piece of the script for *Septerra Core* (the game has over five hours of dialogue) are the reference numbers to the specific dialogue for each character listed, and the status of the overall game at that point in time.

Hot Spot List — **C316-Graveyard1**

Characters in Location:
None

Enemies in Location:
1. Statue Endboss
2. Living Dead

Special Animation:
1. Grubb puts head on statue.
2. Statue is destroyed to reveal exit to catacombs.
3. Gate Opens and Closes.

Items Found in this Location:
Power-Ups

HS#	HS Name	Status	Action	Inv1Name	Inv2Name
023	Drax's Tomb		023LC316		
024	Drax's Statue	Before Head	024LC316	024IC316 - 005 - Drax's	
025	Zombie		025CC316		
025a	Acid Pool		025aLC316	025aIC316 - 003 - Acid	
026	2nd Gate	Closed (front)	026UC316		
026a	2nd Gate	Closed (behind)	026aUC316		
037	Secret GraveGate		037IC316		

The hot spot list for the graveyard scene in *Septerra Core.*

The first step in moving from a narrative without pictures to visual storytelling is bringing the conceptualized characters and sets to life. This is true for any visual storytelling medium, where the design—the physical appearance—of the characters themselves is all-important. Here we have the early sketches of a few of the *Septerra Core* characters, including Maya, the protagonist, and Doskias, the story's antagonist.

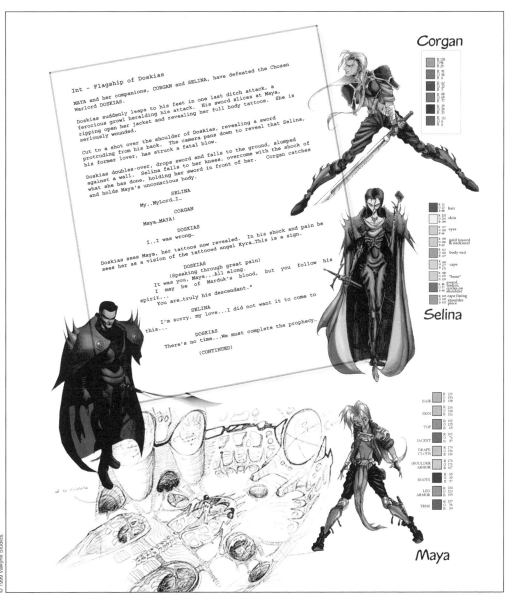

THE VISUAL STORYTELLING DESIGN PALETTE

No matter what the visual storytelling medium, and no matter what kind of special effects and CGI magic have been used, there are four major components which shape the way a master storyteller spins out a tale and which together determine how successful the storyteller has been at achieving the ultimate goal, the audience's total immersion in the story. They are clarity, realism, dynamism, and continuity. The best visual storytellers also rely on finely-tuned intuitive abilities. Intuition—the storyteller's gut feeling that a particular way to move a story forward is *the* right one, no matter what everyone else working in the same genre says—is essential. Orson Welles once said, "I passionately hate the idea of being 'with it.' I think an artist has to always be out of step with his time." The various established "formulas" to move a story forward can be ignored—or turned upside down—by, to paraphrase filmmaker Robert Rodriguez, filmmakers "ready to take a stand and go in the opposite direction."

I've met maybe two people who are able to be creative on demand. Creativity comes when creativity comes; for some people that's at two o'clock in the morning. You try talking to them at eleven AM and you get tapioca—you get nothing. You wait until they wake up in the middle of the night and by God, you get brilliance. It's very hard to schedule creativity.　　—Catherine Court, Executive Producer, *Septerra Core*

Clarity

The best visual storytelling in whatever medium is when the audience isn't really aware of the *way* the story is being told. They get caught up in the story and the characters, and want to see what will happen next. For that to happen, the audience—whether readers, viewers, or players—must be able to *follow* the visual story. They must not get confused or lost as the story unfolds. Skipping elements important to a story, or transmitting them in a haphazard way, will undermine clarity. Jeff Smith, animator and author of the comic series *BONE,* believes that it's the artist's job to make it easy for the reader to follow the visual story: "The clarity of the story is everything . . . the key to making the reader or the audience a participant." It is the task of the storyteller/artist to communicate and convey information using sequential pictures, and from the opening shot or panel or game introduction the composition, layout, and design should be in the service of the visual storytelling— not at the expense of it.

For example, comics design must make clear what is being emphasized in the story. A well-designed comics story shows the readers all the information necessary to advance the story and at the same time create the illusion of movement. If blocks of descriptive text are necessary to explain what the art has failed to show, clarity suffers. Storyboards are designed for a different medium, but the goals are the same: to advance the story visually, through action flow rather than spoken exposition. Kerry Gammill's storyboard sequence for *Species II,* shown on page 39, clearly presents the action using very few words.

In game design, a lack of clarity can negatively affect the player's entire experience of the story. For example, the *Phantom 2040* role-playing game, produced for Sega Genesis and Super Nintendo, neglected to inform the player of a very important component of the story: how to win. There is a crucial point in the game when the player can make a choice between defeating bad guy A and defeating bad guy B. There is a way to defeat both, but if one of them is picked out, the other gets away and defeats the player at the end. A short cinematic sequence that was supposed to inform the player about this was never hooked up, an omis-

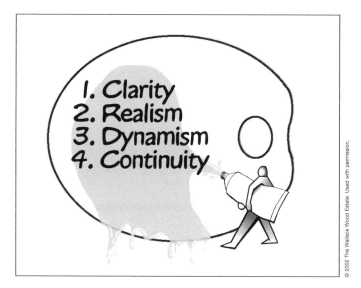

1. Clarity
2. Realism
3. Dynamism
4. Continuity

Clarity + Realism + Dynamism + Continuity = Total Immersion. The ways in which a given storytelling medium achieves dynamism, or visual power, differ, but the objective is the same: The imagery must be compelling.

sion that wasn't discovered until months later, after the product had been released.

Establishing the Scene

One of the first steps in any storytelling sequence is setting the stage: establishing the scene and its characters, objects, and mood. Artists and filmmakers use "establishing shots" to give the audience, after one brief glance at the shot, enough information to know where they are and where they are about to travel. These shots can also be used to establish major characters' relationships to one another. Remember, words won't convince the reader that the scene is really happening if it doesn't "happen" in the artwork and/or visuals.

One of the most effective opening scenes in any visual storytelling medium is from a game, *Resident Evil, Code: Veronica X,* developed by Capcom for the PlayStation 2 game console. First, there is a brief exposition of the background: The villains, who work for a shadowy international corporation, have developed a virus which turns human beings into zombies, and protagonist Claire Redfield and her brother have escaped from an infected city. Claire is searching for her brother. Following a cinematically realistic aerial shot of military helicopters heading for an island, there is a flashback to Claire's pursuit and capture. Surrounded, she pretends to drop her gun, but at the last minute grabs the weapon and shoots at a canister of highly inflammable material, which ignites and blows the bad

guys sky high. The cut scene ends with her capture by yet another of the relentless pursuers. The crisp resolution of the graphics in this scene makes it shine like a top-shelf 3D animated feature out of Hollywood, and players by the thousands were instantly hooked. Another unforgettable opening scene is from Steven Spielberg's *Jaws*. What makes the scene intense is a stew of unusual camera angles (including a shark point-of-view), John Williams's classic score, and the off-camera underwater action.

In comics, it is not necessary to include an establishing shot, or even a panoramic shot, on every page, but at least one panel on every page should have a recognizable background, to provide continuity. One of the very first things John Byrne advises young artists is "back up your camera ten feet." The vast majority of work he sees is wrong, fresh out of the box. "There have to be times when you pull the 'camera' back and just look," he says. If the camera is always three feet away from the action, it's difficult to convey enough information to tell a story efficiently. Byrne is using the word "camera" metaphorically, of course, but the concept applies to all visual storytelling media. "The establishing shot doesn't have to be the first shot," says Byrne, "but it does have to be in there somewhere, so we know where we are and who is in the scene and what's happening and why. Clarity, clarity, clarity . . . and pulling the camera back."

Clarity of Action Flow

The comic artist must direct the reader's eye through a panel not by arrows or written directions but by layout and design, and the filmmaker must direct the viewer's eye not by words but by the way the objects and characters in a shot are positioned. The same principles apply to "flow," or movement of characters from frame to frame. The flow must be natural, believable, and consistent. It must also, in the case of comics, provide the illusion of movement. (Games, of course, can cheat. They'll give hints to the correct path. Some may be as subtle as sparkles when the player takes the right path to something as obvious as all the doors being locked but one.) Provide a solidly conceptualized path for all the characters, and avoid any unseen moves between panels or off camera that may interfere with viewers' ability to follow that path. If a comics reader has to stop and figure out where to go next, the narrative flow is lost

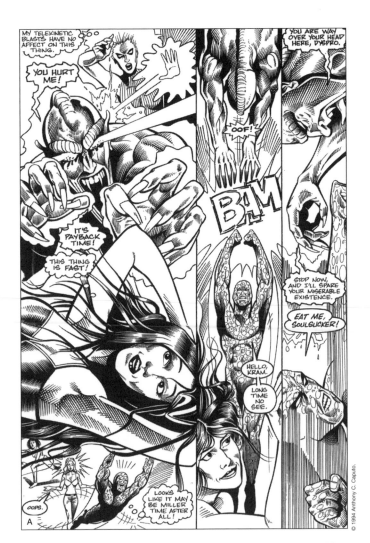

The lack of design clarity makes the action on this page very hard to follow. It has a vertical panel layout, one of the techniques that comics artists can use to make static images more dramatic. But the action is a struggle to follow because the combination of the vertical layout and the plethora of images, word balloons, and "extreme" graphic devices results in visual confusion. A is the finished page; B shows the intended sequence and C, how a viewer's eye might move over the page. In contrast, look back at the cliffhanger page shown at the beginning of this chapter. That page, from *Machine Man*, drawn by Jack Kirby, shows a masterful use of vertical panels in the service of clarity. The tall, thin panels also provide a sense of the cliff's great height.

and the story becomes just a bunch of pictures on a bunch of pages. Similarly, if a moviegoer has to spend valuable viewing time trying to figure out the significance of a given sequence of shots, that part of the film becomes a meaningless collection of screen images.

The audience—moviegoer, game player, or comic book reader—should always be able to tell what is going on in a scene, and know what it is that he/she should be looking at and where it may be going. If there's a character punching or shooting, it should be clear from panel to panel or from

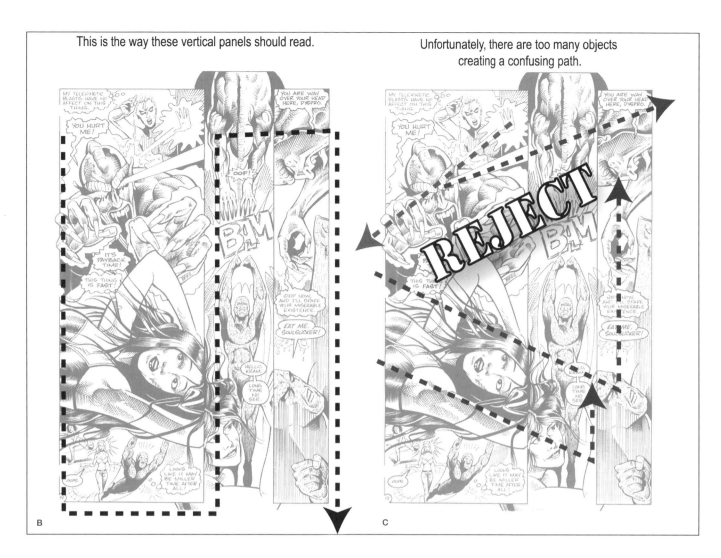

This is the way these vertical panels should read.

Unfortunately, there are too many objects creating a confusing path.

shot to shot who is punching and who is getting hit or who has the gun and who is being shot at.

Designing movement is more important in comic books than in the dynamic media, where actual movement is part of the experience. Comic artists can creation the illusion of motion, and show where a character or object is moving to and from, by using directional shapes, by the creative use of lighting, and by panel composition. An artist who wants to show an object moving beyond the panel border must make sure the reader's eye moves with the object to the next panel in the sequence.

The 180-Degree Rule

In the past, a rule of clarity called the *180-degree rule* was a strict guideline in films (see the accompanying illustration). Jeff Smith, who spent years in animated film, consistently applies that rule to his comics pages, and, he says, he "keeps to it pretty religiously. . . . The 180-degree rule keeps the

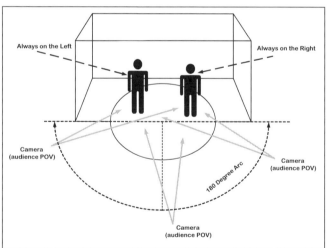

The 180-degree rule.

visual storytelling very clear, so that in any given panel or frame, whatever is established to be to the left, even if it is miles away on the horizon, keep it to the left throughout the scene. I find that helps the audience stay very clear on where they are at all times within the scene and the story."

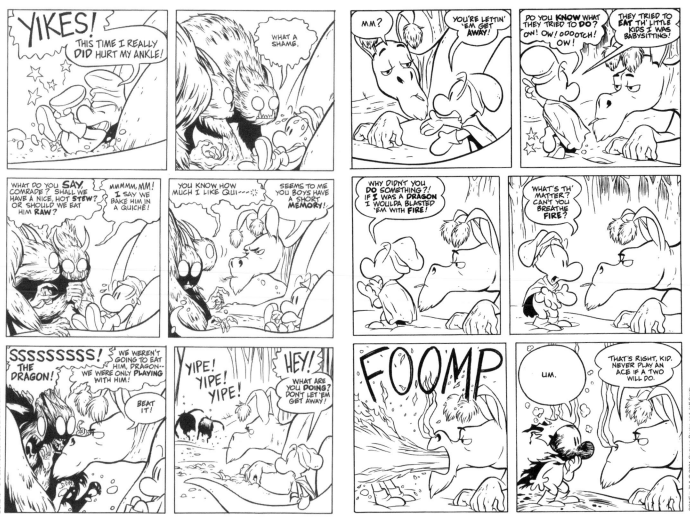

All the panels in this page from Jeff Smith's *BONE* follow the 180-degree rule.

In panel 2 of this page Bone crosses in front of the monolithic dragon to point in the direction of the now-vanished monsters. This "violation" of the 180-degree rule works: The dragon's eyes follow Bone's movement, and the action flow is clear.

Although the 180-degree rule is no longer followed slavishly by filmmakers and comic book artists, arbitrary exceptions to it are always potential sources of confusion for the filmgoer or reader, even if the confusion is registered subconsciously. There are many examples in various media these days where the characters seem to be jumping around from place to place, with backgrounds suddenly appearing and disappearing for no apparent reason. In comics, this happens when artists have not planned where the "camera"/point of view should be to achieve maximally effective action flow. Once a character's position is established in relation to objects or other characters in a panel or film shot, it is good action flow design to maintain that position in the following panels or shots until the character changes course within his or her environment. If the reader needs to stop and reacquaint him or herself with the character and settings, it will slow down the pace. Of course, carefully planned exceptions can be effective. Suppose, for example, the protagonist/hero in a story always moves left to right, which follows natural eye direction. Then suppose that in a scene in which the protagonist is being beaten back by an enemy, both protagonist and antagonist move from right to left: such moves, which are *against* natural eye direction, can create a feeling of chaos unleashed! This can be very effective during a boxing match, where directors may have the characters frequently cross the line and break the 180-degree rule. As long as the camera/point-of-views stays on the two fighters, this technique can add visual tension to the mayhem in the ring.

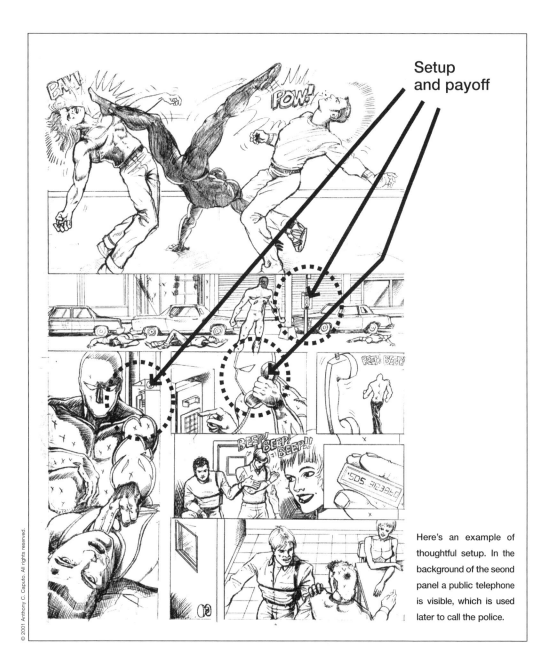

Setup
and payoff

Here's an example of thoughtful setup. In the background of the seond panel a public telephone is visible, which is used later to call the police.

Setup and Payoff

Any items that are to be a focus of attention later in a story should be set up in an earlier scene. For example, if a woman in the story is going to use a flashlight from her bedside table as a weapon against a prowler at some point in the story, make sure that the flashlight is seen on the table when the stage is first set. It can be as prominent or unobtrusive as necessary for good design. If characters who are trying to figure out how to escape will eventually use an exit door or broken window, show the door or window in an early scene.

Action-Reaction

In comics, a good rule of thumb is to include both action and reaction in one panel, unless a deliberately slower pace will work better. In most cases, an action-reaction sequence comprised of a series of small panels is less engaging and exciting for the reader, and makes for a lack of clarity in the overall flow of action. In contrast, in today's film or in game cut scenes, the dynamic nature of the media makes quick cuts, offering rapid-fire action sequences such as action-reaction scenes, an effective storytelling tool. Whatever the medium, the goal is to advance the action in such a way that the audience, without confusion, can follow the sequence without losing interest.

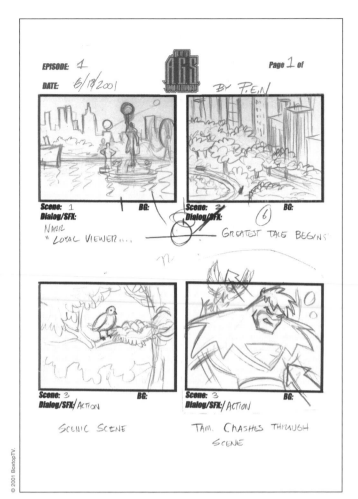

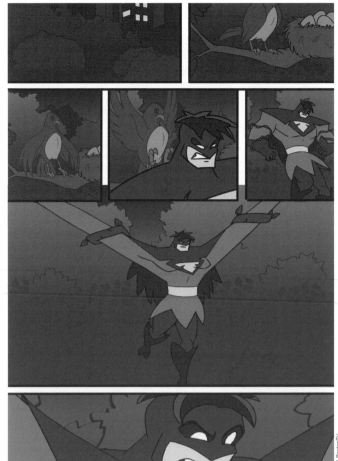

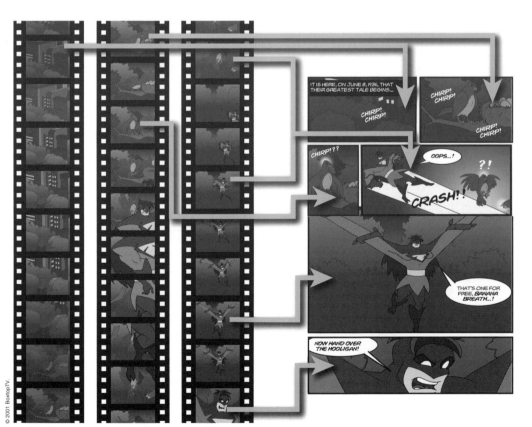

In dynamic media—film and animation—action and reaction take place in different frames, but everything happens so fast that the viewer takes it all in as one event. Here, the four panels labeled Episode 1 are from the actual storyboards drawn for the action-reaction scene from *Age of Guardian Strangers* shown in the filmstrip. (The filmstrip sequence starts with the second drawing, and goes on to show part of the scene not depicted in the portion of the storyboard shown here.) To the right of the filmstrip is a static version of the same scene, which retains the dynamic quality of the animated version by combining the action (the character crashing into view) and reaction (the bird's shock) into one panel, as the storyboard artist did. In contrast, the "literal" translation of the film, (above right), where the action and reaction are in separate panels, is much less dynamic.

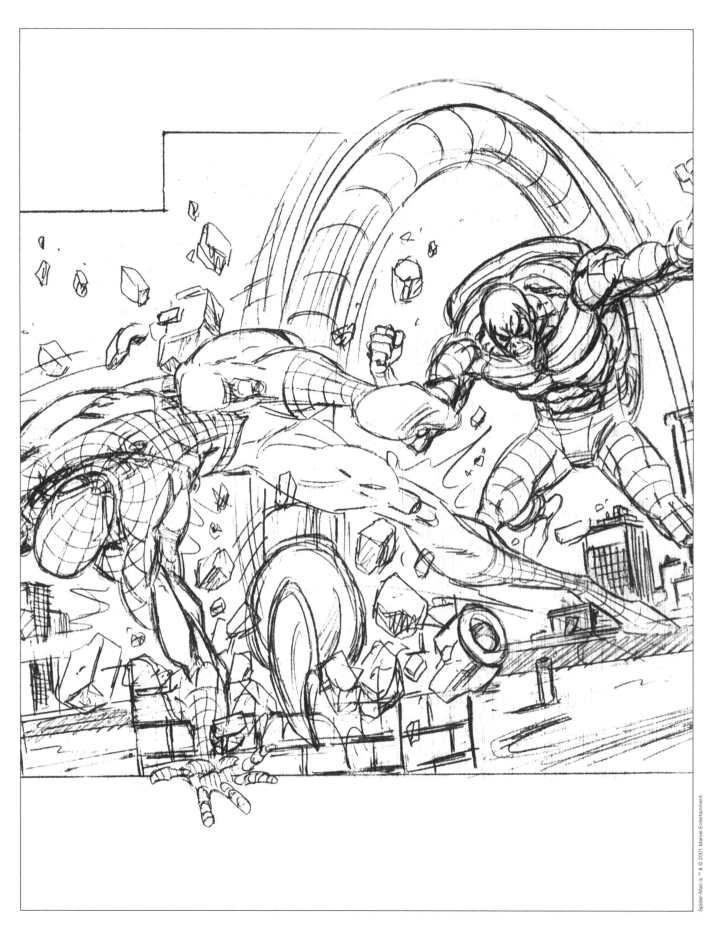

This action-reaction shot wouldn't work if the punch were shown in one panel and Spider-Man's fall in another.

Realism

Realism in the context of visual storytelling doesn't refer to photorealism—a duplication of the world we live in—but to the perception by the audience that what is happening is real within the context of the story and graphic style.

In films, comics, or interactive games, just as in the real world, seeing must be believing. Both imagery and story-line must create the illusion that the world being portrayed—and the characters who inhabit that world—are real. But what, in the context of visual storytelling, is realism? What elements so absorb readers or filmgoers or game players that they perceive the scenario on comics page or movie screen or game console as real? The foundation of a well-conceived and seamlessly executed visually told story is, simply, that every creative choice made by the people working on the story be logical within the structural and stylistic framework of the story.

Today, there are many different types of media offering many different types of "reality." Realism in the context of film (or the digital equivalent) is photographic realism: the camera records actual people, places, and things. Although scenes may be "impossible" because they could never happen in the real world, they appear very real to the audience because the medium makes it possible. The dinosaurs in the film Jurassic Park are more believable as actual dinosaurs than those in the Walt Disney film Dinosaur because the Jurassic Park computer-generated dinosaurs are incorporated within the context of photographic realism. The audience sees real actors, on real ground, in a real landscape, running from those beasts as if they were in the real world. The context is real, so the dinosaurs are real. Similarly, although the characters in comics are two-dimensional outlines, placing them in a real-world environment can help bring those outlines to life. The flat pixilated characters that once inhabited the worlds of interactive games have turned into modeled 3D renderings resembling real people and real monsters, and they move through realistic landscapes and buildings, with shadows, lens flares, and blood.

In some visually told stories with "impossible" story-lines, realistic sets, costumes, characters, and dialogue provide an environment that makes outlandish imagery and events seem natural. In the film The Exorcist, when the possessed 12-year-old girl played by Linda Blair starts spinning her head around 360 degrees, it appears very real because of the environment. It happens in a young girl's bedroom, in the real world. The movie wouldn't have been half as scary if it had been conceived as a surrealistic fantasy set in the burning inferno of hell. Several recent films have dealt with the nature of reality itself. The Truman Show and The Matrix portray elements of a "known" world, one that we understand and identify with, so that we are drawn into their fantastic worlds and can accept the stories. When reading a Spider-Man comic book, the reader believes that this guy in skin-tight leotards is spinning a spider's web and swinging from building to building. If Spider-Man lived in a domed city on the dark side of the moon, people wouldn't be so caught up in the story. The sense of realism comes from Spider-Man swinging through a known cityscape: New York City.

Structure and Character Development

For centuries, the basic narrative format, beginning with early theater and continuing through the development of the short story and novel form, was founded on what can be called "classical structure": the story was focused on a central character, the protagonist, who experienced external conflicts in an ever-changing world. The stories unfolded chronologically, and the endings provided emotional and intellectual closure (the climax, or "punch line"). There, are, of course, a number of other possible approaches to basic structure, including stories about multiple protagonists whose actions take place in a "minimalist" world and at the end of which there is no real closure (e.g., The Big Chill, Diner) and free-form films which are deliberately "antistructure" (e.g., Monty Python and The Holy Grail). Still, most comics, films, and interactive games rely on variations on the classical structure. (Even in the so-called "buddy movies," or interactive games in which the "I" player changes identities during the course of the game, most filmgoers or game players will identify more strongly with one of the characters.) A relationship develops between the character(s) and the audience, helping draw the reader/viewer/player into the story. Stan Lee, the creator of Spider-Man and Fantastic Four adapted the superhero con-

Keeping It Real

- Viacom, the American publishers of the role-playing game *Septerra Core,* were so delighted by Maya's (the protagonist's) popularity, the reviews, and the quality of the game that they began discussing a sequel with creator Brian "BMAN" Babendererde. BMAN laughs when he recalls the mortified look on the publisher's face when he told them the awful truth (Maya dies at the end). "You can't kill off the main character!" they said. BMAN disagreed. In Shakespeare's tragedies, the protagonist always dies at the end. In the films *Gladiator* and *Braveheart,* the protagonists die at the end. "It's epic," said BMAN. "It's drama. It's reality. People don't live forever like iconic characters. People die in real life." BMAN didn't care about the spinoff sales and sequels and dolls and stuff. The story was more important than the ancillary rights and profits. "I believe the fans really see that in the game; they love the story. Isn't that what it's all about?"

Legendary filmmaker Alfred Hitchcock deliberately violated film convention when he killed off Janet Leigh early on in the film *Psycho.* He was playing on the emotional impact of the audience seeing the person everyone thought was the protagonist stabbed to death in the shower. Leigh's brutal murder left the audience groping for answers ("Why?" "Could I have missed something"?), for closure, and thus drew them more deeply into the story. Anthony Perkins's "off camera" ("between panels") actions were left out. Hitchcock made the audience hurt, but at the same time they were hooked, immersed in the real story, which Hitchcock liked to keep hidden. Hitchcock was a master at creating an overwhelming sense of anxiety that leads to what every maker of thrillers wants to create: suspense. (If Janet Leigh can die, anything can happen.) His own classic example of how to create suspense is this: If a character says, "I've got a gun and I'm going to shoot you," well, at that point, the audience is just waiting for the bang. But if two people are talking about the weather, and during this conversation the camera moves down below their table, which exposes a bomb strapped underneath it, then the audience wants to shout at those two people to get out of that room! Suspense, to Hitchcock, involves slowly getting the audience and the characters (not necessarily in that order) to realize that the bomb is ticking.

Septerra Core is ™ & © 2000 Valkyrie Studios.

Maya, in the foreground here, exists in a world of fantastical floating islands and hideous monsters, but she herself is mortal, and dies a mortal's death at the end.

cept popularized by *Superman* and *Batman* at DC Comics and made his heroes more human and hence more "real." In his book *The Origin of Marvel Comics*, Lee said, "I would create a team of superheroes, if that's what the market required, but it would be a team such as comicdom had never known. For just this once, I would do the type of story I myself would enjoy reading if I were a comic book reader. And the characters would be the kind of characters I could personally relate to; they'd be flesh and blood, they'd have their faults and foibles, they'd be fallible and feisty, and—most important of all—inside their colorful, costumed booties they'd still have feet of clay."

Style

Style—whether it is an artist's drawing style, a film director's approach, or a particular combination of CGI effects—has little or nothing to do with the effectiveness of a visually told story. As long as the images are convincing, compelling, and dynamic *within the context of a good story,* the audience will be drawn in.

"Funny animals" drawn in different styles—Krazy Kat, Gertie the Dinosaur, Mickey Mouse, to name just three—have been around since the early days of comic strips and 2D animation. The advent of newer techniques, such as 3D and stop-motion animation, has not affected the basic truism: it's not a style of animation that grabs and holds our attention, but the story. The anthropomorphic animals in *Chicken Run* and *Ice Age* are more three-dimensional than Bugs and Mickey, but that's not what brings them to life. Without a good story, they'd just be so much eye candy.

The same holds true for film. The dark, violent, angry world of *Scarface* is directed by Brian de Palma for maximum photographic realism. In the musical *Moulin Rouge,* director Baz Luhrmann uses jump cuts and a brilliant color palette to create a totally different kind of look. Yet the world of *Scarface* is no more "real" than the wild fantasy world of *Moulin Rouge.* In both, the style serves the story.

Depth of Field

All visual storytelling output media are two-dimensional forms attempting to convey the illusion of three dimensions. To create the feeling of depth, the artist or scene designer usually tries to differentiate among the three set planes: foreground, middle ground, and background. This is done by using contrasts in size, lighting, texture, rendering density, detail, and color. If there is a dark object in the foreground, then making the background light will create a sense of depth, and vice-versa. Similarly, if the middle ground is light, then the foreground and background should be progressively darker, and vice-versa.

Artists sometimes deliberately blur the distinction between planes to achieve a desired effect or mood. For example, an artist drawing DC Comics Batman will blend the black on Batman's costume into the black of his surroundings. This establishes him as a creature of the night who can easily travel in the shadows without being seen, adding a sense of menace to the character. At the same time, the illusion of depth is maintained using the other objects in the panels.

In these panels from *Artesia* Mark Smylie has used shaded, blurry characters in the background to create the feeling of depth.

Dynamism

Webster's Dictionary defines *dynamic* as "full of force and energy; active; potent." A list of synonyms for dynamic include "energetic," "compelling," "vigorous," "electric," and "high-powered"—all adjectives that describe why audiences are drawn to dynamic images, whether the dynamism is pure motion, or the result of panel or scene design.

The differences in the ways in which dynamism is expressed—and the limitations of what can be done to achieve dynamism—depend on the output medium. For example, if the audience has come to see a live-action film, like *The Matrix,* the laws of optics dictate that there is just so much that can be altered without risking the loss of the illusion of reality. In addition, special effects, no matter how innovative, are not necessarily dynamic. Well-done special effects can add excitement—the "wow" factor—but unless the effects have been used for a clear enhancement of the story, they are just eye candy. Suppose, for example, an artist at the drawing board conceptualizes a particularly visionary scene and sketches it out on paper. The scene may or may not be doable in a traditional live-action film, but with today's technology, almost any scene that an artist can imagine can be created on the screen via digital effects. But digital effects, although they might recreate the *scenario* the artist had in mind, could result in a final output that is far removed from the "feeling" of the artist's original vision because the output can only recreate what current real-world technology allows. Thus screen representations of the conceptions of exceptional artists must still adhere to the real-world laws of physics—which is why physics is a requirement for students learning 3D design. In contrast, the scenarios drawn by artists whose output medium is the printed page are not bound by the laws of physics, but only by their imaginations.

2D Art and 3D Modeling

No two output media achieve dynamic effects in exactly the same way. What may be dynamic in film or in an interactive game may not work in a comic. When John Byrne began working as a 3D animator, he was surprised at the limitations of 3D modeling. "I'll get this idea that I know

To me, it's all about making the characters believable and getting the reader or viewer involved in the action. I want the character I'm drawing to have personality and emotion. I want the reader to know what he's thinking by his expression or the way he stands. That's whether I'm doing comics or storyboards.

—Kerry Gammill, Storyboard artist, monster maker

would be easy to draw, but when I sit down to model it in 3D, it can't be done," Byrne says. "The various angles, perspective, depth of field, or various parts just won't come together as I envisioned it." Byrne realized that comic artists very casually, almost unconsciously, "cheat" when they draw; they can get away with *making* something fit or turn or bend. A solid 3D object doesn't behave exactly the way artists picture it in the mind's eye, at least not without a massive effort. Once you've built a 3D model, that's it; it's an object in three dimensions, not an artistic *version* of an object in three dimensions. Say it's a character. Just as actors do, it needs direction; and, as in film, playing with camera angles to twist and distort is done by moving the character around on the 3D stage. The "camera" has to be manipulated, for example, pushed in and pulled out for a wide-angle view so that things look distorted. The same effects can be achieved by the comics artist just by drawing them—without having to think too much about it. "It's made me very aware every time I draw a comic," said Byrne. "Look at that, I just did something I couldn't do in a model, or there's something that would've taken forever; just a very simple shot."

Of course, Byrne also believes there is a flip-side, which is that with 3D modeling once a single 3D object has been created, duplicating that object multiple times can be done by the touch of a key. "Not that it would be difficult to draw it, but it would have taken forever to figure out the perspective, angle, texture; getting everything worked out."

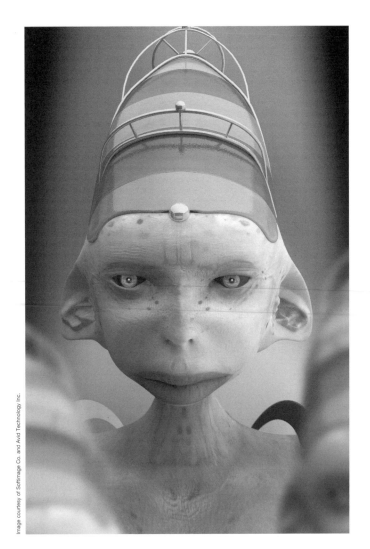

Dynamism in a Static Medium

Dynamic Shot Composition

One way to analyze shot or panel composition is to look at the "lines" (or movement) within a frame. In general, compositions in which the lines are all horizontal or all vertical, and thus replicate the lines of the frame, provide the greatest sense of stability and are, in a sense, less dynamic than compositions in which diagonal lines are dominant. Diagonal compositions create a sense of energy and movement. A good way for a comics artist to set up for a punch line or climax is to draw a series of horizontal panels and then switch to a dynamic diagonal composition at the end.

Artists hone their composition skills in a number of different ways: by observing what works in other visual media; by seeing what goes on around them in a design-oriented way (the eye as camera); and through books, classes, and practice. Intuition—gut feelings—are also important, the ingredient without which no composition will "work."

"Motion Capture" in Comics

Static images—whether drawn on storyboards or reproduced on the pages of a comic book—don't literally move, and it is the artist's job to express his or her vision in as dynamic a way as possible. Particularly in comics, where

Manta is a photographically realistic character created by using Softimage XSI, a leading tool for 3D modeling. See Chapter 5, The Drawing Board, page 89, for more details on how Manta, and other 3D-rendered characters, are developed.

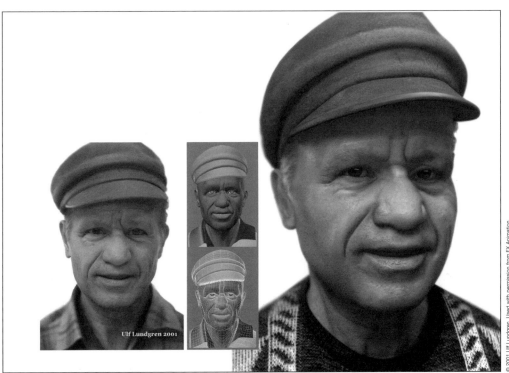

Ulf Lundgren 2001

This 3D modeled character by Swedish 3D artist Ulf Lundgren *almost* looks like a photograph.

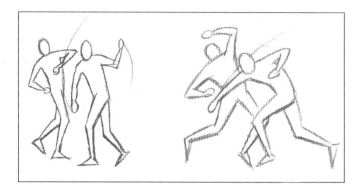

In both of these pairs of drawings, the figures on the left are static; the figures on the right show the same action, but have been drawn to emphasize dynamism and motion.

the drawings are "final," the artists' work must be drawn so that readers can "fill in the action" themselves. As stated in Chapter 1, it is, in a sense, the collaboration between artist and reader—the interpersonal experience—that makes the characters move.

Exaggeration—of style, camera angle, and characters' bodies—is one way to add dynamics to the static page. In their book *Drawing Comics The Marvel Way* (1971) Stan Lee and John Buscema emphasize the importance of keeping figures loose and agile. Almost 30 years before that, Andrew Loomis's *Figure Drawing for All It's Worth* (see Chapter 5, pages 91 to 95) provided aspiring comics artists with invaluable tips on how to infuse dynamic life into their characters. Amplify figure action to show extreme movement and practice foreshortening to add three-dimensional life to the images. Many comics feature superheroes. When these powerful, larger-than-life characters are engaged in physical battles, the panels need to look as if there is real motion.

Continuity

The visual details—from hair length to the color of a rug to a character's mannerisms—must be consistent from scene to scene unless the storyteller is deliberately emphasizing the change. In the scene in which Dorothy meets the Scarecrow in the film *The Wizard of Oz,* the length of her hair changes five times! Because the medium is film, and the filmgoer has no control over timing and pace, this shocking breach in continuity probably slips by many first-time viewers, but it shouldn't have happened in the first place. Anything that might cause viewers to do a mental double-take can shake their belief in the immersive world of the story. In comics, where the imagery is static, and in interactive games, where players can go back often to a particular setting, scene, or character, such a mistake would be far more obvious and would be likely to pull the reader or player outside of the storyteller's world.

All the elements of a story—characters, objects, landscapes, structures, etc.—should be consistent throughout the life of that story. Even if the plot is compelling and the characters complex and interesting, not paying attention to consistency is an easy way to lose the audience. In film, the shots must be edited into sequences that form an unbroken, coherent whole. The scenes must match up properly. The same is true with comics and interactive games. When the scenes don't match up, the reader or player will be distracted and annoyed. If the continuity problems are severe enough, the reader may stop reading or the player may quit the game. An example of lazy and inconsistent visual storytelling is when two people are talking for a few pages or scenes in a room that appears to be morphing with 12 corners and 5 different doors, with various items that seem to shift constantly. An obvious exception to the need for solid continuity is when a character wakes up in a mysterious environment and the writer or artist wants the reader to explore and discover the environment *with* the character—someone who suddenly has a flashback, or walks through a door only to find she has stepped into the Twilight Zone, or a delirious and confused man having jumbled hallucinations spinning before his eyes. There are no clear thoughts expressed, and perhaps even no clear eye path to follow. The

confusion created is deliberate, and becomes part of the storytelling experience.

Using Points of Reference

One simple test of effective visual storytelling, which comes from legendary comic book artist Dick Giordano, is to simply move your eyes from one panel to another and add the imaginary caption: "Meanwhile, ten miles away." If this caption actually fits as an appropriate description to a scene, but the scene is not meant to be ten miles away, then you've got a continuity problem.

One way to ensure continuity is to provide visual hints that serve as identifiers for characters or locations. One kind of visual hint in comics panels is called a "point of reference." For example, suppose two people are seen in one panel in a hallway next to a lighted elevator button and are seen in the next few panels next to an inside elevator control panel. Both the button and the panel are points of reference that together let the reader know that the two characters are not inside a room or a cube, but an elevator. A point of reference might be a store sign, graffiti on the outside of a building, a distinctive color—anything that would let the audience know exactly *where* the scene is supposed to be taking place.

Continuity over time is exceptionally important in any serial visual medium. The fact that Peter Parker and his alter ego The Amazing Spider-Man haven't changed too much since the early 1960s indicates that continuity in serial comics is as important as it is in soap operas, dramas in general, games, etc. People identify with immediately recognizable characters and their environment and actions. Maintaining continuity doesn't mean rehashing the same

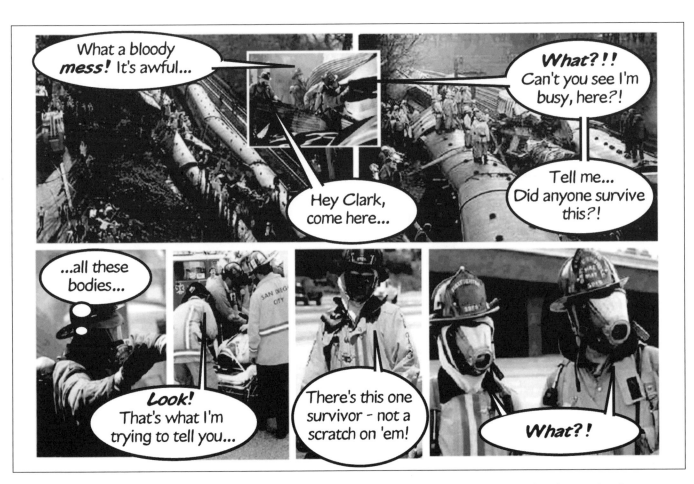

The long shots of the wreck in this series of panels are not from the same source as the rest of the shots, and none of the shots are shown in the order in which they were taken. Yet the panels work to tell a sequential story because the speakers are all firefighters with similar uniforms and masks—a single point of reference.

The mood is established with multiple shadows, crumbling pavement, and scattered debris.

The "Shipping and Receiving" sign in the second panel could have been used in the first panel as an indicator of location—a point of reference. The way a character looks can also be a point of reference.

In both the second and third panels, she is looking over her shoulder apprehensively.

She's still looking over her shoulder; the suspense builds.

The relative sizes of the trash bin and the human figures change drastically from the third to the last panel. The bin becomes the point of reference, which is confusing. There should have been some hint of the running figure (a shadow, perhaps?) in the previous panel. It's hard to tell which of these tiny figures is the woman from the first panel.

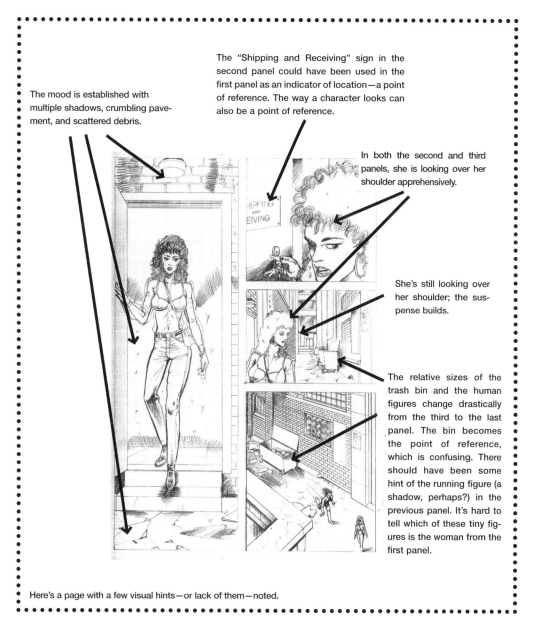

Here's a page with a few visual hints—or lack of them—noted.

plot or scenes, but making sure everything stays within the same world.

The following page shows a sequence from *Strangers in Paradise,* an on-going series by Terry Moore that has been released every six weeks for almost a decade and has legions of devoted followers. *Strangers in Paradise* won a prestigious Eisner Award for Best Continuing Series in 1996, and the GLAAD (Gay & Lesbian Alliance Against Defamation) Award for Best Comic Book in 2001 and has been reprinted in seven languages. Says Moore, "I wanted to read a comic like a novel, where I can be immersed in the lives of everyday people that I can grow to like and love and care about and just follow them along."

Total Immersion

Realism, clarity, continuity, dynamism—the ultimate goal of any visual storyteller is to use these tools to create a totally immersive world, one that the reader, viewer, or player "falls into" and, once there, doesn't want to leave. Anything that doesn't work within the context of the story being told, and the style and output medium being used to tell it, can interfere with immersion.

The extreme imagery and art of comics can be very immersive, but what a comics artist can pull off in print doesn't necessarily work in live-action film. For example, take the last scene in the Universal Pictures' film *The*

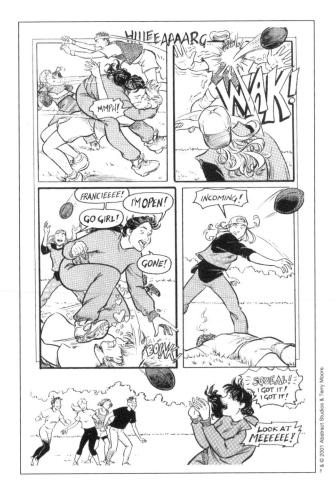

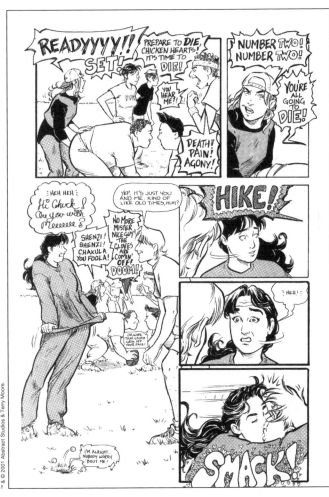

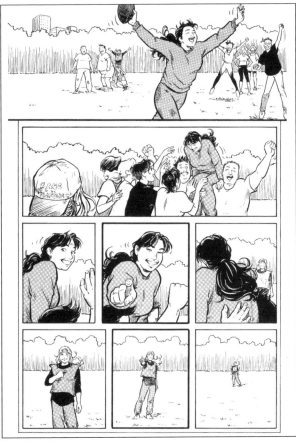

These pages show a master artist using cinematic elements to tell the story. Terry Moore uses everything from dynamically shaped word balloons to signify shouting, to breaking the panel barrier as a way to show chaotic action, to having no panel borders at all to show the boundless joy of making a touchdown. The last half of that same page in the sequence is a wonderful example of how mood and feelings can be conveyed with imagery alone. No word is spoken, but the characters don't have to say anything and the reader gets that, too.

Mummy Returns, starring Brendan Fraser, Rachel Weisz, and Dwayne "The Rock" Johnson, who plays the Scorpion King. In the climactic conclusion (apologies, if you haven't seen the film) Johnson's face is embedded on a giant computer-generated scorpion. In an interactive game, where everything is rendered, the effect would have been plausible, if not striking, but here the integration of a simulated live face on the completely rendered scorpion body pulls the viewer out of the immersive realm and back into the real world, just enough to say—"hey, that's not really the Rock!" In contrast, in the *Lord of the Rings: The Fellowship of the Ring,* when gentle Bilbo Baggins (Ian Holm) is trying to convince the ring bearer to give him the ring to hold one last time, his features become horribly distorted in a way which could not have been done without CGI but which is completely convincing. The audience gasps: They have been *shown,* not told, just how powerful the evil force of the ring is. They have been drawn in, not kicked out. Animation, of course, is different, but in live-action films in which the intention is that characters and locations be believable within a real-world context, the integration of special effects with photographic images must be seamless.

Anything that encourages the comics reader or game player to have a sense of being a participant, rather than merely watching, is empowering and immersive. With comics, as stated earlier, the artist/storyteller provides the visuals, but the reader participates by controlling pace and timing. A reader may be immersed for a long time in a two-page spread that offers outrageous detail and outstanding artistic values created in the service of a multilevel story. Filmgoers, who have a passive role, are drawn into the story without actually participating. Cinematic immersion in live-action films is achieved in many ways: outstanding cinematography, scenic beauty, great acting or charismatic stars, state-of-the-art special effects, build-up of fear and suspense, etc. Interactive games also have a multitude of ways to keep the experience immersive (too many to get into here). One of the biggest flaws in many of the games produced before 2000 was that little attention was paid to writing a solid story, and the player's suspension of disbelief was blown by inferior plot lines and clumsy dialogue. Fortunately for the gamer, all that has changed, and the best of the recent games effectively blend sophisticated storylines, complex characters and dialogue, and photographically detailed 3D locations.

John Byrne tells all aspiring comics artists that before they can effectively use extreme techniques, they must learn to draw the real world. "All the wild stuff needs to happen in something that we can understand. We need the world to be a real world, so that the outlandish elements can themselves seem real. If everything is outlandish, then you don't plug into it."

One medium that does not fit within a frame-by-frame mode (see Chapter 2) consists of the adventure/storytelling rides at theme and amusement parks. They are a subspecies of theater, but they move the audience through a changing staged landscape rather than change the "stage" itself. Landmark Entertainment, designers of attractions such as Terminator 3-D and Spiderman 3-D for Universal Studios, continues to push the "attraction" envelope in the form of electric theater or "motion theater." (Motion theater falls within the "interactive" part of the visual storytelling continuum in Chapter 1.) Gary Goddard, the President of Landmark Entertainment Group, points out that with a live-action attraction, unlike, say, interactive games, which have hours to draw players in, there is only a matter of minutes to capture the audience's attention. Only a few motion theater experiences can truly be said to be immersive (examples are Univerals's T2/3D and the new Star Trek Experience at the MGM Grand in Las Vegas), but as technology advances, that will change. Goddard says that one of the reasons those two theater pieces are so successful is that that there's an "instantaneous connection" to the stories because the public knows these mythic characters so well that they are immediately comfortable with the fantastic environments.

As I said at the beginning of the chapter, it all starts from within, intuitively and personally. At the layout stage, it may be a good idea to work a sequence out intuitively before trying to apply the guidelines discussed in this book. Then go back and intellectually examine it for flaws. If the approach to visual storytelling is totally analytical right from the start, the resulting work may be stiff and sterile. Trust the right side of your brain, be true to your personal style, and express yourself in every image. The audience will see the passion, and appreciate it.

6

THE DRAWING BOARD

lthough Scott McCloud's book *Understanding Comics* explores the process that goes into the creation of the comic book, much of what he says can be applied in a general way to the process of creating a work in any of the output media discussed in this book, including film, animation, and interactive games. There are six basic components that affect what a given work of art will be in its tangible, finished form. ✳ Idea/Purpose: The inner passion for expressing oneself creatively. ✳ Form: The output medium (e.g., comic, film, interactive game). ✳ Idiom: The subgenre to which the work belongs. In interactive games, for example, is it a first-person shooter or a role-playing adventure? ✳ The production process. ✳ The specific skills and craft required. ✳ How the audience will interact with the work.

The tools used do not run the artist. It's the artist that runs the tools.
—Wayne Hanna, Dean of Education, Illinois Institute of Art

Art and Technology

This chapter explores Scott McCloud's fifth component, the required skills and craft for creating effective images. In today's high-tech world, there are myriad skills that a truly versatile visual storyteller needs to master, but they all start with the drawing board.

Today, many artists (illustrators in particular) who have come up in the traditional digital media have not had the tactile experiences of working with paper and paint, that low-tech skill that used to be basic training for one's creative muscles. Wayne Hanna, Dean of Education for the Illinois Institute of Art, believes that there is a positive and a negative side to the increasing reliance on computer graphics packages to produce a drawing or story. Many younger artists don't have highly developed drawing skills. The flip-side, he says, is that they *do* have a whole new set of values that are electronic—virtual. "It sort of expands their capabilities beyond the physical limitations of using a 1200-dpi pencil." The power of technology should serve as a tool to the creative process and not *become* the creative process. Artists need to stretch beyond their intellectual and analytic perceptions of the world and think outside the box, beyond even software limitations, and make technology a servant, rather than the other way around. Hanna says, "One of the problems I see is after an artist masters the software, they limit their problem solving to what the software can accomplish, rather than looking at the problem, finding the best solution to the problem and then figuring out how to make software accomplish that for you. I call it 'design by default.'"

Although educational institutions such as the Illinois Institute of Art offer many technological courses, from digital filmmaking to 3D modeling, the core studies also include the traditional fundamentals of art instruction. There is a need to develop skills beyond computer literacy in order to achieve success as an artist in new media. "The course path for a BFA in Media Arts and Animation," says Hanna, "requires courses such as fundamentals in design, English I, life drawing, color theory, effective speaking, and even physics." Hanna also says that an artist who's required to design and illustrate computer 3D animation "needs to be able to problem-solve in that environment." Today's students are being prepared for a new visual literacy—for a cross-disciplinary world in which art and science have together created a new kind of output, a new level of three-dimensional consciousness.

The process of bringing a character to life begins on the drawing board. Shown here are four storyboard sketches for episode 1 of *Age of the Guardian Strangers*, an animation produced by Serial Box Studios. This sequence features Tanzar (yes, his name is an anagram for Tarzan, and, like Tarzan, he was raised by apes). On the home screen of boxtoptv.com, at which Internet users can access this and other animated films, Serial Box Studios announces that its goal is "to capture the feel of the radio and movie serials of the 1930s and 1940s." Another striking example of cross-pollination at work.

From pencil sketch to animated character: The evolution of Tanzar. Every line of the pencil drawing is evidence of the artist's skills—both as a drafter and as a creator of character.

This drawing below, the basis for a scene from *Age of Guardian Strangers,* is done in a very different style from the Tanzar sketch shown on the left, but with equal skill. On the same page as the sketch of the character, the artist drew three storyboard panels to be used for the final animation, a comic sequence in which the telescope spins and hits our hero in the head.

Using Reference

The realistic figures seen in animated film, final storyboards, and comics are first drawn, sometimes using reference and sometimes from the artist's imagination. In order to be successful at dynamic imagery, the artist's brain needs to be "programmed" with enough data to be able to draw—realistically—a wide variety of objects and figures in numerous poses. As Hanna says, it's visual problem solving. The success of visual storytelling also relies on the artist's ability to create an environment (not just the objects within that environment) that is realistic—on its own terms—and immersive. As discussed in the last chapter, however, the knowledge and skills required to realize an immersive world vary depending on the medium and the complexity of the desired effect. Often it is impossible for an artist to go it alone, no matter how extensive his or her background. For example, James Cameron needed to hire hydrologists to help the 3D animators replicate water for the film *Titanic.*

With interactive games, the player's ability to walk through the game world and look at many of the objects from all sides means that the 3D modelers must adhere to strict standards of realism throughout the environment. For example, a rock in a movie frame, whether it's a photographic film or a 3D animation, has only one side: the side the audience sees. The same is true of a rock in comics: whichever side is drawn is the only side the reader sees. It can be half a rock—the side that's visible to the "camera." If the shot is set up right, the "dark side" of the rock doesn't need any special attention. In interactive games, a rock (or anything else) that the designer wants the player to be able to walk around and look at has to be a virtual solid rock—top, bottom, and sides—with believable textures and colors. Everything needs to be there.

In whatever medium a storyteller is working, the best way to produce top-quality work is to first learn to draw from life and reference. Extensive practice in drawing imagery, stories, and characters from real life "programs" the brain so that the subjects previously drawn can be expressed in whatever medium chosen.

Winsor McKay (1867–1934), one of the pioneers of animation, drew all 4000 of the cels for his first animated cartoon, *Little Nemo,* a spin-off from his famous comic strip of the same name. In the final scene of his second film, *Gertie the Dinosaur* (1914), McKay joins his animated creation on screen.

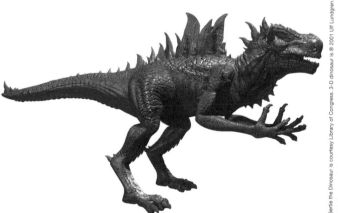

In *Gertie the Dinosaur,* the first animated feature by Winsor McKay, 10,000 images were needed to bring his dinosaur to life. Today's dinosaurs, like this one by Ulf Lundgren, are three-dimensional objects that are programmed to move.

Do I Have to Draw *Everything?*

A good visual storytelling artist has to draw everything on and off this planet with a convincing level of skill, whether for final production or to communicate a visual foundation for dynamic media. Other fine and commercial artists usually end up specializing in one or two areas (such as head portraits, flowers, landscapes, product shots, and so on). However, for visual storytelling, one must be able to draw a variety of figure types, city scenes, cars, animals, fantasy creatures, and so on—all requiring an equal level of ability. If, say, a comics artist draws people well, but his or her horses look very weak, the difference in drawing levels will make the weaker drawing stand out that much more and will distract the audience from the flow of the story.

Whatever an artist doesn't like to draw is almost sure to be something he or she has been neglecting to draw and therefore needs to work on. Animals, for example, with their enormous variety of anatomical types, present a challenge. Cars are difficult to draw, both because of their complexity and because they require the ability to render smooth metal and reflective surfaces (glass) realistically; surprisingly, perhaps, so are phone handsets; like cars, they have dynamic angles and smooth surfaces.

Any poorly rendered image may distract the reader from the flow of the story. If a story calls for a close-up of a person getting bad news on the phone, for example, and the face is rendered convincingly but the person is holding an unconvincing blob for a phone, the entire panel will seem unrealistic. And, if the artist decides to "cheat" by pulling the "camera" way back and/or silhouetting the shot, the desired dramatic effect is lost. Artists who force themselves to conquer a drawing deficiency may even find that a subject they used to avoid becomes one of their favorite things to illustrate.

Tracing, Plagiarism, and Motion Capture

It's common for artists to trace reference images in order to become familiar with a particular object's shape and size so that drawing the object will be easier. This may help an artist to internalize an object's form, but traced images will always look static, as they will lack the artist's vision of how the object might be amplified or exaggerated for effect. Of course,

tracing any copyrighted image—whether a drawing on paper or a photograph—and reproducing it for publication is plagiarism, effectively violating someone else's copyrights.

One form of "tracing"—*motion capture*—is the process of tracking and recording real-life movement for use in 3D modeling for films or interactive games. Motion capture, which is definitely not plagiarism, can shave months off schedules for the average computer game, animated film, or film using computer-generated characters that must move realistically. For decades, studios used a technique called rotoscoping—projecting live action stills on paper and tracing the outlines—to recreate the movements of human actors for animation. In the late 1980s, Silicon Graphics developed a high-powered 4D workstation that was used by Jim Henson Productions to create a virtual puppet (as virtual as it could be in 1988). At the 1993 SIGGRAPH conference (the Association of Computing Machinery's International Conference on Computer Graphics and Interactive Technologies), game producer and publisher Acclaim Entertainment showed off a complex two-character animation, which used their internal proprietary system.

Motion capture for 3D modeling starts with attaching markers to actors' (human or ainmal) bodies and/or faces, tracking the movement of those markers, and feeding the sequential data collected into a computer, where it is used to animate characters. Red Eye Studios, a motion-capture facility in Hoffman Estates, Illinois, uses the award-winning Vicon motion capture system. The Vicon system is

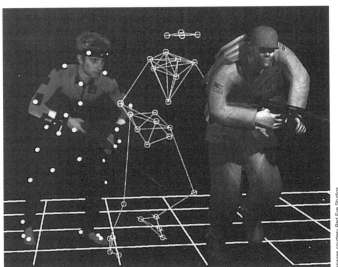

From markers to skeleton to 3D character in action.

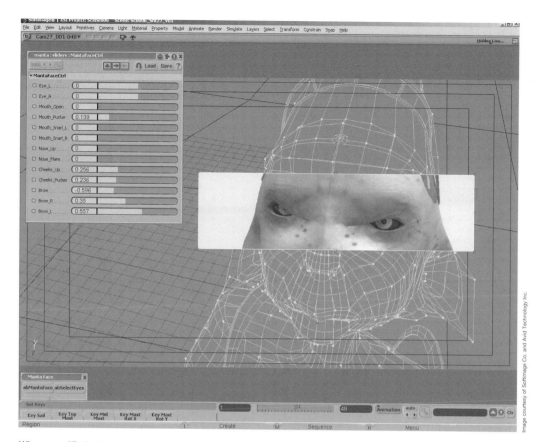

Whereas a 2D drawing is rendered *onto* a flat piece of paper or screen, a 3D model is rendered *within* a virtual three-dimensional space. Using programs such as Softimage 3D and XSI, artists build characters using polygons. The more polygons used to create the shape, the less "blocky" the shape will be and the more details that can be used for the object or character's distinguishing features.

an optical one, in which megapixel cameras capable of capturing 250 frames per second, each placed so that it has a unique perspective on the actor, are used to pick up the changing positions of hundreds of reflective markers and then digitally transmit the data, in real time, to Red Eye's computers. The software uses the data to create a skeleton, or digital manikkin. The skeleton, which can replicate all the actors' captured movements, moves around inside the already rendered skin of the character.

"Essentially, we're tracing real life," said Maggie Bohlen, Producer at Red Eye Studios. "You can get the best possible realistic quality because you have the advantage of picking up subtleties of human motion." If the movement of characters in films or interactive games successfully creates the illusion of real motion, the characters will be believeable. If rendered characters, as, for example, in the *Final Fantasy* movie, look, walk, and talk like they're real, then they must be real!

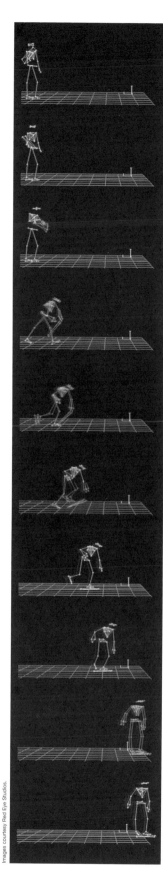

These frames show the motion capture "skeleton stage" for a skateboarding sequence.

The Question of Style

For some reason, there is widepsread confusion over the difference between skill and style. In most cases, the "style" of a talented artist or director will not affect how successfully that artist or director (or game designer) tells a given story through imagery. The foundation skills set for great visual storytelling does not include prescriptions for style. Individual audience members may prefer one style over another (e.g., *Shrek* vs. *Chicken Run* vs. *Monsters, Inc.; Stuart Little 2* vs. *Resident Evil*), but in the end, it's not style, but clarity, that matters.

Neal Adams and Will Eisner, in Will Eisner's book *Shop Talk,* discuss the relative merits of a "big foot" and "little foot" drawing style. ("Big foot" characters tend to be more cartoony, but drawing a big foot character successfully requires a solid mastery of human anatomy.) Says Adams, "From the point of view of exercising ability, to draw 'big foot' stuff makes you see all kinds of shortcuts that are available in all kinds of different ways." The shortcuts he refers to are not copouts: they are an integral part of the storytelling process.

The Importance of the Line

Artists have used the line—to draw purely 2D outlines or to create the illusion of dimensionality—since the first cave dwellers decided to pick up charcoal and illustrate the world around them. Drawings of all three-dimensional objects, whether they are destined for the pages of a comic book or are the concept sketches for a film or interactive game, begin with the outline. Artists can also use lines to create lighting effects, special effects, and sound effects (see Chapter 10, An I for an Eye, page 168). Of course, line drawings for comics must be completely realized—more realistic and detailed and powerful than images drawn for an intermediate stage in the production process. Andrew Loomis, artist and author of *Figure Drawing for All It's Worth*, says, "The eye perceives form much more readily by contour or edge than by . . . modeling. Yet there is really no outline on form; rather, there is a silhouette of contour, encompassing as much of the form as we can see from a single viewpoint. We must out of necessity limit the form in some way. So we draw a line—an outline."

Lines can be thick, thin, precise, loose—the possibilities are almost limitless. Artists in training need to sketch using a wide variety of line types.

To the nonartist, art drawn with few lines (images relying mainly on outlines and solid white or black areas) may be less impressive than art that is highly rendered with lots of lines. In fact, artists who have mastered the line can say more, with less. At the same time, if there are only a few lines to a drawn image, each line becomes crucially important. The lines drawn for Patrick the Wolf Boy's father's glasses, in the illustration shown here, are also used for his eyes; his pants are his legs; his smile is his chin; and so on. Another master of line and shape is Vincent Locke, the artist who drew the page from *Rust* shown at the beginning of the chapter. Locke's muted, dark, impressionistic style contributes to a unique experience for the reader.

Even 3D objects take shape starting with lines.

Figure Drawing

The ability to draw all types of people convincingly is a prerequisite for visual artists, whoever the audience may be for the final images—the comic readers, the film director, or the game designer. Most lead characters in comics and in animated films and interactive games based on comics have idealistic proportions and features—rendered in an approach called "heroic representationalism." (Kerry Gammill was once asked why artists draw their human figures as these perfect specimens. "Because we can," was his reply.) However, since these characters interact with people within a wide range of body sizes, types, and ages, it's necessary to be able to draw all sorts of people with the same high level of accuracy.

It's best not to get too caught up in precise anatomical details early on in your studies. Learn the major "masses" and "planes" of the body and head first before wondering if all the striations of the deltoid muscles are right. Learning the position, mass, planes, origins, and insertions of the major muscle groups will enable you to draw realistically proportional figures and muscles, as well as to exaggerate, when needed, in a convincing manner.

Most of the artwork in the following series of illustrations on figure drawing is from Andrew Loomis's 1947 classic, *Figure Drawing for All It's Worth.* *

Proportion

Loomis was the first artist to publish the proportional charts that almost all illustrators, from comics to storyboard to interactive games, use today. (Fashion, of course, is another animal, and is beyond the scope of this book.)

* *Figure Drawing for All It's Worth*, by Andrew Loomis, © 1943 by Andrew Loomis, renewed © 1971 by Ethel Loomis. Used by permission of Viking Penguin, a division of Penguin Putman, Inc.

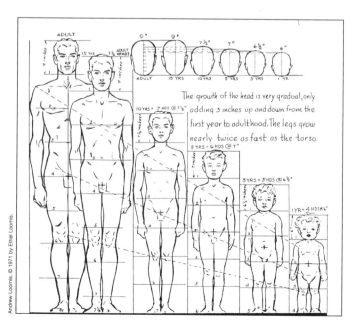

The scale assumes that the child will grow to be an ideal adult of eight head units. If, for instance, you want to draw a man or a woman (about half a head shorter than you would draw the man) with a five-year-old boy, you can use the chart here to determine their relative heights. In order that children under ten years old look like children rather than very short adults, they are drawn shorter and chubbier than they would be if the proportional guidelines were adhered to strictly.

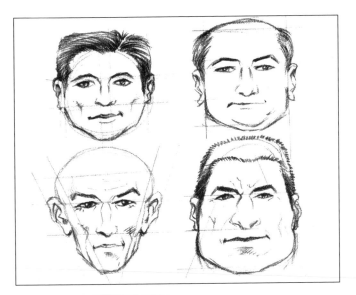

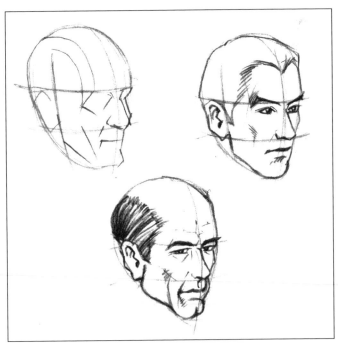

Above left and right: **Head details.** Whatever the outline shape of the head, it is usually divided into thirds, as shown, which helps the artist keep the character's appearance consistent throughout the story.

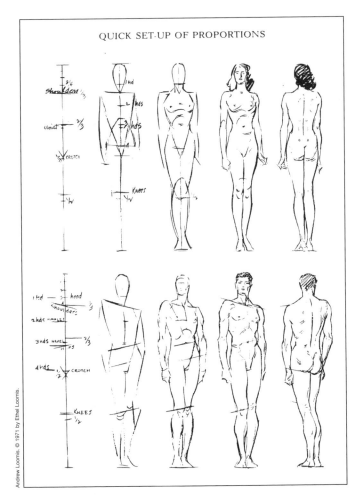

A quick and easy method of assuring the proper proportions for any figure is to measure (using the height of the head as a ruler), from the top of the head to just below the crotch. This should measure four heads and is also the center point of the figure (the legs taking up the other four heads).

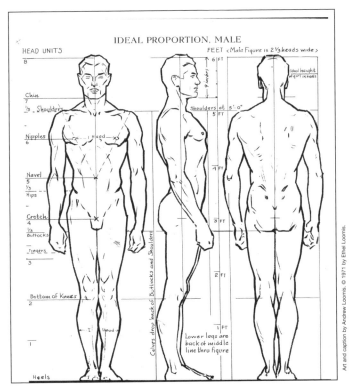

Take any desired height, or place points for the top of the head and heels. Divide into eighths. Two and one-third of these units will be the relative width for the male figure. It is not necessary at this stage to attempt to render the anatomy correctly, but fix these divisions in your mind. Draw the figure in the three positions: front, side, and back. Note the comparative widths at the shoulders, hips, and calves. Note that the space between nipples is one head unit. The waist is a little wider than one head unit. The wrist drops just below the crotch. The elbows are about on line with the navel. The knees are just above the lower quarter of the figure. The shoulders are one-sixth of the way down. The proportions are also given in feet so that you may accurately relate your figure to furniture and interiors.

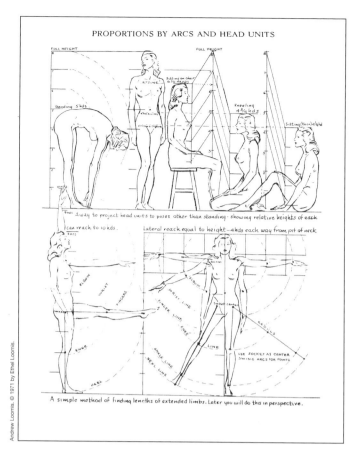

Andrew Loomis's basic technique for using arcs and head units to determine correct relative heights for different poses—bending, sitting, kneeling, etc.—and for drawing extended limbs.

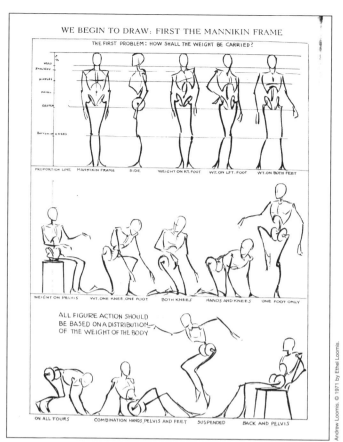

Andrew Loomis's mannikin frame in a few basic poses. The reverse tilt, shown in the third and fourth figures in the top row, is a more dynamic pose than either the rigid stance of the first figure or the stiff figure at the extreme right.

The Manikkin Frame

The manikkin frame is a universal tool used to build the foundation for drawing the human figure. Most artists develop their own version of the manikkin frame, which is a good place to start in developing one's own approach to building the human frame and learning the stationary pivot points for action, movement, and direction. A manikkin frame can be used to:

* Provide an accurate assessment of the amount of space that will be needed to hold the completed figure

* Ensure proper proportions

* Give the artist a way to do a rough placement of the figure in a specific environment

* Most importantly, help with correct distribution of the weight of the body and with drawing the most dynamic representation

Loomis's mannikin frame in motion.

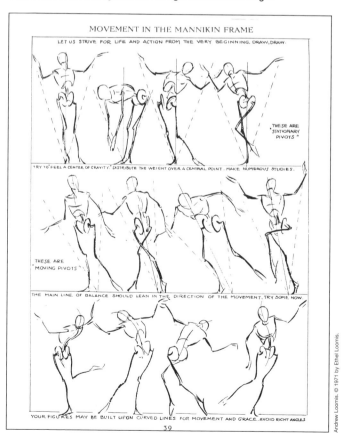

Perspective and Relative Proportion

The foundation of our ability to perceive objects in the real world as three dimensional is binocular vision—our brain combines the two 2D images seen by each eye into one 3D image. Depth perception is mediated by visual clues, such as size, shape, and lighting, as well as by accommodation (our eye muscles adjust the shape of the lens according to how far away an object is), convergence (when we focus on a near object the two lines of sight of our eyes cross at a large angle; when we focus on faraway objects, the lines of sight become almost parallel, and the objects appear flat), and parallax. Artists use certain well-established rules of *perspective* and *proportion* to simulate in two dimensions what we see when we look at a scene in the real world. Shown here are four valuable mini-lessons from Andrew Loomis on perspective and relative proportion.

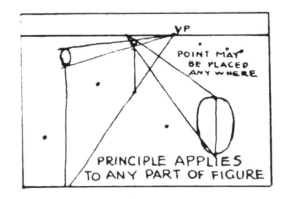

Many artists have difficulty in placing figures in their picture and properly relating them to each other, especially if the complete figure is not shown. The solution is to draw a key figure for standing or sitting poses. Either the whole figure or any part of it can then be scaled with the horizon. AB is taken as the head measurement and applied to all standing figures; CD to the sitting figures. *This applies when all figures are on the same ground plane.* You can place a point anywhere within your space and find the relative size of the figure or portion of the figure at precisely that spot. Obviously everything else should be drawn to the same horizon and scaled so that the figures are relative. For instance, draw a key horse or cow or chair or boat. The important thing is that all figures retain their size relationships, no matter how close or distant.

FINDING PROPORTION AT ANY SPOT IN YOUR PICTURE

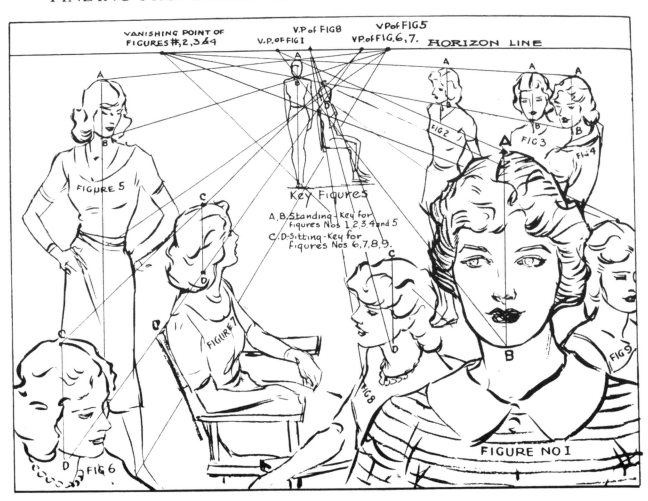

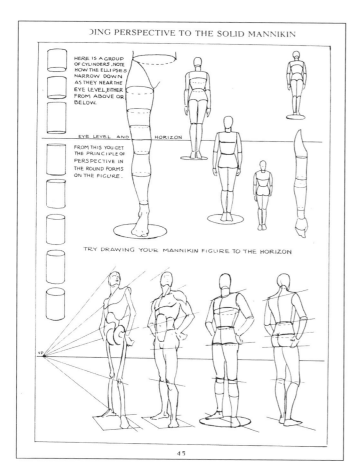

Creating solid mannikins and drawing them in perspective views. The initials VP stand for *vanishing point,* which is that point on the horizon at which all lines drawn from any part of an object in the picture not seen head on will disappear. The vanishing point (or points, if you are using two- or three-point perspective) in a drawing can be anywhere on the horizon line the artist wants it (or them) to be.

Below left: Loomis called this series of drawings "The John and Mary Problems." The two figures in the top eight drawings are seen from eight different angles, but in all cases, they are drawn in correct perspective relative to the horizon and in the proper position relative to each other. In the bottom eight drawings, Loomis shows us graphically what happens when the rules of perspective are ignored. **Below right:** The Andrew Loomis technique for "hanging" figures on the horizon to establish proportions. Notice Loomis's technique for close-ups, shown at the lower left, where the horizon cuts the men through the mouth and the woman through the eyes, making them shorter relative to the men. In the diagram at the lower right, Loomis has chosen two heads' length (one and a half, or three, or some other other number could also have been used) as the distance from the top of each figure to the horizon. The next time you draw a crowd scene with different-sized figures, try checking your relative proportions using the head-length criterion.

THE JOHN AND MARY PROBLEMS

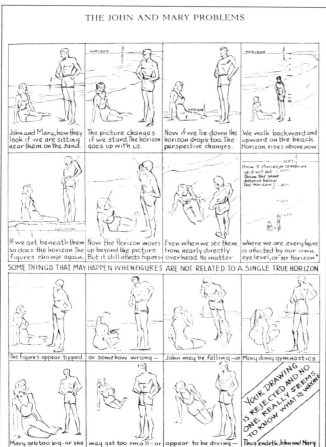

"HANGING" FIGURES ON THE HORIZON

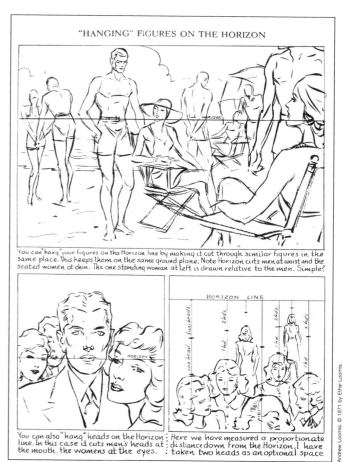

THE
CAMERA
IN THE
MIND'S EYE

"You can't depend on your eyes when your imagination is out of focus."
—Mark Twain

Whether you are a director, camera operator, or comics artist, you have to make conscious decisions about all aspects of "shot" composition, including how far away the "camera" will be, what vantage point the spectator will see the action from, and how distance and camera angle will change from shot to shot as the scene progresses. The vantage point of the spectator, or point of view, will in turn determine the perspective, how the objects in the frame appear relative to the horizon line. Decisions made about how to frame a scene for a screen or panel will determine whether the shot will enhance or detract from narrative power.

"In the beginning of interactive [video] game development, the programmers did all the art. As the graphics became more sophisticated, the technology became more sophisticated. You had more colors, depth and textures. Eventually, they'd say, "You know what? We can't draw. We need to hire real artists."

—Alisa Kober, Creative director, game designer

Distance

What's in a frame? A lot depends on how far away the camera is. The camera/eye can see as much as the shot designer wants it to see, from one tiny part of an object or face that fills the frame to alien hordes seen from high above.

Long Shots

The *extreme long shot*—where the camera is quite far away from the objects in the frame—can be use to used to orient the viewer as to where the characters are, who the characters are, and the spatial relationship between characters and their environment. Extreme long shots are often used for the opening scenes in interactive games, where the designer wants the player to have a feeling for the world he or she is about to enter. Extreme long shots (and long shots) can be used as *establishing shots* (see Chapter 4, Visual Storytelling Design Palette), but sometimes they are chosen simply because the director or artist wants the audience to have an overview of a panoramic vista—a landscape of surpassing beauty, say, or the aftermath of a disaster.

A long shot from *Operation Extermination,* a 3D comic book adventure on CD-ROM. The camera has pulled back so the viewer can clearly see all four characters and the very dangerous environment where the action is taking place.

This extreme long shot from the role-playing game *Septerra Core* sets the stage for where the action will take place in the next series of scenes.

A medium long shot from *Age of Guardian Strangers.* The interaction between these two characters is the narrative focus here.

HOLY CRUD! RALPH WAS A ROBOT!!

YOW-YOW-YOW-ZA.

The panel on the right is a medium shot of Ralph Snart. Ralph and his weapon—which is about to fire—are the center of the reader's attention.

CORRECTION—RALPH IS NO FOOL, BIMBO!

ZAP!

Medium Long Shots and Medium Shots

Medium long shots are typically used to present a full view of the character(s) or the action, but only a partial view of the setting or environment. In film, the term *medium shot* generally refers to shots in which the characters are seen from above the knees, or below the waist, to the head. In comics, the term may be used for a shot in which the focal character is

seen from head to toe. Often, the motivation for using a medium shot (or a close-up) is so that the viewer sees what is taking place from the same viewpoint as the other characters in the scene, becoming more of a participant than a spectator.

Close-ups

Medium close-ups are shots that include approximately half of a character's body in the frame, usually from midway between the waist and the shoulders to above the head. The setting is still recognizable. Like medium shots, medium close-ups can be used to highlight an interaction between two—and occasionally three—characters.

In *close-up* shots, the full character or object that is the subject of the shot is much bigger than the frame. The setting is barely recognizable, or not recognizable at all. *Extreme close-ups* (also called *big close-ups),* are in-your-face shots. Only a very small portion of the object or character is visible, and none of the setting is visible. Both close-ups and extreme close-ups are often used when the visual story-teller wants the audience to see something about a character up close and personal, something that might not be obvious to one of the other characters in a scene. Extreme

close-ups are very effective for getting across emotional highs or lows, extreme fear or profound indifference, uncontrollable rage or radiant joy.

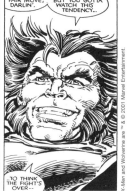

An extreme close-up from the film *Ways of Knowing.*

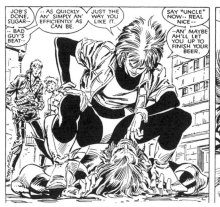

In the right panel we see a close-up of Wolverine of the X-Men, down but not out! When drawing a close-up panel in comics, the artist may also have to leave room for word balloons, as here.

From left to right, two close-ups and one extreme close-up. Both clearly show that the character is profoundly sad, and the artist could have stopped with the close-up, but instead chose to use a cinematic zoom-in technique that works to emphasize the depth of her sadness, to let the reader "feel" her pain.

A medium close-up from *Operation Extermination.*

Here, actor and screenwriter Chris Gabel witnesses the landing of an alien space-craft! The low-angle shot adds to the power of the revelation.

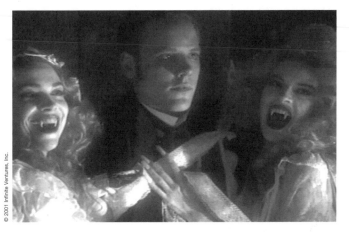

In this point-of-view shot from *Dracula Unleashed,* a DVD game by Infinity Ventures, you're invited to meet Dracula and his friends, face-to-face.

This point-of-view shot from the level of the bug-sized characters gives the human character more presence, further emphasizing the power of the bugs who captured him.

Camera Angles

The choice of camera angle, like any other choice made when deciding what should be in a frame and from what vantage point the viewer will see it, must be motivated by what works best—both for the individual scene and for the overall narrative. The three "classic" camera angles—eye level, low angle, and high angle—have very different psychological implications.

Eye-level shots, as the name indicates, are shots taken with the camera at eye level. In point-of-view eye-level shots, the object or character is seen from the point of view of another character in the scene. There is no vertical distortion in eye-level shots, and scenes shot at eye level are typically neutral; they project normalcy, because this is how we naturally observe the world around us. For *low-angle shots* (also called up-shots and worm's-eye view shots), the camera is positioned below eye level: the viewer is looking up at the subject. Often, low-angle shots are used when the storyteller wants to suggest an inherent strength of the object or person being seen from that angle. In *high-angle shots* (also called down-shots, or bird's-eye view shots), the camera is positioned above the characters and objects in the scene; the viewer is looking down at the scene. High-angle shots can be used to suggest that the object or person seen from above is in a position of weakness. They are also often used as establishing shots. For Jim Steranko's take on these three camera angles, see page 176.

High-level and low-level shots can be taken to extremes, where the perspective is exaggerated, or forced, beyond the scope of what would be possible if the object or characters were being viewed by a real observer (or camera) in the real world. Comics artists take forced perspective to extremes more often than filmmakers. There are, however, some famous examples in film, such as the exaggerated up-shot of Gutman (Sydney Greenstreet) used the first time Sam Spade (Humphrey Bogart) meets that character in the film *The Maltese Falcon,* where his head seems to be sprouting out from his outsized stomach. For some other examples of forced perspective, see Chapter 9, Tricks of the Trade, page 146.

This down-shot from *Skeleton Krew* creates a sense of menace. Big Al, the tough leader of the Krew, appears small and vulnerable. He is definitely in danger.

An extreme camera angle from *Operation Extermination,* where Vinny Mazola finds the chambers of the anthill covered with nasty ant larvae, army ants to be.

Depth of Field, Focus, and Movement

A tracking shot, as the name suggests, tracks a moving subject along the same path the subject is taking. The camera can be mounted on a dolly or moving vehicle or can be handheld.

Depth of field is a photographic term meaning how much of any given shot is in focus. In a deep-focus shot, all of the planes within the frame are in focus. In a selective-focus shot, only one plane, usually the foreground, is in focus. It wasn't until the 1940s, after Orson Welles and cinematographer Gregg Toland made extensive use of deep-focus photography in *Citizen Kane* (1941), that Hollywood filmmakers embraced deep-focus techniques. Shift of focus from one plane to another is called *rack focus.* Comics artists, of course, cannot duplicate out-of-focus photographic effects, but they can, and do, blur background objects or characters both to focus attention on the sharper figure or figures in the frame and to enhance the feeling of dimensionality.

In early silent films, the camera was stationary. It was not possible to physically move the camera toward or away from an actor while the action was taking place, or track the movements of an actor or a vehicle. When the *Great Train Robbery* was filmed, the train moved toward the camera, but the camera stayed where it was. Today, camera operators can

Dolly shots are shots taken with the camera mounted on a dolly that moves toward (dolly in) or away (dolly out) from a stationary or moving object or character.

move along with the action using handheld cameras, and cameras can be mounted on dollies, camera trucks, even helicopters. Using the Steadicam, a handheld camera mounted on a shock-absorbent apparatus, camera operators can take footage of moving actors with almost no shake. One technique for creating the illusion that the viewer is moving toward or away from an object or character in a single, continuous shot is to use a zoom lens, which can switch from wide angle to telephoto (zoom in) or from telephoto to wide angle (zoom out) while the camera position remains the same. Zoom shots are similar to dolly shots, but in a zoom, the size and position of the objects in the frame relative to each other don't change and in a dolly shot they do. A comics version of a zoom in is shown at the beginning of this chapter (page 96).

In this realm, the dynamic media have a huge advantage over the static media, and cinematographers can create mind-boggling effects by using a combination of techniques. One famous scene that has a disorienting effect on the viewer is the diner scene close to the end of *Goodfellas* where the Ray Liotta character realizes that he will never come back alive from the supposed "hit" Robert De Niro is telling him about. The size of the actors relative to the frame never changes, while the background, seen out of the window next to the booth, looms ever larger. Cinema-

tographer Michael Ballhaus achieved this effect, which emphasizes the pivotal importance of the scene, by pulling the camera back at the same time that it was zooming in on the subjects. A comics artist could design several sequential panels that did the same thing, but the effect on the reader would be negligible.

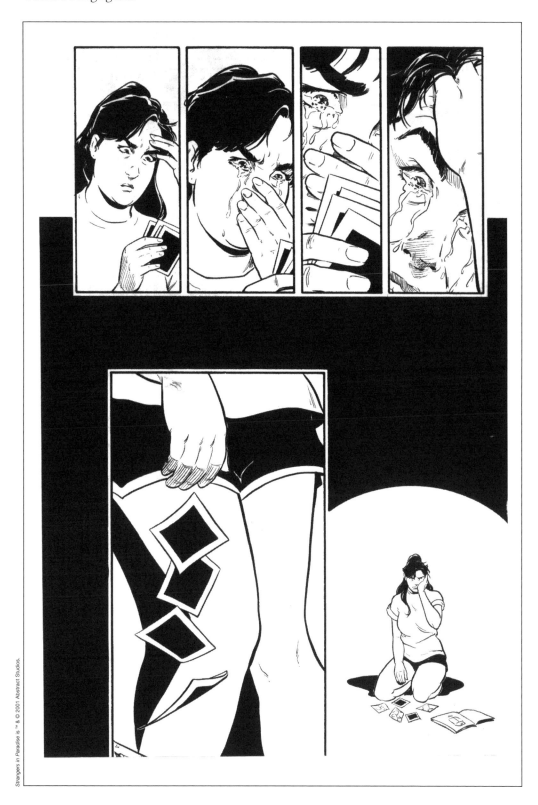

A comics version of a tracking shot. Our eye "tracks" the cards as they fall to to the floor—all in one panel.

Here are a few frames from an animation using a zoom to dissolve.

A Miscellany of Shots

A sequence in which what is seen gradually disappears until the screen is blank is called a *fade-out.* A sequence in which the objects and characters in a scene gradually appear is called a *fade-in.* The overlapping of the fading out of one shot and the fading in of another, giving the impression that the second shot appears out of the first, is known as a *dissolve,* or a *lap dissolve.* The term *wipe* refers to an optical effect in which the second of two shots abruptly pushes the first off the screen. *Superimposition* is when two or more images can be seen on the screen at the same time, in the same space. Most of these are used extensively in films (superimposition is employed sparingly), and comics artists can emulate the effects, adding cinematic dynamism to the static images.

A Perennial Favorite: The Over-the-Shoulder Shot

The next time you watch a film on television or in a movie theater, count the number of times a shot of two people talking is taken from a camera positioned behind one of the characters. You may be surprised how often this shot—called an *over-the-shoulder shot*—is used. In over-the-shoulder shots, common in both film and comics, one side of the foreground shows the back of the neck or the shoulder of one of the characters; the other character is farther away from, and facing, the camera.

What's *Not* in the Frame: Off-Camera Action

Although off-camera action is not a *shot* per se, there are numerous occasions in films and comics where something happens which is not seen. The audience knows what is going on off-camera through dialogue or sound effects, or because of something that was just seen which provides them with foreknowledge.

For obvious reasons, Jeff Smith wanted to leave this scene to the reader's imagination.

A creative example of 2D superimposition. The large panel in the background shows the suspicious character thinking someone may be hiding behind him, lurking in the shadows, while the three superimposed panels present more detail on how he arrived at that deduction. The glowing eyes provide a hint, in both instances, that he is probably right.

Over the shoulder and head of General Tranc, looking down at his tarantula army in *Operation Extermination.*

A good comics artist can cross-pollinate techniques to come up with some unique effects on the static page, as Terry Moore does here in his version of a wipe, from *Strangers in Paradise.*

LIGHTING AND COLOR

Without light, there would be no vision: the human eye needs electromagnetic radiation within a specific wavelength range to see. But the power of light goes far beyond its role in vision and the perception of color. Light is transformative. For centuries painters have used lighting effects to give dimensionality to their works, for dramatic effect, and to create mood. Visual storytellers from D. W. Griffith to Martin Scorsese to the creators of the interactive game *Resident Evil,* released in 2002, have used lighting and color, together with composition, focus, and camera angle, to maximum immersive advantage.

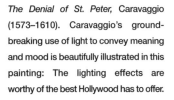

The Denial of St. Peter, Caravaggio (1573–1610). Caravaggio's groundbreaking use of light to convey meaning and mood is beautifully illustrated in this painting: The lighting effects are worthy of the best Hollywood has to offer.

Lighting:
The Invisible Character

In his book *Graphic Storytelling,* Will Eisner makes the point that comic book art regularly uses stereotypes—"the simplification of images into repeatable symbols"—as a kind of visual shorthand to get across certain narrative points economically. Lighting can also be used to immediately present a character's role or personality to the audience, providing what might be called storytelling "hints." For example, the bad guy may have catlike eyes which can shine in the dark. The face of the evildoer, who often has irregular or downright ugly features, is almost always under harsh contrast lighting. The good guy or woman, the one with symmetrically handsome looks, is lighted much more flatteringly. There are many exceptions, of course (think of Ed Norton, the killer in *Primal Fear,* and Seymore from *Final Fantasy X*), and interactive games, which may be explored by players for over 100 hours, have less need to rely on visual shorthand.

One aspect of lighting that film, animation, comics, and interactive games have in common—one which distinguishes them from live drama—is the emphasis on the lighting of characters' surroundings. In the theater,

Without Lighting	With Lighting
A	A

Lighting can add depth and three-dimensionality to anything, even a single letter.

Some creative lighting effects from Mark Smylie: a stark silhouette, with a hint of menace; the face of the same figure illuminated with a single weak source from high above, leaving the eyes in darkness; finally, the character's face, lighted for three dimensions, but still mysterious.

Uplighting is a technique that everyone first learns in their youth, with flashlight in hand; it can be loads of fun scaring little brothers and sisters by jumping out of a dark room, with the flashlight illuminating a screaming face from below the chin. Shown here is the Claw, uplighted for maximum menace.

the frame is the stage and lighting technicians have limited effects at their disposal. In the media that are the subject of this book, the action can take place over vast distances, along endless roads, and on hundreds of different sets. Thus comics artists, filmmakers, and interactive game designers must devote considerable creative talent and/or technical wizardry to establish—through lighting effects—the mood and tone that fit the action in each frame/panel/level, the visual nuances that are registered, if subconsciously, in the minds of the audience members. In effect lighting becomes a distinct, albeit silent, character.

D. W. Griffith's widely imitated lighting techniques, the first lighting "special effects," were a collaborative effort that required only two people: the director and his cameraman. Today, a given effect may start with the vision of a director working with a cinematographer or director of photography, but the end result requires the combined talent of lighting technicians, camera operators, and computer graphics artists, all of whom must have an extensive theoretical background. There are big dollars at stake. In film, redoing a scene to change the lighting can cost megabucks, which is why so many scenes from live-action films are still shot on a sound stage, where the director has absolute control of the light. And, of, course, filmmakers may decide not to reshoot a scene with a less-than-perfect lighting effect, as the linear momentum of film makes it difficult if not impossible for all but the most fanatical viewers to catch suble errors. In contrast, in interactive games, 3D modeling, even with state-of-the-art lighting software, usually takes more time than rendering the animated characters themselves. Comics artists, like interactive game designers, must "get it right" because readers can return to a single page or panel of artwork whenever they want to.

Storytelling Light

Lighting in the real world is usually diffused in one way or another: sunlight can be diffused by cloud cover, for example, or filtered through the leaves of trees. In interiors, the degree of diffusion depends not only on the light source, but also on what objects are reflecting the light (shiny objects will reflect more light than dull objects). Surfaces that are not directly lit by a source of light will never be completely dark, as long as there is some light in the room. Artificial lighting is diffused by human beings, who by and large want to avoid the glare of direct light (who wants to be caught in the beam of a headlight?). They can use any number of devices, such as fluorescent tubes, frosted light bulbs, and lampshades, to soften the light in their environment. The effects of environmental lighting can also be mediated by careful choice of color combinations. The way

Some variations on Griffith-Biograph lighting. Griffith found that shots lighted from a single source pointed straight at a subject facing the camera were flat, and lacked drama. Top: Both of these faces, one back-lighted and the other lighted from one side, convey a feeling of mystery, although the one lighted from behind is decidedly more menacing. Middle: A three-quarters view with the light coming from a single source heightens the illusion of three dimensions but at the same time creates harsh shadows. Bottom: A three-quarters view with dual-source lighting; the shadows are more diffuse, and the effect is more like what one might see with "natural" lighting

a person moving around in a room experiences light, therefore, is endlessly variable. In contrast, the light that the audience for a comic book, film, or interactive game sees is only a representation of the real world, and thus limited either by the skill of the artist or lighting technicians, what prevailing technology makes possible, or both.

What will work also depends on what medium you are working in. For example, the inverse square law, which states that the illumination of an object lighted from a point source varies inversely as the square of the distance from the source, is the formula used by the makers of photographic equipment to specify how far from a subject a given flash attachment can be and still provide adequate light. Practically speaking, that means that if a filmmaker wants an object that is being shot from 2 feet away from the light source to have the same illumination as an object that is 1 foot away, the intensity of the light source must be 4 times, not 2 times, as great as the source for the object 1 foot away. In practice, however, and especially when working in 3D animation, using the formula will result in scenes that are too dark. As always, it takes a certain amount of trial and error, and a lot of left-brain intuition, to come up with the best solution to any lighting problem.

Early filmmakers had to compensate for the limitations of what could be done to light a sound stage at the time. Harsh lighting created sharp contrasts and deep, often unrealistic, shadows in the black-and-white world in which their stories took place. Many, including Orson Welles, Robert Wiene, and Karl Heinz Martin, purposely used deliberately harshly lighted images to create mood, an approach that was

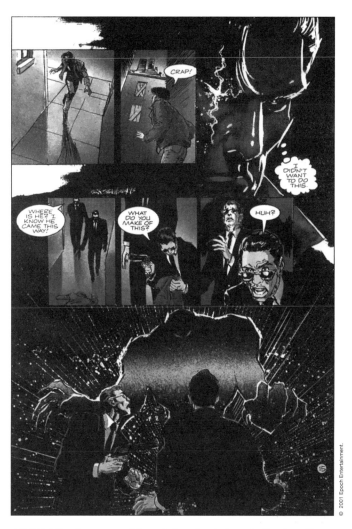

Artist Mark Beachum successfully created a malevolent mood with a dramatic use of black and a single light source, while incorporating the blacks into the actual comics page design.

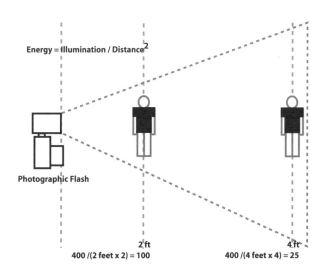

$$\text{Energy} = \text{Illumination} / \text{Distance}^2$$

Photographic Flash

2 ft
400 /(2 feet x 2) = 100

4 ft
400 /(4 feet x 4) = 25

An extremely effective use of light. The mood is dark, and the shadow stripe on the man's forehead adds a claustrophic touch. Notice the muted greys in the background.

related to expressionism in the world of art. Black-and-white comics also rely on expressionistic lighting techniques, most borrowed from film pioneers. The earliest interactive games were flat 2D, even farther removed from the illusion of three dimensions than comics, but they were dynamically animated so realistic lighting wasn't an issue.

Lighting Options

Burne Hogarth (1900–1996), who took over the Sunday *Tarzan* strip from Hal Foster in 1937 and is one of the most influential comics artists of all time, distinguished among five distinct types of lighting:

* Single-source light
* Double-source light. Two different levels and even colors of lighting highlight an object or character from both sides at the same time.
* Diffused, or ambient, light
* Moonlight
* Sculptural light

Another approach, one that is perhaps more useful when trying to decide how to light a comics panel or page, or a set (whether you are working on a sound stage or on location, or are lighting a 3D animation), is to think of light as point, spot, distant, or "natural."

* *Point light* is light that radiates from one or more distinct sources.
* *Spot light* does not radiate, but directs a concentrated beam of light on one subject.
* *Distant light* may come from a point source, but one that is far away from the set being illuminated.
* *Natural light,* in the context of visual storytelling, is real-world lighting—direct sunlight, or diffused sunlight—or lighting designed to simulate real-world lighting. Storytellers simulate diffused light by setting up multiple light sources and avoiding direct, single-source lighting.

Chester Speiwak, a 3D game designer, says, "An improperly lit scene, with incorrect balance of light and shadows, can ruin an entire illusion of three dimensions. Although the rendering of the lighting is time-consuming, it's well worth the effort to exude a more realistic feel to the scenes." Speiwak, who designed Mushroom City for *Operation Extermination,* generally chooses daylight, which casts a wide spectrum of shadows. The two shots of Mushroom City shown at the beginning of this chapter show how lighting can add depth and mystery to a scene.

Light and Color
..

The basics of storytelling light don't change whether scenes are being shot, inked, painted, or rendered in color. From the point of view of the storyteller, however, color offers both advantages and disadvantages. One obvious plus is that since human beings see in color, stories told using colored images—if the color is handled skillfully—are more "realistic" from the outset. The "if," of course, is a big one because the use of color in any medium requires a different sort of expertise from that needed to work in black and white, and the translation of real-world color into storytelling color is a multifaceted technical task. At the same time, color gives storytellers an entirely new way to create a desired effect. In Bernardo Bertolucci's *The Last Emperor* (1987), for example, the audience *sees* that only the emperor was permitted to wear yellow. The filmmakers used orange to symbolize life in the Forbidden City, and green appears for the first time when the young emperor's tutor arrives. In a scene in which P'u Yi is being interrogated by the Japenese, cinematographer Vittorio Storaro shows the passage of time through the changing quality of the light streaming through the window behind the boy, and the progressively muted colors of the objects within the room, an effect that could not have been achieved in black and white.

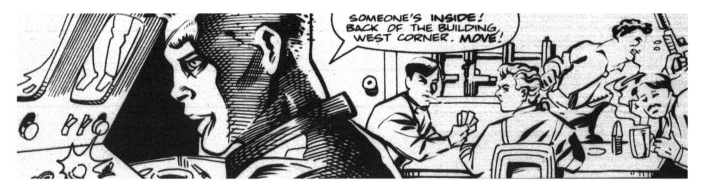

In designing the light and color effects for their panels, comics artists will often deliberately make no attempt to simulate "natural" lighting. The top image shows the scene without color. The cross-hatching on the figure in the foreground indicates that the penciler had envisioned either two sources of light, one primary and one reflective, or two separate sources. The bottom image shows what the colorist actually did: the chosen colors and lighting are definitely not "real world," but give the speaker dramatic intensity.

This artifical but dramatically effective lighting scheme consists of an orange, sun-like source, which backlights the character with the glowing eyes, and a secondary source, coming from the right, which casts a bluish hue.

Lighting and Color 115

Radiosity in 3D

To understand the difficulties facing the technicians who want to reproduce real-world lighting and color in 3D interactive games, we need to start with a few facts about the physics of light. What we call light is a small part of the electromagnetic spectrum, representing the narrow range of frequencies visible to the human eye. In the real world, light travels from its source (the sun, for example, or an overhead light) both as vibrating particles called photons and as waves. (To make it simple, we'll call them photons.) Light that passes through a prism is broken down into rainbow colors, with each color having its own wavelength. Once the photons strike an object, they are absorbed or reflected, depending on the physical characteristics of the object. What the human eye "sees" and transmits to the brain depends both on what happens to the photons when they strike a surface and what the human eye/brain combination is "programmed" to receive. What we see as "white" objects have reflected most of the photons;

what we see as "black" objects have absorbed most of them. The color of an object depends on the wavelengths of the light absorbed/reflected from the object.

The term *radiosity,* or secondary illumination, refers to the fact that the actual illumination and color of any surface are not just a function of its physical properties and the intensity of the light that is falling on it from a direct source, but also of the light reflected from other surfaces. The early interactive games were flat 2D (even more two-dimensional than comics), but they were dynamically animated—things moved—so realistic lighting wasn't an issue. But with the advent of 3D rendering, from *Doom* to *Toy Story* to the more sophisticated XBox games such as *Hunter: The Reckoning,* lighting became important. Characters and objects in three dimensions should be lighted, insofar as possible, as they would be in the real world. For a time, the most sophisticated software available for creating lighting effects in 3D games worked by calculating the intensity

© 2001 Valkyrie Studios.

of light waves from a specific source, where the light waves would go, and how they would react to a particular surface. These programs could simulate transparency, reflection, and refraction, but not the effects of secondary illumination. With newer programs, designed to simulate radiosity, specific surfaces are assigned different reflective intensities, and the effect they have on other surfaces in the environment is then computed. Only then is the total amount of light hitting each surface calculated, by adding the amount of light energy from all other surfaces that reaches the surface of interest.

Even the blackest black surface, as long as it's not a flat matte finish, will both absorb (making it a warm or cool black) and reflect some color.

The light reflects off the colored candy, and the colors are then integrated into the white of the dish.

The still on the left, from *Septerra Core,* shows how single-source lighting can be used to create deep shadows and hence the illusion of three dimensions. Alisa Kober of Valkyrie Studios, and creative director for the game, said, "I don't think many people noticed it's not a 3D game, like the first-person shooters. We have characters walk past colored lights and the lights cast colored shadows behind them and change the colors of the characters. We were successful in creating a 3D game in 2D, thanks to the effort that was put into the lighting."

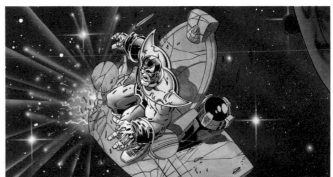

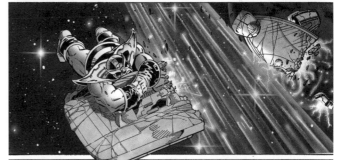

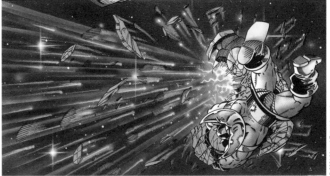

Colorist Tom Vincent provided the final dramatic flourishes to the already dynamic penciled page shown above, using only a few colors made vibrant by out-of-this world radiating light.

™ & © 2001 Anthony Caputo.

In the past, color in comics art and 2D cartoons was achieved by using flat color tints, applied by hand. Today, artists working in 2D can use the computer to achieve color separations and layering effects not posssible with manually applied colors. Here, the satiny sheen of the sheets and the soft dimensionality of the woman's skin were created via computer.

Operation: Extermination is ™ & © 2001 CWS Studios.

Vinny's bright red uniform and the Jester's lime green outfit stand out from the background images, effectively establishing the importance of these two characters.

Steranko Cover Art Gallery: Storytelling in a Single Image*

Production illustrations often depict story high points with characters in fully-rendered settings, although sometimes only the settings are required (such as those painted by Syd Mead for *Blade Runner*). I call this approach *dramatic realism* and, whether the assignment is for a film or a book cover, there are two basic variations: the first is literal, in which the image is based on an actual scene from the story; the second is nonliteral, in which the pictorial content *suggests* the story, perhaps using a montage of elements pertaining to it. While developing either solution, determine which visual aspects best represent the story's themes, place the lead characters in a prominent position, and maximize their conflict!

Sometimes I combine the variations by inventing a scene using characters from the story in an intriguing situation. For example, with many of the Shadow book covers I painted, I created confrontations using the major characters because the story did not incorporate a definitive visual situation. While this may qualify as a cheat technique, it elicited no complaints from readers that I heard about, but it did sell books—the job I was hired to perform. Movie posters use similar treatments. There, eye-catching art that stimulates ticket-buyers' imaginations is the goal.

Editor's note: The text on the next six pages was written by Jim Steranko.

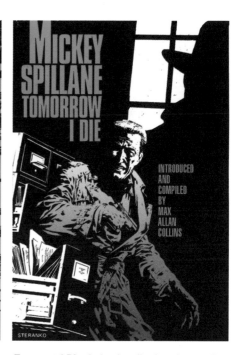

The 30th annual San Diego ComicCon International cover. An effect with light that conceals more than it reveals and relies heavily on readers' imaginations. The restrained, stark quality of black and red images can be memorable, especially displayed among competitive covers that are generally kaleidoscopes of color. This cover, and *Prince of Darkness* and *Tomorrow I Die,* feature the hardboiled detective of my graphic novel, *Red Tide.*

Graphic Prince of Darkness. The potent, symmetrical composition of this image is structured on the interplay between mass and texture, angular and sinuous rhythms, lights and darks—a symphony of visual conflict capturing the calm before the storm. None of the images on this page were inked; instead, they were pencilled to create a photographic quality similar to that of noir films, with hard-edged shadows and soft graduations.

Tomorrow I Die. A classic collection of storytelling elements—a dark office, ransacked filing cabinets, an oppressive shadow throwing an ominous presence across the tableau, and the trench-coated protagonist drawing his weapon in response. All three covers are visually evocative and crackle with tension and impending violence, although any indication of adversity or menace is strictly out of frame—a device that typifies much of my work.

Argosy. My version of Doc Savage is purposefully as far from Walt Baumhofer's pulp character and Jim Bama's paperback hero as possible; he almost appears to be made of metal, in keeping with his billing as the Man of Bronze. I evoked the period with a stylized, deco cityscape and spotlights, then added the golden Mayan idol to ignite a story in readers' imaginations.

Prevue. A Star Wars grouping predicated on tight design (in wraparound format; front cover only shown) and suggesting the dynamism of a movie poster. I'll often paint with a limited palette to easily control and unify an image. For this painting, I felt that a full range of color was needed to capture the galactic sense of action and adventure demanded by the subject matter.

Comic Book Marketplace. Originally painted for the The Shadow paperback *The Silent Death,* this image depicts a scene not in the novel, but one abstracted from the fantastic elements that energized the series—bizarre villains, exotic props, women in peril, and the omnipresent figure of the mysterious hero. Note how darkness and atmosphere are used to create a strong, evocative storytelling scene.

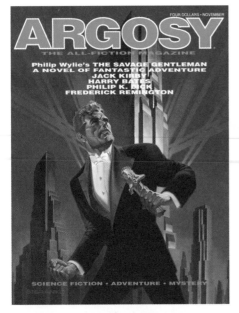

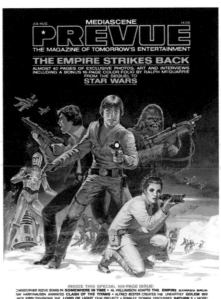

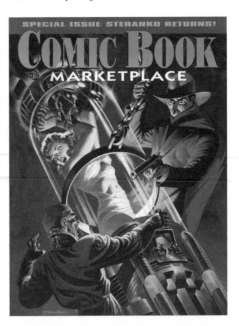

The Victorian. Among the artistic trends I introduced to comics, Surrealism is the most prominent. Here I distilled the essence of paranoia by depicting the fear of pain, sex, darkness, insects, and the unknown. Not a typical comicbook cover, newsstand browsers may have picked this up out of curiosity, which was my marketing strategy. The publisher liked the idea of offering something different to represent his line.

Norgil. To suggest the mix of magic and mystery in this collection of pulp thrillers by the creator of *The Shadow,* I garbed the hero-detective in a full-dress suit and cloak, surrounded by doves that seem to have been conjured out of nowhere. The background figure of a playing-card king brandishing a bloody sword resonates with magical tradition and the 1930's title treatment completed the illusion.

The Revenge of the Hound. While the image is replete with Sherlockian bric-a-brac (including the bullet holes in the wall), it is the seemingly inadvertent shadow of Holmes's hands that forecasts the theme. Although the image does not appear to be lacking in hues, it was painted with only two colors, in addition to black and white. The multitude of textures and shapes disguises the limited palette.

The Bride Wore Black. I used a strong, matching design approach for this series of Cornell Woolrich classics: On the lower third of all the covers, I orchestrated an unusual panel treatment, one that reflects my comic-book background. A falling man, a woman stripping to her lingerie, a pair of deco shoes, and a running couple all contribute to a visual summary of the story.

Phantom Lady. The Woolrich series was primarily written for the pulp magazines of the '30s and '40s, and the color combinations on this cover typify that period. The art style itself—massive flat areas, fadeaway figures, silhouettes, and graduated outlines—was deliberately evocative both of the vintage material and of what might be expected from the thrillers beneath the covers.

Rear Window. One of my trademark approaches—defining images by their light sources to create a dramatic atmosphere—is clearly evident in the series. The stark simplicity of the main figures, which are all virtually silhouettes with hidden features, interacts kinetically with the almost-oppressive complexity of the inset panels to create heightened suspense and mystery.

Lord of Blood. This cover took a slightly different approach to the heroic-fantasy image, a bit more Tarzan than Conan, but perhaps no less evocative of the genre. As a fencer and edged-weapons collector, I enjoyed the challenge of designing the exotic weapons and armor brandished by the characters who populated my swords-and-sorcery visions.

Blade Runner. I suggested dynamic movement by using a diagonal design and a strobe-type effect on the Deckard figure, building the composition against a strong horizontal foundation and adding a series of elements in a traditional movie-poster treatment. I used a full palette here, but its vivid effect is restrained by the use of mixed colors and limited raw-color spots.

Warlocks and Warriors. The art was one solution to the problem of wraparounds, where both front and back covers must stand alone as compositions and also as a single image. The opposite side of this painting depicted a naked slave girl chained to the bleached skeleton of a prehistoric beast, and an exotic cityscape of towers, spires, and minarets in the background.

Illustrating for Film

The Bat Staffel. The giant bats and the old castle silhoutted against the moon establish this book's intriguing premise.

Master of the Dark Gate. I originally painted this image as a sample, but author John Jakes found it so compelling that he wrote the heroic fantasy novel around it.

Bounty on Wildcat. The bullet hole in the figure's hat and his response—cocking the Winchester—build the story. Note the shell ejected from the chamber.

Movies require a range of art, from early concept designs to working storyboards to finished poster art, all of which stress different approaches and demand different results. My personal favorite is the initial concept stage, where the look of the characters, costumes, props, settings, and even the visual tone of the film is being determined. The emphasis is on design at this point and, if the film is in the science fiction, fantasy, horror, or action fields, imagination becomes one of the prime factors. Alex Tavoularis, Joe Johnston, and Ralph McQuarrie were brilliant in applying their imaginations to the design problems of *Star Wars*.

George Lucas asked me to work in a similar capacity for a film project he was developing in the late 1970s. The character was the kind of two-fisted soldier of fortune who had often been portrayed on screen by Clark Gable, Tyrone Power, and Gary Cooper in the '30s and '40s. George's picture was set in the same period and in the same exotic locales of such adventures as *Gunga Din, Too Hot to Handle, Morocco,* and *The General Died at Dawn.* He named the project in the classic cliffhanger tradition: *Raiders of the Lost Ark.*

The function of a production illustrator is to visualize concepts and key scenes from the screenplay. In this case, there was none, just a detailed outline and a collection of ideas that George had been amassing since he was a kid. Art, however different it may be from the final product, provides everyone on the project with a starting point, a visual guide upon which to build their own ideas.

George singled out a series of scenes, each defined in terms of action, and provided a very spare description of each, essentially leaving the embellishments to me. He was more specific about the character: Indiana Jones (named after the filmmaker's dog Indiana). The hero was to wear a hat like Bogart's in *The Treasure of the Sierra Madre* and a leather jacket (similar to the one George wears), carry a whip (like Don Diego's alter ego in the serial *Zorro's Fighting Legion*), and have a garrison belt around his waist, suggesting some kind of military service.

I knew precisely what George was looking for: a larger-than-life quality that was one of my specialties; over the years, I've probably rendered as many popular heroes as any

artist on the planet: The Shadow, James Bond, Batman, Conan, Doc Savage, G-8 and his Battle Aces, Captain America, Sam Spade, Buck Rogers, Norgil the Magician, Sherlock Holmes, The Green Hornet, Mike Hammer, The Fantastic Four, Captain Kirk, Spock, and an army of others, from trigger-quick Westerners to battle-scarred spacemen.

Casting actors was years away, so I cast the role on my own. I envisioned Indy with a strong, rugged, weather-beaten face and a physical attitude that suggested he could handle any danger that George would throw at him. As usual, I began the assignment with a series of layouts, concentrating first on the image which I felt would show the hero most clearly: the desert scene with Arabs in the background.

In the temple ruin scene, I began stating the difference with color. Although it maintains a unity with the others because of its neutral earth colors, I used green to suggest a cool, dark, isolated area that's alive with danger; the textures and contours of the crumbling columns, burial jars, and spidery vines surround the figure with menacing presence. I focused on the peril by pulling one of the cobras very close in the foreground and rendering it in a stronger silhouette than the figure, which it overlaps. The reptile's tense striking position and the fixed eye-to-eye contact suggest an imminent, harrowing climax.

I decided to paint in scope ratio of 2.35:1 to relate the elements to the screen size. In order to reveal Indy in a definitive manner, I made him closest to us so that he'd dominate the frame by sheer mass. Then, I used a cropping trick, cutting him across the legs and into his hat, to suggest his dynamic presence was even greater than what could be seen. My rendering approach was based on an agreement with George that the images could be less than reproduction quality because they were only meant to be used as inspiration. (I later heard they were used as presentation pieces to sell the film to Paramount). I *golden-sectioned* the layout to unify all the elements and painted the image in a limited palette that suggested the arid heat of the desert. Something minor seemed missing with Indy's garb, so I added a holster, an ammo pouch, and the Sam Browne belt that crosses his torso. (George apparently agreed because he adopted it for the series.)

The horse-to-vehicle transfer is an update of the classic runaway stagecoach scene. The vehicle is a composite, pieced together from references of WWII German trucks and half-tracks. Note that I enhanced the danger of the stunt by pinning the horse and rider between the rocky mountain and the ominous, angular bulk of the truck. In all three shots, I was careful to establish the horizon, an important aspect in outdoor adventure epics.

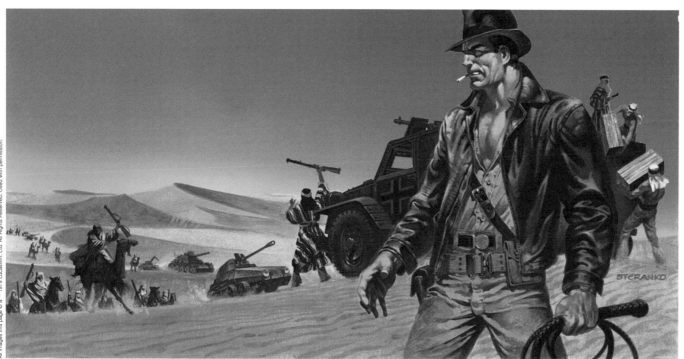

A number of comic book artists have migrated to the film area, where their skills at visualizing scenes and rendering them rapidly are useful in creating storyboards (advertising agencies generally pay much better for commercial boards that pitch products and visualize movie and TV show title treatments). The work is grounded in the reality of the cinematic process, so a working knowledge of camera technique, specific lenses, and stage direction can be important. Even more critical, however, is the ability to articulate a story with clarity and dramatic authority. Some storyboard artists work under directors and benefit from their instruction. I sometimes do the opposite, and create scenes and visual concepts that I want to present to the director for consideration.

That was the case with a number of sequences I boarded for *Bram Stoker's Dracula,* on which I functioned as Project Conceptualist. All of them varied considerably from the script (changed on a daily basis) and were created as alternatives for Francis Ford Coppola as he assembled, shaped, deconstructed, and refined the horror classic. Because Francis is so visually literate, there were many times when generating storyboards was unnecessary. When he'd ask for a visual solution to a specific dramatic problem, I'd often just provide a written list that described a series of possibilities.

Dracula began as a kind of experimental film and went through the creative expansion and reduction process that many of Coppola's projects undergo. In addition to developing script variations which explored new and radically different ways to dramatize the horror classic, I produced a gallery of concept illustrations, including the four shown here.

Castle Dracula. One of the concepts under consideration during the preproduction stage moved the action from the Victorian era to the post-Industrial period, a possibility that would have changed the look of the film significantly. To define the change, I painted a Bauhaus version of the castle, a desolate, imposing, brutally stark structure built upon the burned-out ruins of the original Carpathian fortress (destroyed in a previous scene). The image depicts Harker's arrival in a touring car, instead of a traditional horse-drawn carriage, and, similar to the scene in the Stoker book, it is chased by wolves.

Mina's Dream. At a point early in the production, Francis Coppola considered using 3D sequences, an idea that triggered a number of concepts I felt would be worthy of exploring visually. In this scene, Mina is on her way by train to Transylvania to reunite with Dracula. She is accompanied by Van Helsing, who puts her in a hypnotic trance using the crucifix of a rosary upon which to focus her attention. As the dream sequence progresses, parts of the *Orient Express* and its passengers begin a surreal, slow-motion process of disassembly, ultimately stripping away everything but Mina and the universe.

Graveyard Chase. The story of Dracula is riddled with sexual connotations, which Coppola was interested in exploring. In this scene, Mina's friend Lucy has come to her Hillingham estate and, as they watch a gathering storm (symbolic of Dracula's approach aboard a ship), Lucy teases Mina about her fiance. Mina's shyness to discuss her passion makes Lucy bolder. She begins to tickle Mina and the two women chase each other, playing hide-and-seek, screaming through the estate's graveyard, finally wrestling and rolling down a hill like surrogate lovers. Coppola liked the metaphor of the large crucifix separating the women.

Harker Meets Dracula. The two men confront each other for the first time, on the esplanade of the Bauhaus castle, the cool palette expressing the bleak and isolated location of the structure. To maintain the wolf theme that encompasses the entire production, I positioned a series of pedestals on top of which stood decorative, black, cast-steel statues that were heavily entwined with thornbushes. To break with the tradition of Dracula's classic, but predictable, appearance, I dressed him in a white, military-like outfit with a crimson armband, which suggested he was some kind of warrior-statesman.

The Silhouette

The instantly recognizable silhouette was a staple of early animation. One reason that Ub Iwerks, the first animator of Disney's Mickey Mouse cartoons, gave the famous mouse big round ears was so that even in silhouette the audience could identify Mickey. After World War II, Japan's Osamu Tezuka created Astro Boy, a boy robot whose silhouette, like Mickey's, can be recognized by millions. Tezuka's work became the foundation for what is arguably the richest comic and animation culture in the world. Nintendo game master Shigeru Miyamoto, the creator of Mario Brothers, Pikmin, and Zelda, recognized the importance of silhouette character recognition and brought the formula to interactive games.

Silhouettes can be used in a number of ways:

* For dramatic effect.
* To quickly focus the audience's attention on a character, object, or action. Silhouettes are a good way to do this since there are no details to distract the reader from the primary image(s).
* To create mood, such as impending danger, the unknown. (To see the work of a master of the mood-creating silhouette, look back at the Steranko gallery on the preceding pages.)
* To heighten a sense of mystery.
* As a design element.

When considering using silhouettes, keep in mind the following guidelines. And remember, silhouettes become a powerful visual focus wherever they are used, so be sure you *want* your audience to focus on the silhouetted image.

* Many artists recommend first roughing in the entire figure to be silhouetted, so the final image will be totally convincing.
* If you are silhouetting an action, make sure the action is simple. For instance, if the scene is a battle with hundreds of antagonists, just silhouette the two fighters who are important—and make sure the audience can see their outlines and weapons.
* Keep the silhouette clean and the component parts clear. For example, draw the arms out, away from the body, and separate the legs. Don't draw another silhou-

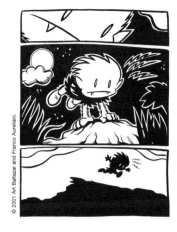

Art Baltazar and Franco Aureliani understood the importance of having Patrick the Wolf Boy recognized by his silhouette.

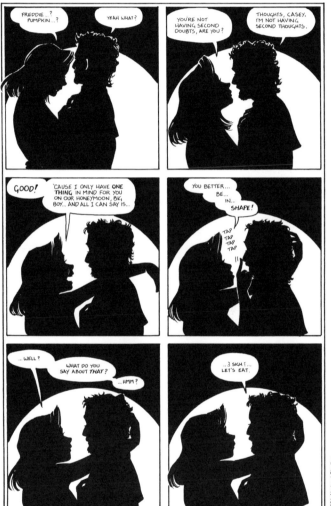

A dynamic silhouette page from Terry Moore's *Strangers in Paradise*.

etted object touching your main silhouette; the resulting outline will be confusing. If a character is supposed to be firing a gun, we have to see the gun clearly.

* Make sure the silhouette is recognizable, for example, by using simple "tags" (Mickey's or Batman's ears or Wolf Boy's spiky hair).

Planes and Light

In reality, the planes of the human body are almost all curved, or rounded, and if you are interested in creating photorealistic art, you'll draw your human figures that way. But according to Andrew Loomis, extreme smoothness or roundness in art results in a "slick" or "photographic" style and should be avoided. Loomis's widely imitated methods for using lighting to draw figures or objects that look three-dimensional involve breaking down the figure or object into plane surfaces rather than rounded curves and then calculating how light from a specific source would affect each plane. Comics artists, in particular, will find Loomis's methods useful in developing a vital individual style.

In Loomis's classic lesson on lighting, he suggested that there are twelve basic ways of lighting a figure or object. He illustrated his text with twelve photographs of a plaster model of a simplified human head and neck (true to his precepts, the form is an angular one) seen in different positions, with the light coming from different sources and directions.

No two artists see planes alike. "Squareness" of rounded forms imparts a certain ruggedness and vitality. A good axiom is "See how square you can make the round. . . . There is no set of planes that will fit a figure at all times, since the surface form changes with movement such as bending at the waist, movement of the shoulders, etc. The planes are given mainly to show how the forms can be simplified. Even when you have the live model . . . you still work for the main planes of light, halftone, and shadow. . . ."

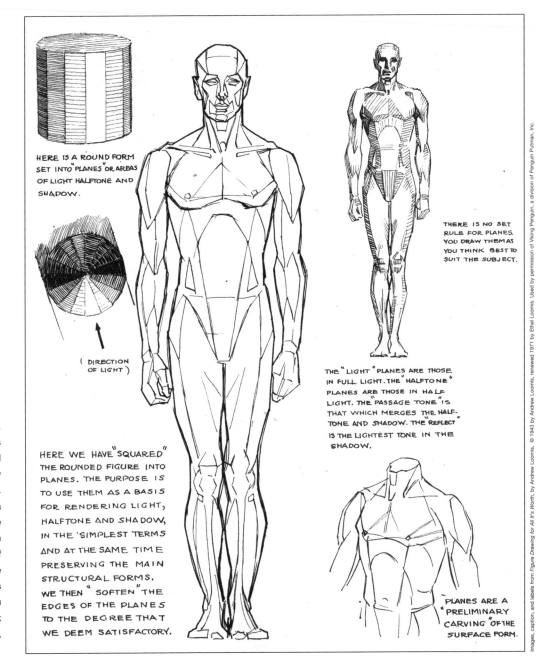

HERE IS A ROUND FORM SET INTO "PLANES" OR AREAS OF LIGHT HALFTONE AND SHADOW.

(DIRECTION OF LIGHT)

HERE WE HAVE "SQUARED" THE ROUNDED FIGURE INTO PLANES. THE PURPOSE IS TO USE THEM AS A BASIS FOR RENDERING LIGHT, HALFTONE AND SHADOW, IN THE SIMPLEST TERMS AND AT THE SAME TIME PRESERVING THE MAIN STRUCTURAL FORMS. WE THEN "SOFTEN" THE EDGES OF THE PLANES TO THE DEGREE THAT WE DEEM SATISFACTORY.

THERE IS NO SET RULE FOR PLANES. YOU DRAW THEM AS YOU THINK BEST TO SUIT THE SUBJECT.

THE "LIGHT" PLANES ARE THOSE IN FULL LIGHT. THE "HALFTONE" PLANES ARE THOSE IN HALF LIGHT. THE "PASSAGE TONE" IS THAT WHICH MERGES THE HALF-TONE AND SHADOW. THE "REFLECT" IS THE LIGHTEST TONE IN THE SHADOW.

PLANES ARE A "PRELIMINARY CARVING" OF THE SURFACE FORM.

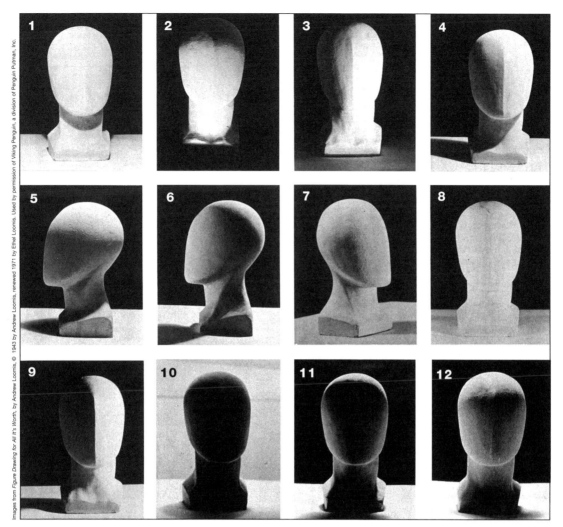

Images from *Figure Drawing for All It's Worth*, by Andrew Loomis. © 1943 by Andrew Loomis, renewed 1971 by Ethel Loomis. Used by permission of Viking Penguin, a division of Penguin Putnam, Inc.

Loomis's lighting options.

1: Flat, one-source lighting. The light is shining right on the center of the front of the head, but the chin still casts a shadow. This type of lighting is good for posters, a decorative effect, or plain simplicity.

2: "Stage" lighting, or light coming from the lower front of the figure. Stage lighting is used for dramatic effect. According to Loomis, it is "weird, ghostly, like the light from a crater."

3: Three-quarters side. The light source is about 45 degrees to the right side of the center of the head. Loomis called this "good lighting"; it certainly adds dimensionality.

4: Three-quarters top side. Loomis considered this combination one of the "best," as it provides an immersive combination of "light, halftone, shadow, and reflection."

5: Top-side. Notice the luminosity of the shadows.

6: Top backlighting with a front reflector. This provides both luminosity of shadows and a strong sense of solidity.

7: Equal lighting from both sides. Also called "crisscross" lighting, this is a poor choice, as it provides only weak shadows and there is little dimensionality.

8: Strong illumination from all sides. This can wash out any form, no matter how solid in reality.

9: Half and half. A light source that illuminates one entire side, so that one side is totally lit and the other in total shadow, is considered less effective than either of the three-quarters choices.

10: Silhouette. Loomis calls this "the reverse of number one, good for posters, design, and flat effects."

11: Fringe. Using a light source from the back, and slightly top, can be very effective for dramatic presentation of a menacing character.

12: Sky. The lighting here is from the top, and the light background provides reflective effects that mimic natural, diffused lighting.

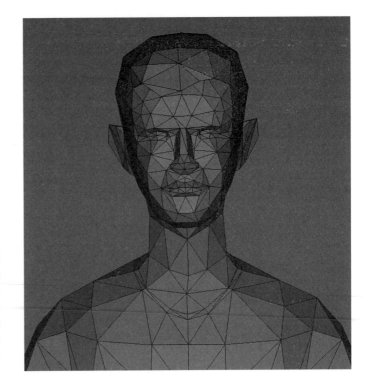

The most dramatic application of Loomis's approach to drawing the human form is in 3D modeling, where the illusion of three dimensions is created by software that first breaks down the object/figure into hundreds of plane surfaces, as shown here.

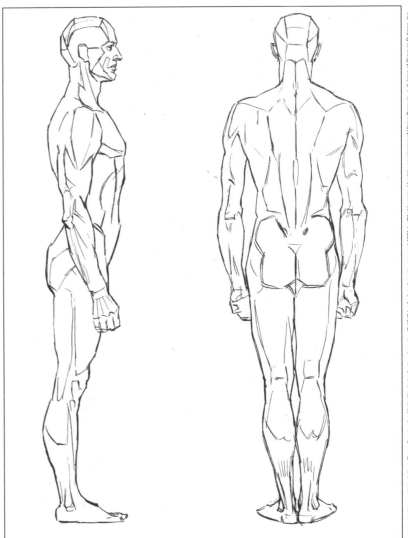

Remember! When working without a model or copy, you draw the planes for the light, halftone and shadow. When working with the model or copy, you draw the planes from the light, halftone and shadow.

Images, caption, and labels from *Figure Drawing for All It's Worth*, by Andrew Loomis, © 1943 by Andrew Loomis, renewed 1971 by Ethel Loomis. Used by permission of Viking Penguin, a division of Penguin Putman, Inc.

Film

Comics

3D

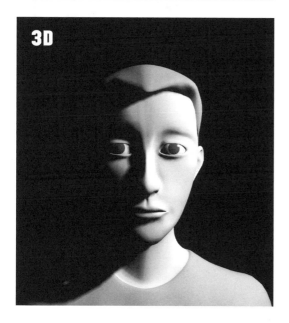 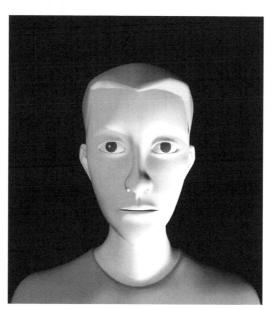

The accompanying illustrations show two of the Loomis lighting choices—three-quarters side and a variation of stage lighting—in film, comics, and 3D rendering. Notice how close the 3D lighting is to the photographic versions. In contrast, the comics artist can bend the "rules" of light, creating effects not possible with real-world lighting.

TIMING AND PACE

> **"The reason for time is so everything doesn't happen at once."**
> **—Albert Einstein**

Every visual storyteller owns a time machine, which controls—to a lesser or greater extent—how the filmgoer, comics reader, or game player perceives the passage of time in a given story. The level of control over pace and timing depends on the medium. Whatever the medium, all visual storytellers use timing and pace to create the desired immersive effect: a quickened pulse rate, a deeper involvement in the drama, visceral dread, even the laughter on hearing or viewing the punch line in a comedy sequence. And, as with any other visual storytelling tool, creative approaches to timing and pace may help move a story along according to the intentions of the filmmaker/artist/game designer, but in the end it's the story, and how the audience experiences the story, that will keep them coming back.

If I'm having somebody spin around in a fight, I'll try to find that precise moment [of] the most extreme turn—with their hair flying—and then find a close-up with that same energy and that same angle, and that same frame where their hair is at that same kind of extreme point of motion. That's where I make my cut. When you do that it creates a very specific kind of energy to a fight scene, but the timing is crucial. . . . I'm definitely influenced by my comic book background in terms of the storytelling and some visuals. —Kevin Van Hook, Filmmaker, special effects artist

Who Runs the Time Machine?

In film, a totally linear medium, the filmmakers (director, director/writer, director/writer/film editor, etc.) have absolute control over pace, dictating how long a viewer gets to see any object, character, or sequence of actions (like how long it takes a character to hit the ground after jumping off a building), and they assume that the sophistication of their intended audience is at a level where they will be able to follow the story. Similarly, the pace of cut scenes in interactive games is totally controlled by the game designers. And, although different game players will take different paths through the interactive sequences, game designers do use certain devices that will slow down or speed up a player. In the *Tomb Raider* games, while the player is guiding Lara Croft through a treacherous cavern, she may suddenly decide to look high up at the side of a cliff (instead of where she's walking), then, just as abruptly, return her gaze forward. The switch is a visual hint—provided by the storyteller—that Laura should slow down and look around.

Comics are very different from films and cut scenes in that the reader ultimately determines the pace. One reader may skim the story first, getting a sneak preview or movie trailer effect; another will start from the beginning, reading and taking in each panel and page deliberately, in sequence; another may take a quick look at the ending first. Readers can flip pages rapidly, turn them slowly (building a sort of "personal" suspense), or even skip a page or pages completely. This doesn't mean that the creators of comics have *no* control over timing: page and panel design can and do provide a path or guide for how the visual storyteller wants the reader to experience the story. One way to slow the reader down is to fill both page and panels with a multitude of detail and/or dialogue. Another, as the two versions of the street scene shown on the next page illustrate, is to break down a scene into multiple smaller panels: the gutters slow the reader down. In general, things that are supposed to be happening quickly should occupy as little panel/page space as possible; events that are supposed to be happening over a long period of time, as much space as possible.

Vertical panels tend to move the pace faster, while horizontal panels slow things down. And, given two horizontal panels of unequal size and content, a larger panel with a lot of detail will take longer to read than a smaller panel, with less detail.

Style in Motion

Just as artists have different styles, so too do film directors, and that includes their approach to timing and pace. John Woo, director of *Face-Off, Mission Impossible II,* and *Broken Arrow,* for example, is known for his fast pacing and his balletic, seamlessly choreographed action sequences. Tom Cruise, star of *Mission Impossible II,* called the phenomenon "we got the Woo." Other directors, even when filming action scenes (Robert Redford and Clint Eastwood come to mind), let the stories unfold with a more deliberate pace.

Slow Motion

Many directors and cinematographers effectively use slow motion to represent high speed. The reason is simple: the audience needs to follow action that would, in real time, be taking place so rapidly that viewers wouldn't have time to see the details. A notable recent example is Bullet Time technology, which was used for four scenes in the Wachowski brothers' groundbreaking film *The Matrix.* (The Bullet Time sequences, so named because in them the characters are seen to be dodging bullets while circling in midair, required the use of 120 still cameras arranged in a circle around the live actors, two motion picture cameras,

high speed and slow motion techniques, and jump cuts.)

Like the Wachowski brothers, John Woo uses slow motion so that the audience can see every detail of events that are taking place at high speeds. He also uses slow motion to let the audience know that something important is going on. For example, the scene in which the John Travolta character joins his team of evildoers from beyond a hilltop in the film *Broken Arrow* is shot in slow motion, which gives filmgoers more time to absorb the impact of what is happening. The dramatic slow motion spin-out in *Mission Impossible II* gives the viewer enough time to see the dawning fear on Nyah Hall's face (played by Thandie Newton). In another scene from the same film, when Ethan Hunt (Tom Cruise) and Hall meet for the first time, slow motion gives the audience a sense of how the characters are feeling as the world around them seems to slow down and fade away for a few moments.

Jump Cuts

A *jump cut* is an abrupt transition between two scenes in a film or cut scene—or two panels in comics—that is used for building suspense or simply for shock value. In films, a fluid, linear medium, jump cuts force the viewer to sit up and take notice. A given director may be known for his or her use of jump cuts (Baz Luhrman) or may not use them at

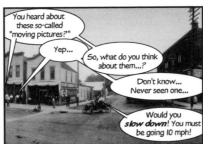
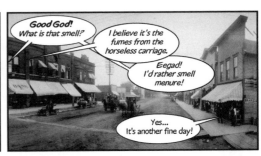

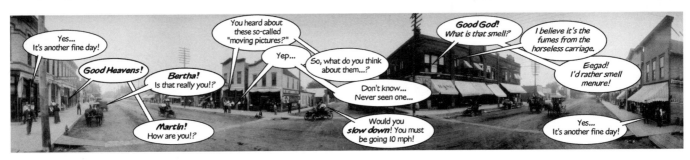

It would take most readers longer to take in the three-panel scene here than it would the single-panel version.

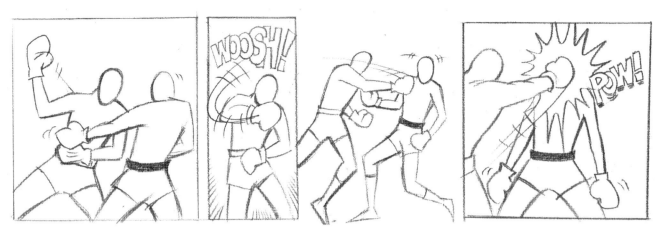

Top: A knockout punch in four panels—the comics version of slow motion. Middle: A two-panel version of the same action. Bottom: A single action-reaction panel showing the punch. Although there might be times when an artist would want to use multiple panels to show action and reaction, in general, the single-panel approach is most effective. There are other ways to slow the reader's pace without sacrificing energy: the panel could be made large, and include images of the crowd through the ropes behind the fighters, even word balloons.

all (Richard Brooks). Most directors use jump cuts selectively. When Robert Rodriguez works on a film, he prefers working at a manic pace because he believes that the "visceral, hyperkinetic energy transfers to the screen." Not surprisingly, he uses jump cuts extensively. Rodriguez's cuts, however, are not usually dramatically different in angle, and he normally doesn't use them one right after another, but intersperses them for more variety.

In Alfred Hitchcock's film *The Birds,* there's a jump cut to a corpse with its eyes gouged out. For a few seconds, the viewer's point of view is the same as that of the characters who found the body, and the close-up of the mutilated face causes the audience to react in visceral horror.

There are several distinct types of jump cut:

* Cutting out of the continuous action, so a character seems to jump between two places
* Switching between two actions
* Cutting between two different times or places, but using the same angle and light
* Suddenly changing the camera angle, so a character or object is seen from a totally different point of view
* Cutting from a long shot to a close-up, without a zoom
* Jumping from one view to another, then returning to the original view, which now has another character or element in it (e.g., the shower scene in *Psycho*)

Obviously, just as there is no real slow motion in comics, there are no exact analogues to the jump cuts created by a filmmaker. In a sense, the comics reader "jumps"

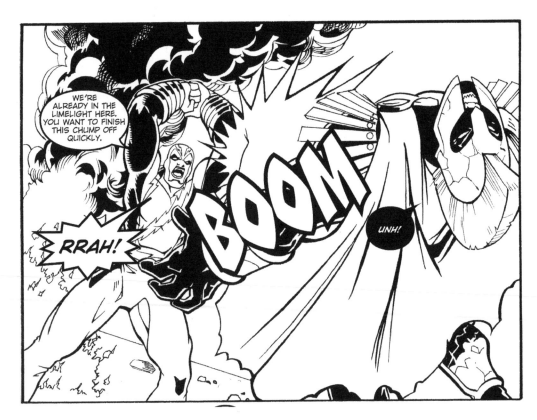

A perfect action-reaction panel: The pace is meant to be fast, and the reader's eye takes in everything quickly.

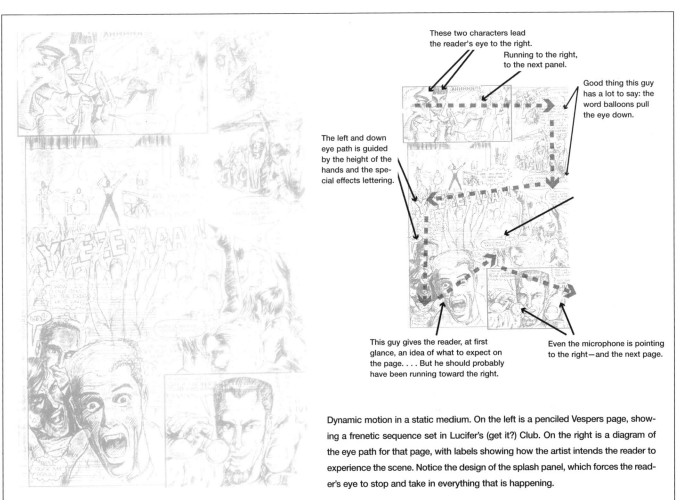

These two characters lead the reader's eye to the right.

Running to the right, to the next panel.

Good thing this guy has a lot to say: the word balloons pull the eye down.

The left and down eye path is guided by the height of the hands and the special effects lettering.

This guy gives the reader, at first glance, an idea of what to expect on the page. . . . But he should probably have been running toward the right.

Even the microphone is pointing to the right—and the next page.

Dynamic motion in a static medium. On the left is a penciled Vespers page, showing a frenetic sequence set in Lucifer's (get it?) Club. On the right is a diagram of the eye path for that page, with labels showing how the artist intends the reader to experience the scene. Notice the design of the splash panel, which forces the reader's eye to stop and take in everything that is happening.

from the empty gutter (or some type of space) between every panel and the next, but the real-time speed at which any given reader jumps depends on the reader. There's no way for the comics artist (director) to *force* a particular pace on the reader. On a panel-to-panel basis, timing has a lot more to do with layout and design, what's involved in the scene, how it's drawn, the line style, and even the panel border style. Thus, a comics artist can, by deliberate design of panel and page content, use that medium's versions of quick cuts to create a hyperkinetic, energetic experience. For example, the artist may draw a few panels featuring two characters talking, or engaged in some action, then abruptly switch to a close-up. Or, an artist might use six panels to get a character across a room and only three panels to get the character to the other side of the universe.

Although this page can be "read" in a few seconds, the artist has signaled to the reader—by going from daylight to starry night sky and back to daylight—that Jimmy Dydo, a character from *Patrick the Wolf Boy,* has been sitting in the same place for at least 8 hours.

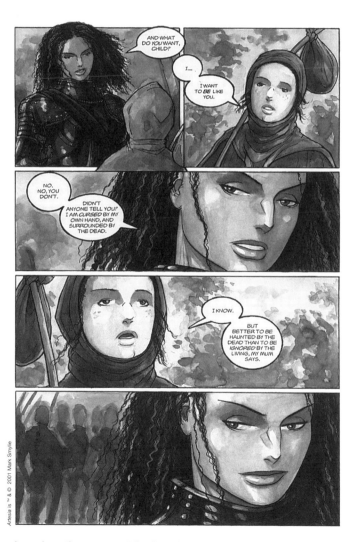

In comics, artists can use a "silent" panel within a series of dialogue-filled panels to provide a dramatic pause, a beat between scenes or dialogue, or even a metaphorical "fade-in" or "fade-out."

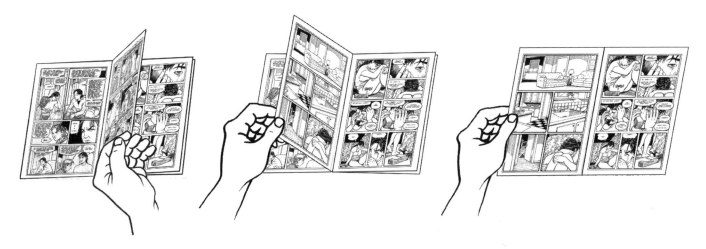

Terry Moore, the creator of Strangers in Paradise, says that although he usually designs from a script, when he created the four pages shown here, he worked more from the hip. "This sequence came to me while I was designing it—laying it out. I just closed my eyes and pictured the characters arguing, as if I was drawing a movie." The first of the two spreads shows a fierce argument. The characters and their angry words are the focus. Then the reader turns the page—there is a transition, a fade-out, fade-in—and is struck by the stark contrast between the busy scene on the previous pages and the now-silent apartment. Moore's "camera" slowly pans around the empty spaces, until we see a lone figure in the crack of the door. On the final page, he uses close-ups and extreme close-ups to achieve the desired aftermath effects.

Timing in Interactive Games

In certain interactive games, the designers program in a sort of timing device, which involves forcing a player who is fighting an enemy to stop and "recharge" energy before inflicting another blow. This not only slows the action down, but generates excitement by creating anxiety: the creature you are battling may blast you to death unless you know where and how to move. The player has control of the fight, but it is how the player as coauthor times the action and reaction that determines whether the story will move along or he or she will die. After the battle ends, the view returns to the traditional interactive scene, or moves straight into a cut scene explaining what this battle may or may not mean to the story unfolding. Another way to pace interactive game play is to create visual hints that the player should stop and have a closer look around: the hints can be as subtle as sparkles or a brighter color, or as obvious as a character entering the scene through some secret passageway. And, of course, when a player doesn't have something needed to advance the action, for example, the key to a door that must be opened before the player can get to the next level, the player is forced to go look for the needed object.

Anticipation

Jeff Smith, co-founder of the Character Builders animation studio and creator of the critically acclaimed comic series *BONE,* likes to use a timing effect that he calls "anticipation." "Say Bugs Bunny is about to hit a bull on the head with a big wooden mallet. He takes out the hammer and holds it in the air for just a second, and then hits the bull in the head. That mallet poised above him for that moment is just as important as the actual hit, because that's what alerts the audience to anticipate the hit. They know it's going to happen." Using the anticipation-hit sequence, rather than off-camera hit or single panel showing mallet *and* hit draws the readers in, makes them participants. At the same time, it slows the pace a bit. Says Smith, "Same thing happens in any visual storytelling, the setup is just as important as the event. So, whether telling a joke or setting up an action, or anything; make sure the audience is with you and anticipating what's going to happen. You don't always have to deliver the mallet hit you promise (in fact,

In film, you can build anticipation with a series of jump cuts; letting the audience know what may be coming, while the characters themselves are in the dark. These frames build to an embarrassing scene where Rachel searches for Nick (her boyfriend) in his apartment, only to find him playing superhero. In comics, this could be done in a single panel with Nick in the foreground and Rachel walking through a doorway in the background.

sometimes it's funnier if you don't), but by letting them anticipate the outcome, you're somewhat controlling the pace to amplify an end result. That's really, really important." The sequence of panels on the opening page of this chapter is a fine example of anticipation/build-up and payoff/climax—but to see the payoff, the reader has to turn the page.

Dynamic Timing in a Static Medium

Jeff Smith says that what he calls "extremes" are very important in film, animation, and comics. "In animation, the extremes exist even within a single motion," Jeff explains. "There are key moments or poses that you draw, and then an assistant will fill in two to four drawings between those extremes to complete the action." The same principle holds for live-action film, only in that medium the storyboard will lay out the extremes and during the actual filming, whether with motion picture or video or digital camera, the "blanks" are filled in. And, of course, in film, after the editing process, what the audience sees can be very different from the footage that was originally shot. In comics, the "extremes" become the final deliverable images on the page.

In comics, the fact that each panel can have its own time becomes crucial. In film, what is happening in one series of frames can only be experienced by the viewer in the time it takes for the sequence to unfold from start to finish. In addition, rarely will the viewer see an action and reaction at the same time. The viewer will see a monster *or* an extreme close-up of a woman screaming at an off-camera menace, not both at once. In comics, as we have said, action and reaction can be shown simultaneously, as shown in the illustration on page 136. Another possibility is to draw an important action/event in the upper left-hand corner of a panel—an explosion, a monster—then, in the lower right-hand part of

the panel, a close-up of a character's reaction. Although both of these elements are confined to the same panel, the action and reaction are temporally separated as the reader's eye follows the eye path from top left to the bottom right. This kind of "slow-down," the length of which depends on the individual reader, is possible because it takes time for the reader to move from the upper left to the lower right and absorb the content and context of the image. The reader contributes the movement, and the anxiety. Once the reader moves on to the next panel (and the timing of this is also ultimately controlled by the individual), which may have the monster swooping down on the character, that moment of anxiety and menace is gone. In contrast, in film, the viewer has no control over timing. In *North by Northwest,* when the airplane is chasing Cary Grant, there is a scene where you can see the plane behind him as he runs towards the viewer. But it all happens in a matter of seconds (there is no way for the viewer to slow it down), and then the scene changes angles, directions, etc. A single comics panel can achieve what it takes multiple frames to achieve in a film.

It is best to arrange all elements and objects in each panel so that the reader's eye will exit in the direction of the next panel. Structuring a path of least resistance will offer the reader at least a clear subliminal path to follow. To slow the reader down, add more objects in the path, but avoid blocking it completely, without a good reason (such as a close-up of a character jumping into the middle of the scene with some news).

Creating a subliminal path through the objects of each panel is often easier to talk about (or to write about!) than to draw, as the comics artist has to maintain the established action-flow direction and at the same time keep the overall effect dynamic. For an excellent account of how one of the best in the business—Jim Steranko—approachs the design of a page, see "The Ideal Page," page 184.

A sequence from Jeff Smith's *BONE* showing a not-so-subliminal path from panel one through panel three!

23

TRICKS OF THE TRADE

Although many of the "tricks" covered in this chapter were born on comics artists' drawing boards, some of them can and have been translated into film, animation, and interactive games. Increasingly, success in all visual storytelling media depends on artists' rendered creations. Even techniques which might seem exclusively comics-related—foreshortening, for example—can be used in the design or storyboard stage. Consider the purpose of drawing initial concept sketches, character designs, and storyboards: they are used to convey a story through imagery, to communicate ideas and thoughts about how an artist perceives a character, scene, set, or environment. They may not be the final product, but they are crucially important in developing that product.

The panels in a comic book are used as a passage of time for the characters within the story. How the characters think and react is what most of our planning is about. Even the smallest of nuances can give the characters personality.

—Franco Aureliani and Art Baltazar, Creators of *Patrick the Wolf Boy*

Xtreme Techniques

Almost any tool used by a visual storyteller can be exaggerated. How much to exaggerate, and when, depends on the effect the filmmaker/artist/game designer wants to achieve. Always, of course, there should be a clear motivation for using any extreme technique.

Foreshortening

Foreshortening is one of the important tools used by comics artists to create a dynamic illusion of three dimensions—to make it seem as though an object or character is actually jumping out of the panel or page. And there are no physical limits on where the artist can place the "camera," as there are in filmmaking and 3D modeling.

The artwork on the opening page of this chapter is a Neal Adams page from the premiere issue of NOW Comics' *The Twilght Zone* (1990), adapting Harlan Ellison's story "Crazy as a Soup Sandwich." It is a quintessential comics page. The design, the facial expressions, the use of line, and the brilliant use of foreshortening all work together to make the page unrepeatable in any other visual storytelling medium. The dynamic effects achieved by Neal Adams go well beyond his artistic talents. Every penciled or inked line—even word balloon placement—is an expression of Adams's personality and energy.

Forced Perspective

With forced perspective, the perspective, whether from a very high or very low point of view, is exaggerated beyond the scope of possibility if the object or characters were being viewed by a real observer (or real camera) in the real world. As with foreshortening, comics artists can take forced perspective to fantastic extremes.

Exaggeration of Physique

Chapter 5, The Drawing Board, discusses the use of heroic representation as a standard of proportion for characters in comics. But exaggeration of a character's height and musculature need not follow textbook guidelines for drawing superheros, nor need it be confined to the character or object as a whole. In comics, exaggeration is also regularly used in drawing typical poses of larger-than-life characters. The stance of a typical superhero is deliberately imposing: the feet are often wide apart and the chest is thrust forward, imparting a look of self-assured determination and power.

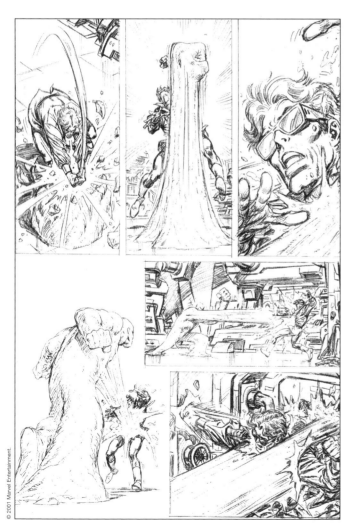

Exaggeration the Marvel Comics way.

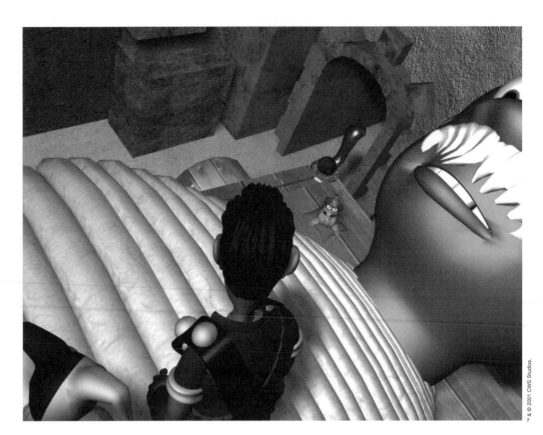

An "impossible" camera angle from *Operation Extermination,* where Vinny Mazola, after being shrunk down to insect size, peers down from the chest of Uncle Guy, a captive of General Ant.

Here we have both foreshortening and a different kind of exaggeration. The "big guns" style was first made popular in the 1960s by Jim Steranko, with Marvel's Nick Fury: Agent of *S.H.I.E.L.D.*

Specialty Line Work

Comics artists and the creators of 2D interactive games have to rely on the creative use of lines and shading to render certain effects that are achieved by FX and lighting technicians, and CGI, for films and 3D interactive games. If any of the effects shown in the accompanying illustrations are overused, or used for no particular purpose, the reader will be distracted from the story. Keep in mind that these are enhancements, not replacements for action.

Aura, Impact, and Explosion

Visual storytellers can use lines or glowing areas of light and/or color radiating out from characters or objects to convey important information, for example, that a character has achieved a certain status (2D interactive games) or is wielding magical power, or that a character is feeling some sort of extreme emotion, such as total surprise. They may also simply indicate that an object or character is radiating energy, or a force field. Impact lines, which can be drawn in a number of ways, are used to render collisions and explosions.

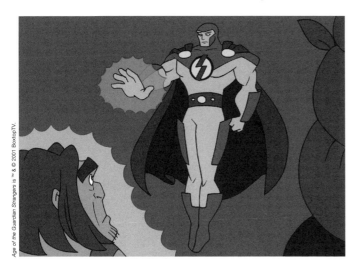

The glow of power.

Here's a comics page with a multitude of specialty line and aura effects.

In these panels, the radiating lines emphasize both the force of the zombies' attack on the masked hero and the power of the punch that knocks them off.

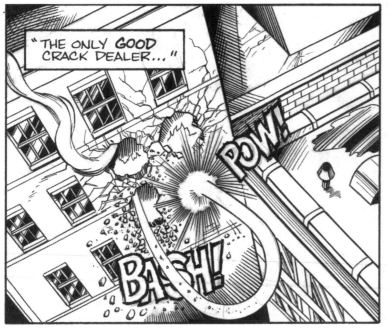

A classic approach to impact/explosion lines: The lines are different lengths, and the point of impact is treated as a single source of light, obliterating the line segments closest to the source.

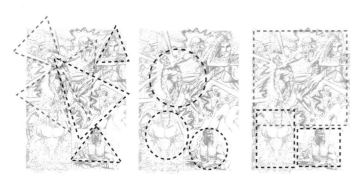

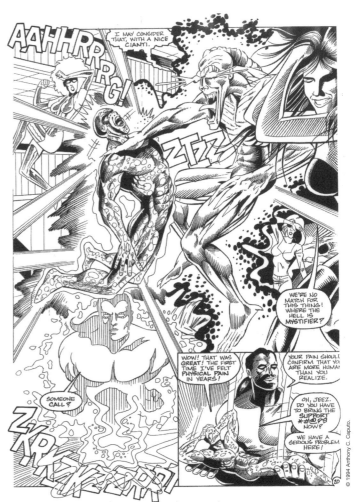

The wavy pattern around the giant creature in this panel, which consists of crisply laid-out particles of energy that radiate out from the character, is called the "Kirby Krackle," after its creator, legendary artist Jack Kirby, who introduced this unique effect around 1968. [Word has it that Kirby was inspired by the discovery of the first quasar in 1963 (Quasar 3C273), by Maarten Schmidt.] The Kirby Krackle is much imitated by artists (including me) because it provides a dramatic effect way out of proportion to the skill needed to draw and ink it.

Notice that although this is very much a nontraditional design, basic shapes—circle, square, triangle, etc.— have been used to help build figures, sets, and objects. Take a close look at the design here.

Most of the triangular elements draw attention to the character screaming. Circles are always a great way of grabbing a reader or viewer's attention, kind of like a bull's-eye on a complex comics page, and sure enough the largest of the circular components here "contains" the most important action on the page. On the right are traced some of the rectangular elements, which stand in for panel borders (the only "real" borders are at the bottom right) and which are designed to move the reader clearly through the action.

Speed Lines

Using speed lines to suggest rapid movement is a classic comics (and 2D game) technique that's also widely used in Japanese animation (anime). (Yet another example of cross-pollination: effects which were created as a way to simulate movement on static paper found their way into an active medium.) Of course, if a character or object that is supposed to be moving hasn't been drawn convincingly, the addition of speed lines will not serve the intended purpose. Western comic artists typically use speed lines to signify rapid motion, and they are sometimes drawn in roughly, or with sweeping brushstrokes. In contrast, speed lines in the manga style, and in anime, are strictly ruled and often fill the panel from border to border.

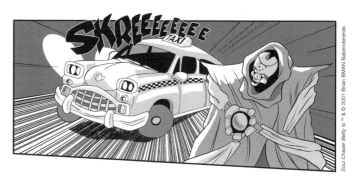

The classic manga-style speed lines shown here convey the movement of the car toward the camera, almost as if the road itself was moving

In this illustration, the foreground image represents the tails of a demon, who is hurtling forward. The same effect could be used in animation: as the demon picks up momentum, the background might blur into speed lines.

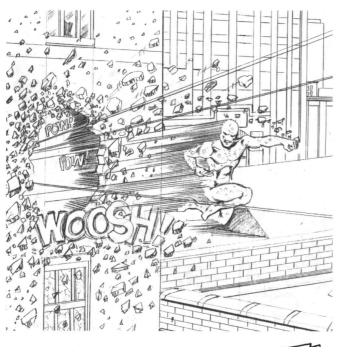

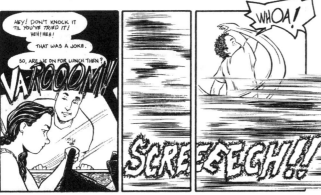

Some Western-style speed lines.

Comics drawn in the manga style have long used speed lines not only to signal rapid horizontal or vertical motion, but to create a sense of anxiety or shock. The "speed" lines here are really "drama lines": perhaps a horrible creature is slithering toward this character.

Miscellaneous Effects

Multiple Images and Morphing

The use of multiple images can provide an illusion of movement or speed in a static medium. The first use of multiple images in comics was by Carmine Infantino in the comic book *The Flash,* in 1956. Said J. David Spurlock, coauthor of the *Amazing World of Carmine Infantino,* "Carmine Infantino's historic 'How I Draw the Flash' includes an absolute, classic example of the artist's innovation in illustrating movement. This technique is more work for the artist, but Carmine felt he needed to develop a new approach to set his co-creation apart from the Golden Age character of the same name, and from the traditional comic's motion lines."

A pencil sketch showing the basic technique used by Carmine Infantino for Flash.

Morphing effects in film, which have come a long way since the 1932 film *Dr. Jekyll and Mr. Hyde,* cannot really be duplicated in comics, but talented artists can draw dramatically effective transformations—and the style doesn't matter.

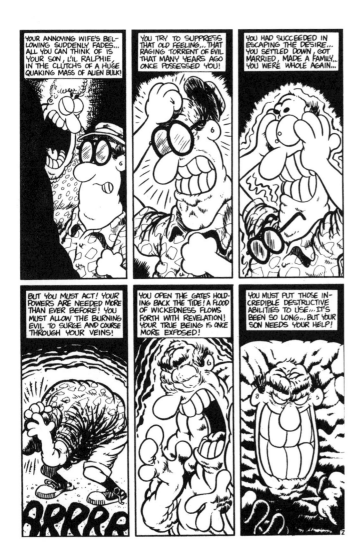

Marc Hansen's contribution to the library of transformation effects in comics.

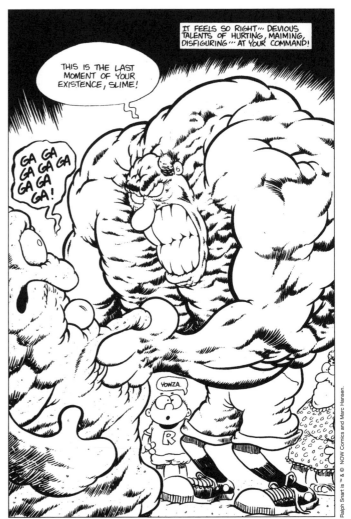

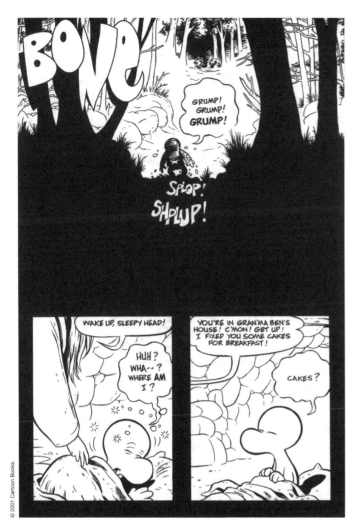

This highly effective use of framing is from comics, but using objects within the environment to frame a scene for effect is not exclusive to any one visual medium.

Framing

Using one or more of the objects or characters within a panel as a frame can be an effective way to draw the reader's eye to what is most important. There is an almost endless list of things that can be used for within-panel framing: trees, bridges, windows, characters, etc. Using heavy shadows or a different rendering technique can do a lot to emphasize what's being framed.

Tilt

In comics, *tilt* refers to an effect in which either the panel itself is tilted or the panel's horizon line is on a diagonal, so that everying in the room is tilted. In film, only the second kind of tilt is possible. A classic example of cinematic tilt is provided by the original *Batman* television series, where every scene in the villain's hideout was crooked. Tilted panels in comics should be used sparingly, as they lose their effectiveness if overdone.

To give the reader a better feeling of the shaking ground in the story, the middle panel was ripped out of its traditional place, and tilted on an angle. Double lines, signifying shaky movement, were added at the top and sides of the panel.

Some Effects to Avoid

- Here are a few cardinal don'ts of panel design.

 * If you are including only part of a figure in a panel (close-ups and medium shots), don't cut off, or crop, the figure at a major joint: neck, waist, elbow, wrist, knee, or ankle. Cutting off a figure off at the neck, for example, will make it look as if the figure has lost its head. This rule also applies to film, animation, and interactive games.

 * Don't crop anything out that the reader needs to see to understand exactly what action is taking place.

 * Don't crop anything out just because you don't feel like drawing it.

 * When drawing two characters or objects that are close to one another, don't draw them with merely their outlines touching. Have them overlap or separate them completely, making sure there is no ambiguity about their position and depth.

 * Don't draw a character whose outside contour (shoulder, hand, or foot) is touching a panel border. Butting a character's arm up against a panel border, for example, will make it look as though the character is leaning on the frame.

Is this a careless violation of the rule that says don't crop at a major joint, or did the artist just run out of room and drop that head in at the last minute? Whatever the reason, the result is that it looks like the woman in the striped shirt is holding up Mike's head. ("Ah, young Mike—I knew him well!")

Left: The man here is supposed to be behind the woman, but because only their outlines touch, they look back to back. Middle: There are a couple of no-no's here. The man at the left seems to be standing on the bottom panel border, leaning on the left panel border, and welded to the computer monitor. The poor choice of cropping of the figure in the foreground has what may be his arm coming up from his side, but one can't be sure. The last panel shows the right way to do it. Foreground figure overlaps middle-ground figure, which overlaps the desk with the computer: the illusion of depth is good, and there are no distractions due to poor placement or cropping.

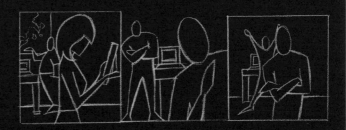

Wally Wood: The Master of the Dynamic Panel

Wallace (Wally) Wood (1927–1981) was one of the pioneers of visual storytelling for comics. He worked on EC Comics in the 1950s, recreated Daredevil for Marvel Comics, and was one of *MAD Magazine*'s first star artists. In the 1970s, Wood drew a series of panels that he entitled "22 Panels That Always Work: Or some interesting ways to get some variety into those boring panels where some dumb writer has a bunch of lame characters sitting around and talking for page after page." Shown here are Wood's original "22" plus a few larger panels showing how some of the principles might work alone or in combination.

WALLY WOOD'S 22 PANELS THAT ALWAYS WORK!!

OR SOME INTERESTING WAYS TO GET SOME VARIETY INTO THOSE BORING PANELS WHERE SOME DUMB WRITER HAS A BUNCH OF LAME CHARACTERS SITTING AROUND AND TALKING FOR PAGE AFTER PAGE!

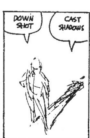
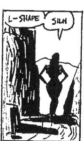
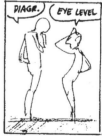

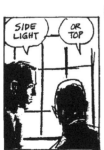

Three-stage plus depth plus L shape.

Big head plus down-shot with cast shadow.

L shape, silhouette.

Left: Extreme close-up.
Right: Full figure, open panel.

Complete object—full figure combo.

Reverse silhouette (meaning the background is black) with open panel bottom.

AN EYE FOR AN EYE

Visual storytellers must, through a combination of imagery and words and/or sound effects, convey to the audience what the novelist conveys only with words. Although words are still part of a visually told story, they are not the primary way that filmgoers, comics readers, or game players are drawn into that story. An effective visual story will give to the audience *all the information it is possible to show visually.* This chapter offers guidelines for choosing the optimal word-picture mix. It also covers some basics of panel and page design, and working from a script.

Comics share two fundamental aspects with film: mise-en-scene (the placement and arrangement of figures, shapes, space, and light within the frame itself) and montage (the cut from one view or shot to the next).

—Mark Smylie

Words with Pictures

There are at least five possible formulas for handling the word-image mix in any visual medium (the first four of these were identified by Scott McCloud in his book *Understanding Comics*):

* *Word- or script-specific,* where the art is there primarily to illustrate an already descriptive text, and is not meant to add to the information provided by the text.

* *Art-focused,* where the words—if any—act as little more than a soundtrack for the pictures of a visually told sequence. The splash panel on page 156—like most splash panels—is most definitely art-focused. The absence of borders accentuates the action: the character is smashing not only through walls, but right through the panel.

* *Dual-focused,* where the words and the pictures are conveying the same message.

* *Parallel,* where the words and pictures have little to do with one another.

* *Interdependent,* where the words and pictures work together to convey a thought, emotion, or idea that neither could have expressed alone.

In general, the best visual storytelling is either art-focused or interdependent. Note that in a story in which the imagery and words are interdependent, the combination is rarely consistently balanced. Films that include a lot of well-crafted dialogue or voiceovers will almost always have sequences without dialogue but with a soundtrack, and may

A "parallel" page. One of the characters is writing in a diary about another character, who is in the park doing something completely unrelated to the words being written.

also have sequences without dialogue *or* soundtrack. In comics, any given panel may rely more on words than pictures, or vice versa, to get the point across.

John Byrne was once on a comic art panel discussion with Will Eisner, during which a member of the audience asked about the right balance between words and pictures. Byrne explained that words are used to communicate something essential to the path of the story that would be impossible to do with imagery. For example, he said, it's impossible to illustrate 4:30 p.m. exactly. Pausing for a moment, Byrne glanced at fellow panelist Eisner. Returning his gaze to the audience, he said, "Well . . . I'm sure Will Eisner could figure out how to draw 4:30 p.m."

Ultimately, no matter what the medium, the most effective visually told stories are those in which all members of a team (see Chapter 3, Behind the Scenes) work closely together to push the art form to its limits.

The typical role-playing game interface mixes words and pictures, both static and dynamic, with dialogue being both text and voice.

No words are necessary in this three-page sequence from Terry Moore's *Strangers in Paradise*. Moore has also used black borders to add to the dark mood. In the last panel the camera pulls back from a close-up to a long shot, showing the symbolic emptiness of the room.

Right: In this page from *Strangers in Paradise* the art and words are completely interdependent: the drawings of the characters, the needle-like rain, the jagged word balloons, even the type work together to create a sense of murderous acts and dangerous emotions.

Below: These two pages seamlessly glide from interdependent to art-focused and back to interdependent. The solid black shapes, tilted and behind the panels, add to the sense of impending doom and chaos

Designing from a Script

The first and most important question for the people who are starting to work on the visuals for a script to ask is, What is the purpose/theme/concept of the story as a whole? What is the writer's motivation? Point of view? At each step of development, and for each frame or sequence, the question can be repeated. What is the purpose of this scene? What information does this panel need to convey? The piece of information that is most important for the audience to grasp will generally become the focal point of the scene or panel. Any vague plot points or descriptions should be clarified by questioning a writer directly; a thorough understanding of the writers's intentions for each scene helps the artist to effectively capture the overall vision and to separate definite visual instructions from "background" information.

When working from a plot, rather than a written script, the artist has the freedom to decide the pacing of the story, what gets emphasized visually, and what actions are combined in the scenes. (This is the way it works at Marvel Comics, for example). But even when the artist has such freedom, he or she should read the story several times and then use a highlighting pen to mark all visuals there. Doing so will allow the artist to make a rough estimate of whether or not the essential visuals will "fit" within time or page constraints. If they won't, the artist can either revisit the plot to identify less critical sequences and cut the number of visuals that need to accompany those sequences or go back to the writer, editor, producer, or director and be prepared to explain the problem and brainstorm possible solutions. Artists should never take it upon themselves to add or subtract scenes from a plot without consulting the appropriate person first.

Once the basic art and plot paramaters have been established, the next step is to do a layout rough, panel by panel, frame to frame, or scene to scene. Some artists do this on artboards while others first work out the story with thumbnails (small layouts). Artists working from the original art can make notes in the margins explaining how the proposed imagery "works" with the plot. Some artists have the clout to make dialogue suggestions at this point. Any notes on artboards or thumbnails must be clear; use dark pencil so the notes will photocopy but can still be erased later.

In film, the director and camera operator will design a shot, and everything can be rearranged right up until they press the button to record. Likewise, in animation and interactive games, a lot of fine-tuning can take place after the characters are rendered and the scene is composed. In comics, once the artist sits down to draw the finished artwork, there is always the chance that the rough shapes and figures on the layout won't work. Maybe the finished scene doesn't have enough room for word balloons, or something needs to be added or subtracted on a page or panel that throws the entire composition off. Artists who don't produce detailed layouts and project them onto a full-size artboard (as Neal Adams has been known to do) must be supersensitive to imperfections in the layouts—misalignments, say, or violation of the guidelines given in Chapter 9 for clearly delineating foreground, middle ground, and background—that will undermine action flow.

Once the entire story has been roughed out, the artist can then look it over and start playing with things like timing, layout, and design effects. It is at this stage that the artist can make sure that any "dry spells" (common if a writer has sub-par visualization capabilities) have been spruced up. One standard formula for a sequence of shots is (1) establishing shot (2) zoom in to a close-up, and (3) pull back to a medium or long shot. However, any artist who uses this or any other formula blindly will just churn out cookie-cutter scenes. Shown on the facing page is a progression from rough layout to finished page. Notice that all the elements seen in the finished page were conceptualized at the layout stage, so no radical surgery had to be done at any time. I knew that one of the most important panels on the page would be the one showing Mark the club owner (first seen, in human form, at the right of the top panel) after his transformation, and had already decided to break panel borders to help get the effect I wanted. I sketched all of the panel breaks in the layout—Mark's shoulder, the flipped cigarette in panel four that leads to the right and then downward to Mark as Monster, the claw and the monster's spine in panel five.

Rough layout.

Detailed pencilling.

Finished page.

Adding Details:
Developing Characters and Sets

The input of the comics or interactive game artist or film-maker into character and set development will vary depending on what he or she has to work with. Some scripts will include detailed descriptions not only of the action, but of just how each character should look, and what objects should be included as props or background. Comics artists, animators, and interactive game artists may even be provided with "model sheets" for all of a story's characters, prop lists, and environment lists.

In comics, as in movies, the characters shouldn't be perceived by the audience as "acting," but, rather, *reacting* to situations and events that have been made real to the audience. It's easy to animate figures, but not so easy to get them to appear involved. Dialogue scenes work when the characters are playing off one another's lines—when they listen and react appropriately. Gestures and facial expressions function as "cues" for the reader and help make the scene work. The trick here is to get the pictures to carry the dialogue, and not vice versa. Each scene will have its own unique set of requirements. It's the artist's job to work out the logistics, to decide who does what, what goes where, etc.

In films, the actors and director work together on characterization—the nitty-gritty details, the consistency, that make a character come alive. In comics, it's the artist's job to make sure that the characters themselves are real. "Okay, here's the script and this guy's an ice cream vendor," says animator and cartoonist Bob Staake. "I mean at that point, I do what I see as an ice cream vendor. That'll include my understanding or interpretation of how he or she needs to be drawn, with the understanding of what the parameters are, the political implications, the style and personality, through the visual image. Cartoonists are not taught to understand that this choice as opposed to that choice is making a statement. That design, in a sense, becomes writing."

Most of the time, says Staake, he isn't given a script and that's the way he likes it. "A lot of the guys at Cartoon Network, they understand the importance of cartoonist driven writing, of cartoonist driven storytelling, of cartoonist driven storyboarding, and cartoonist driven design. That makes all the sense in the world—we're creating a cartoon,

shouldn't it be done by a cartoonist?" Staake has enough experience and a long successful track record to be recognized as someone who doesn't require a script at all. "There's no script," he insisted. "It's a synopsis of the story and my role as a cartoonist is, Okay, how do I take this general plot line and tell a dynamic visual story. What visual gags do I use, what are the scene setups, how do I as a cartoonist interpret the scene?" Staake adds, "I believe every cartoonist feels that they're as comfortable writing visual storytelling as they are illustrating it—to us, it's the same thing."

Props

Props—in films, comics, or interactive games—are any objects that the actors need to play a scene. A prop can be a gun, a telephone, a pad and a pencil: anything that is handled. Props should never appear out of nowhere, unless the story calls for it; the sudden appearance from "nowhere" of a prop that an actor needs will lessen a scene's plausibility. In movies, sometimes the director will give the actors a prop to liven up the action; for example, a character may flip through the pages of a book. Props can be integral to the main action or used to provide an interesting counterpoint to the main action or to enhance verisimilitude.

The energy that cartoonist Bob Staake adds to these simple storyboard sketches for Cartoon Network's popular *Dexter's Laboratory* (the guy in the glasses is Dexter) is generated by many of the same techniques used for finished drawings: angled shapes and figures, speed lines, the dramatic positions of the "camera," and a masterful use of the line. Staake successfully says more, with less.

Communicating Through Design

Once an idea, character, or setting has been conceptualized by a writer or director, it is the artist's job to make deliberate design choices that will communicate the concept. Artists make design choices not primarily according to what is most aesthetically pleasing to them but on the basis of what the writer's or director's purpose is. The aesthetic, cultural, and psychological associations that the target audience will have with a particular style of artwork or cinematography, or a given shape, color, or even type font, will, ultimately, determine what choices are made. For example, the designers of advertisements for grocery stores deliberately make them look as though they weren't "designed" at all: the objects, colors, and typefaces and sizes are all over the place. The reason for this "anti-design" approach is that studies show that elegant design is associated with "more money," and people buying groceries are generally shopping for bargains. Advertisements for Saks Fifth Avenue don't look anything like advertisements for Wal-Mart. A thorough knowledge of the intended audience is also a prerequisite for success in the entertainment industry, including all of the visual storytelling media. A black-and-white science-fiction horror movie by Woody Allen, starring Arnold Schwarzenegger, probably wouldn't appeal to very many people.

Mise-en-Scene and Montage

In classic film theory, *montage* refers to the linkage of scenes in time, and any given sequence of shots can be designed to emphasize contrast or to focus on temporal continuity. *Mise-en-scene* is a term that originated in the theater to refer to the scene-by-scene arrangement of objects and characters on stage. In comics, mise-en-scene is the placement and arrangement of figures, shapes, space, and light in a single panel; montage is the layout and design of panels on a page or across a two-page spread. Today, the tendency of most American comics artists is to emphasize contrast-driven montage—playing with panel layouts, breaking the panels altogether, superimposition, unusual page designs. Frank Miller (*Dark Knight,* the *Sin City* series), Neal Adams, and Will Eisner

Mark Smylie's *Artesia* lends itself to a mise-en-scene emphasis. As Smylie puts it, "The story calls for sweeping vistas showing armies and landscapes, which are best showcased using traditional and relatively simple panel-to-panel page designs. Chopped-up panels and funky page layouts wouldn't work with the story style."

A montage approach to page design: it's like a series of jump cuts, but all in the same space.

were masters of montage. European artists, for example, Moebius, Enki Bilal, and Milo Manara, tend to favor careful design of mise-en-scene, panel after panel.

Page Layout

The panels on a given page may be laid out as a grid or arranged free-form. In grid layouts, all panels are the same size. The reader's eye follows the natural left-to-right path, and no one panel assumes more importance than any other. In free-form layouts, any arrangement of panels, panel shapes, and panel layout can be used. Most designers of comics pages use free-form layouts, as that is by far the more organic of the two approaches.

Free-form page design begins with determining what the dramatic focus of the page should be—what the artist wants the reader to see first, whether that is a character or characters, an object, or an action. Then the rest of the page should be

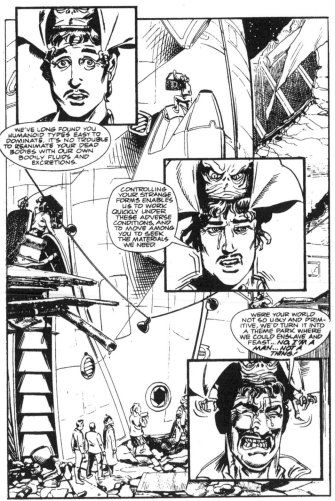

An organic, free-form approach to page design. The floating panels guide the reader along from the top left to the bottom right of the large background image and then onto the next page.

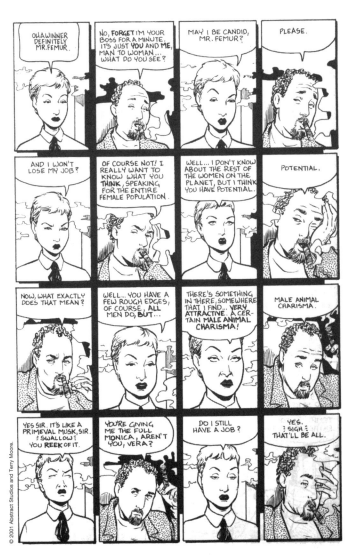

The artist purposely designed this page in a simple grid pattern, as dull as the secretary's emotionless monotone.

designed around that. Many artists do a rough page layout based on the storytelling details before making a decision about which panel should have the most dramatic impact. Important panels can be emphasized by making them larger and bolder or by designing specialty panel borders. An artist might also decide not to use true borders at all.

No matter what the final page layout turns out to be, the reader should be able to grasp the essentials of what is going on without having to read the captions or word balloons. As stated earlier, the words should complement the visuals. Pages that are packed with dialogue will almost always fail the "immersiveness test": the audience will lose interest.

Although pacing in comics is, in general, governed more by individual panel design than by page layout, here are a few guidelines. Asymmetrical balance is usually more visually interesting and dynamic than symmetrical design,

although panel after panel of symmetrical design can work if the individual panel designs are dynamic. As a broad general rule (with lots of exceptions depending on the artist's intentions and skills) a series of thin, vertical panels indicates that the action is taking place at a fast staccato pace and big blocky panels or long horizontal panels indicate that the action is taking place at a slower pace.

Negative Space

Negative space in a given composition (panel or page) is the "empty" space around the main objects. "Empty" is in quotation marks because negative space can be an important factor in how a given design works. Negative space around an object or figure can help make the contour of the object/figure stand out as distinctly as a silhouette. (See the Wally Wood illustrations in Chapter 9.) It can also help in creating exactly the right tone or mood. By doing an overlay on a frame and blackening in all the negative spaces, the artist can see how they work as a whole on the page, without being distracted by the details in each frame.

Creative Blacks

Black or dark areas within a panel or on a page as a whole may be used to focus the reader's eye on important elements in a layout, to create dramatic effects, and to impart a sense of mass and solidity to the scene. The overall arrangement of black areas on a layout, like the overall arrangement of negative space, creates a definite pattern. To see clearly what that pattern is, use the overlay technique. On the overlay, use a marker (if you are using a computer program, apply the mask-and-fill option) to fill in the areas that you anticipate will be solid black. If the pattern of black areas, seen in isolation from the surrounding objects, is too busy, or overwhelming, the reader's attention may be diverted from the desired flow from object to object or panel to panel. Keep the design simple and keep it clear. A good example of blacks used as a design element is the Vespers sequence on page 163.

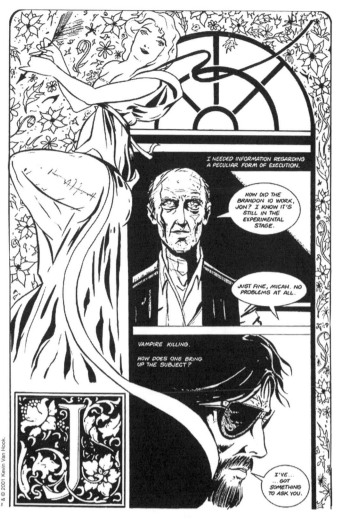

Organic page design. This page from *Frost* looks like a page from an illuminated manuscript—and at the same time it uses some classic modern techniques for leading the reader's eye.

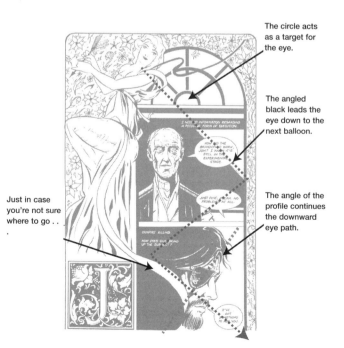

The circle acts as a target for the eye.

The angled black leads the eye down to the next balloon.

Just in case you're not sure where to go . . .

The angle of the profile continues the downward eye path.

Panel Composition

Think of the bottom edge of a given panel as a seesaw, where the center of the panel edge is the center mount of the seesaw. In *balanced* compositions, the relative "weights" of the objects on one side of the panel are equal to the relative weights of the objects on the other side: if they were put on a seesaw, the seesaw wouldn't balance. The balance may be achieved by pure symmetry, where objects on one side are the same basic size and number as the objects on the other, or through balanced asymmetry, where the artist

An unbalanced composition. The asymmetry in this image of an evil-looking solitary driver coming toward the viewer contributes to our perception of him as a crooked character.

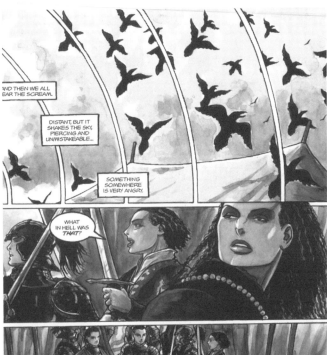

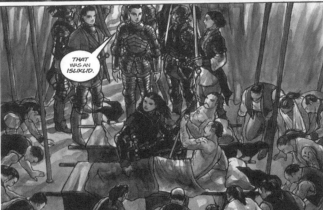

A beautiful example of dynamic page design. Here Mark Smylie has sliced into the top panel with curved gutters shaped like sound waves, creating multiple smaller panels which are symbolic of an enormous sound filling the sky from a distance. The reader's eye is drawn down from the spooked birds to a close-up of Artesia and further down to a detailed panel showing Artesia and the frightened natives around her. In a soundless medium, the artist has *drawn* sound.

Another unbalanced composition, but here the phone is the center of attention.

A balanced composition.

takes into account the object's distance from the picture plane. For example, a large object in one side of the panel that is near the seesaw's center can be balanced by a smaller object on the other side that is farther away from the center. In *unbalanced* compositions, the objects on one side do not have the same relative weights as the objects on the other side, and one side of the seesaw would go down. Unbalanced compositions are necessarily asymmetrical.

Another way to check the overall balance in a panel is to bisect it (either vertically or horizontally), and then look at the two halves to see whether they work to achieve the effect you want. Don't, however, get hung up on theory: trust your intuition. Always conceptualize the design of the panel and draw it—if only a rough—before bisecting it as a check.

Remember, just as using a grid format for page layout exclusively can make any page or sequence of pages seem monotonous, the exclusive use of symmetrical, asymmetrical, or balanced asymmetrical compositions for a series of panels will become monotonous.

Panel Borders as a Design Element

When should I break through panel borders? As always, the answer depends on what effect you want to achieve and where—and how fast—you want the reader's eye to move. "I remember a famous shot by an artist who should have known better," said John Byrne. "I will not name names, but he had a guy sitting in a chair in one panel and his foot coming out of the panel across and into the lower tier below him, where he was kicking the guy in the head. This breaks the flow, obviously, because it pulls you out of it. You go, okay, what am I looking at here? In movies, this is what I call the shots that make you aware of the camera, which I feel is always a sin. You should never be aware of the camera."

The bottom line is: Don't break panel borders without a good reason. A panel border should only be broken if

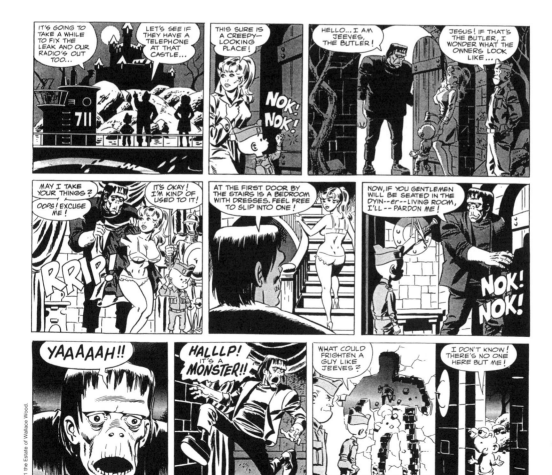

Wally Wood, the master of the frame, rarely broke through panel barriers. On this page, he achieves his comic effect not by drawing Jeeves breaking through the panel, but by drawing him running straight out of the panel—into the distant background!

doing so provides a dramatic punch that could not be economically achieved in any other way. Overuse of this device will dilute the impact when you really need it. Some comics artists—including master storytellers Wally Wood and Jack Kirby—almost never break panel barriers. If you decide to do it, keep the following guidelines in mind:

* Breaking a panel barrier only once on a page will focus attention on that panel, at the expense of the other panels. If you are going to use this device, make it a regular part of your page design.
* Don't let the lines on any figure just sort of blend into the panel border. Make sure the "breakout" is clear.
* Always keep the eye path in mind. Break the right side, not the left side, of a border. Don't break the bottom border unless you want the reader's eye to exit at the bottom.
* Don't push a figure too far outside of the panel.

Most of the time there is white space, or a gutter, between the borders of panels, and gutter design can be an important component in overall page layout and design. Gutter design can affect how rapidly a reader's eye moves from panel to panel: in general, wide gutters will slow down a reader; narrow gutters will not. An extrawide gutter is also an excellent way to signal that a scene is about to change.

Panel borders (or lack of them), can also serve as visual hints as to what kind of event/character/action the reader is looking at, and specialty border designs, or color borders, can affect how the reader experiences the story. Suppose, for example, you are drawing a sequence in which the main character is being hypnotized and falls into a trance. For the borders to the panels showing the hypnotism sequence, instead of the usual ruled white spaces, you might draw wavy, thick, uneven lines.

Another alternative to drawing panels with white space between is to use black, as many of the images in this chapter illustrate. See for example, the three-page sequence from *Strangers in Paradise* (page 160), where black is used between some of the panels and also as a framing device for the entire page.

Dynamic Advertising

In the late 1980s, Arlen Schumer and his wife and partner Sherri Wolfgang created a studio—the Dynamic Duo Studio—for the advertising and editorial illustration markets based on a model borrowed from the world of comics. Schumer's experience with Neal Adams's Continuity Associates had convinced him that he could make a living combining his two major media interests: comics and advertising. After a few years doing many individual ads and editorial illustrations that appeared in major consumer magazines, the studio got a shot at an entire advertising campaign that would appear in comic books, for 3 Musketeers chocolate bars.

After receiving the agency art director's sketch, Schumer did a lot more than merely put the sketch on a light box and trace over it—the approach many studios would have taken. The differences between the art director's rough and the finished page are revealing. The basic "story" of the ad—a two-man spacecraft coming upon a secret space station in the form of a giant 3 Musketeers bar—and the tag line, remain the same, but Schumer's treatment has transformed mundane page and panel design into a dynamic, appealing whole.

One of the things Schumer rejected almost immediately was the "hint"—the end of a candy bar wrapper—seen in the art director's first panel. Despite not having the benefit of a page-turn, the classic way for comics artists to set up an anticipation-surprise sequence (and despite the fact that a reader can easily take in the whole page, including the 3 Musketeers bar, at one glance), he used design to create a single-page surprise. He did it by making the Musketeers Bar in Space, chronologically the final image, a full-page panel and setting the chronologically previous panels "within" that panel. It's the comic book equivalent of a camera pullback in a climactic film scene that suddenly gives the audience a view of something that until then has been seen only by the characters.

Another reject was the caption for the third panel:

"Bob's eyes widen as he sees something shocking in outer space." As Schumer put it, "If we can't effectively illustrate Bob's eyes widening in shock, we should quit the business!" And to add a layer of drama to the effect, Schumer split up the word balloon CHOCOLATE? (the art director had the word in the second panel), tying it in directly with the wide-eyed close-up.

Bottom: Art director's concept. Top right: The Schumers' pencil sketch.
Bottom right: The finished advertisement.

Jim Steranko

Harnessing Mythology: Reflections on Narrative Theory

Whatever success I've had as a visual storyteller might be predicated on a single aspect of my approach: I have a hard, calculated reason for every decision made in the creation of my images. I look upon every picture as a challenge, an intellectual puzzle, a mystery to be solved. Does that sound cold and austere? I guarantee that it's not. If anything, it's the opposite: a passionate search for an artistic solution. Sometimes, it's conceived intact on the drawing board of my imagination. Occasionally, it takes a few minutes. Other times, it requires days. I know I'll eventually find what I'm looking for, so I don't take shortcuts. I confront every problem head on, continuously eliminating possible, but inadequate, solutions as part of the process, until I find a suitable answer. One of the aspects I require in that answer is that it embody a certain kind of magic. It's a feeling, an emotional response that comes more from the heart than the brain. I can't easily articulate that quality, but I always recognize it and I believe that viewers do, too.

Narrative Comprehension

Whoever said one picture is worth a thousand words was obviously looking at storytelling images.

How many words could be written about Gericault's *Raft of the Medusa* or Dupre's *The Balloon?* The paintings are so alive with narrative possibilities that viewers are challenged to create stories about them. The ability to trigger the imagination is a latent force inherent within any image, whether it's a world-shaking picture broadcast on the six o'clock news or a doodle on an Etch-A-Sketch.

The mechanisms of narrative comprehension embrace almost all art forms—in fact, all forms of communication. We employ them in our thought processes as we develop cause-and-response scenarios: If I don't stop for gas soon, I'll run out before I get home. Narrative conclusions of what was or what will be dominate our everyday rhetoric: I won't fix the bicycle until after dinner; then, it won't matter if my clothes get dirty. Beginning in infancy, we learn to identify, analyze, and organize fragments of data, intellectually culling through an ongoing blizzard of spatial and temporal information. Our standard model of consciousness is predicated on our ability to order what we perceive through our senses. That process is a form of narrative comprehension.

Pictures come into play early in our lives, such as in the development of our literary skills. The ABC teaching books, for example, show a picture of an apple because it is easier for the subject to relate to the image than to the word. Prior to 1950, Americans might have been defined as a literary society, but, because of the predominance of television in our lives, we've since become a visually-oriented culture. The importance of images requires that a new and specialized *visual language* become part of our everyday vocabulary. The more we know about it, the more success we'll achieve in the global community.

The media with which we're dealing attempt to evoke *the experience of reality* and all require different, occasionally overlapping, cognitive processes. For the most significant results, creators should understand those differences and use them to develop strengths and mitigate weaknesses. Their prime assets include the number of senses to which they appeal. The more senses that are engaged in the process, the more resonant the viewer's relationship is with the subject matter, and the more pleasure is derived from the experience.

* Animated games assault players on visual, audible, and tactile levels with their interactive qualities, providing the most engaging medium available (until full holographic projection is developed). Coupled with dialogue, music, and sound fx, games are capable of simulating experiential reality and involving players in deep psychological levels of participation.

* Film engages viewers on visual and audible levels with a moderate degree of participation. Most cinematic entertainment requires limited intellectual effort, although sometimes eliciting an emotional response greater than other media. The photographic realism of film is its most convincing asset and so seductive that the unnatural mechanics of jump cuts, disparate shots, and the manipulation of time are easily overcome by audiences.

✳ Animation presents a much higher threshold of intuitive credibility for viewers to contend with—the essential reason why many adults do not find the form appealing—and why children, who are less aware of the laws of physics and more flexible in accepting radical stylization (if it runs like a dog and barks like a dog, it must be a dog!)—are inclined to be comfortable with it. Until recently, the more realistic animation was, the more acceptable it became to universal audiences. Today, audience resistance is near zero.

✳ Comics are strictly a visual medium, combining imagery and text in an extremely convenient form. The demands placed on the reader to comprehend, assimilate, and codify the dual elements often result in a deeper participation level than with other media. In comics, the reader controls the speed of the process, but has no control over pace in film and only marginal control in electronic games. Although comics are the most unrealistic of the forms (there are no black holding lines circumscribing objects in nature) and define their specific dramatic moments within small boxes separated by nonobjective gutters, they are nonetheless in the same storytelling arena as the others.

✳ Literature requires only a visual sense to read text, which in itself is antivisual. To maximize its effectiveness, it must compel the reader to create intellectual connections on one level and, on another, to stimulate the creation of images—the element common to film, animation, and comics—with its descriptive capability. While abstract concepts are often easier to relate in written or spoken form (compared to photographic images or even illustrated material), text falls short in conveying precise physical detail and evoking the credibility inherent in pictures.

Each form is relatively complex and requires its own syntax, yet all are easily learned. It is often as relatively simple to comprehend stories told in each medium as it is difficult to explain *why* they can be comprehended. Only an exploration into the mysteries of cognitive science can provide those answers. But there are a multitude of thought-provoking clues to pursue as we engage in the storytelling process.

The Creative Process: Intuitive vs. Analytical

Creators essentially fall into two categories: intuitive and analytical. Storytellers in the former category would include John Ford, N. C. Wyeth, and Jack Kirby. I doubt that they were able to articulate precisely why they did what they did or why it often worked so well. (Kirby was one of my mentors, the quintessential master of the comics page, yet, in the thirty years I knew him, he could never explain, beyond a few generalizations, the source of his vision nor the profound appeal of his work.) All three creators reveal similar qualities in their efforts: a purity, passion, and power that few others have. Intuitive creators have no reason, beyond curiosity, to seek those explanations; their processes are not only natural, they're true, and often original. Those of us who fall into the analytical category can benefit from the results of that quest because we need to apply reasoning to our processes to generate quality work.

The Meaning of Images

I distinguish between two primary types of perception—intrinsic and extrinsic:

Intrinsic perception relates specifically to the components of an image. A picture of a baby sitting on the ground, holding a teddy bear, and looking up in innocent surprise suggests happiness and contentment, nothing more than what it is—a neutral image.

Extrinsic perception develops when the above-described image is juxtaposed with a picture of a moving car, in itself a neutral image (denoting little more perhaps than its age and condition). Together, however, they create a shocking and suspenseful response (particularly if the car is seen head-on from a low angle), that suggests the child is in the path of the car, even though they might actually be in different locations. Though there is no evidence of proximity, the viewer's mind makes a narrative connection, creating *a third and completely different meaning* than can be derived from the pictures individually.

There is no need for a character to shout a warning that the child is in the path of a moving car. The viewer's narrative comprehension provides an observation more powerful than any dialogue. The challenge of the visual storyteller is

to find ways to express exposition, character development, plot progression, and dramatic themes using imagery that stimulates both kinds of perception.

Here's an example using indirect juxtaposition:

* During a bank holdup, an outlaw is shown prominently with guns drawn, then escapes in a hail of gunfire; a wanted poster with a $500 reward is superimposed over the action.

* Several other scenes subsequently play out, culminating in a sequence where the outlaw is being chased unsuccessfully by a posse; one of the spectators clutches a wanted poster with a $1000 reward in his hand.

* More scenes occur, after which a shootout occurs in the street: a newspaper headline declaring a $10,000 reward is pulled from a printing press.

The repeated visual references to the escalating amount of the reward suggest the abstract idea of the outlaw's growing notoriety. Even though a significant amount of screen time passes between each instance, the printed notice and, more specifically, the increasing dollar amount of the reward, are memorable motifs by which a viewer's extrinsic perception draws the intended narrative conclusion.

There are probably as many ways to use this device as there are stories to tell. Some of them have become clichés, so it's up to the storyteller to invent new, efficient, and imaginative variations to ignite audience interest.

It should be noted that narrative comprehension varies with every viewer because of their memory threshold, cognitive maturity, previous narrative experience, power of analysis, and data-integration skills. It is possible that the more sophisticated or remote the narrative devices used in the storytelling process, the less successful the mechanics of perception will be. It would not be unwise, in certain cases, to tailor the use of narrative devices to accommodate target audiences. When I wrote and drew the *S.H.I.E.L.D* series, for example, I specifically aimed at *three distinct audiences* and shaped the work accordingly:

* For the youngest comics reader (preschool and those in early grades who could not read, but wanted to look at the pictures), I made sure that an intriguing story could be discerned exclusively from the imagery, no words required.

* For grade school readers to mid-teenagers, I took a straight adventure approach that gave them plenty of action and eye-candy to digest that was not in conflict with the initial approach.

* For college readers, I layered on a satirical or over-the-top veneer that neither corrupted the work nor played down to the other two groups.

The concept of several levels of narration operating simultaneously with varying approaches to explicitness and relevance was never apparent to readers until I revealed the strategy in lectures years afterward. (I still believe I did the right thing by concealing it from my boss, Stan Lee. Then again, I may have fouled up by not submitting triple writing vouchers!)

In The Beginning!

What do I do first?

That's the question I'm asked the most by novice storytellers. My answer is: the story will *always* tell you what to do. And in a visual medium, it must be done visually to be successful.

The key is knowing the story and it's visual possibilities. Almost every film director I've discussed this point with—Steven Spielberg, Stanley Donen, John Milias, Richard Donner, Oliver Stone, John Carpenter, Sam Fuller, David Lynch, Richard Brooks, John Landis, George Lucas, and many others—have developed the same process: when they read a script, it plays on the movie screen of their imagination. That doesn't mean they're able to structure the action first time through; it simply means that they *think visually!*

If it's good enough for them, it's good enough for us. My guess is that you already have a head start on the technique. If you see pictures when you read a story, you're on your way to mastering the art of visual storytelling. Your goal is to translate those ideological images into tangible form.

Scene Structure: The Breakdown Technique

Here's how I do it: I reduce the story to an *outline* (or sometimes simply start with a synopsis) which sums up each plot development in a very short line of text and in narrative sequence. The result is a list of *plot points* with no characterization or visual instruction. A comic book can often be

outlined in a single 8 ½ by 11 sheet. Feature films may take a few more pages.

When I'm satisfied that all the primary points have been included, I bracket clusters of lines, grouping them into scenes. Sometimes a single plot point will be a scene by itself; other times, a number of plot points will be grouped into a single scene. Since most scenes occur in specific areas or settings, it is relatively easy to isolate them.

When I can see all the elements within the schematic and how they interrelate, I initiate a refining process. Instead of adding supports to the construction, I do the opposite: I begin a kind of ruthless deconstruction, hoping to eliminate weaknesses, finding other ways to tell the story, and discovering new narrative configurations. That entails shuffling, modifying, adding, or deleting scenes as necessary.

Questions that might be asked at this point include: does the story unfold naturally; are the entrances of characters well-timed; are too many "sit-down" scenes—scenes heavy with exposition or dialogue—too close together; are action scenes spaced judiciously throughout the narrative; can I eliminate or combine any characters; does the conflict build progressively to a powerful climax? Rather than simply depict a series of confrontations in a realistic manner, the storyteller should strive to enhance the audience's perception of the unfolding conflict, to reveal the relationships of the characters, and the meaning of their interaction. Essentially, I become a script doctor. (Objectivity is the operational word here!)

An overview of the scene outline is relatively easy to analyze and manipulate. Experimentation regarding the transposition and synthesis of scenes at this point may produce interesting narrative variations with a minimum expenditure of time and effort. Many filmmakers type summaries of scenes on 3 X 5 cards and tack them in sequence onto bulletin boards to facilitate rapid adjustment and rearrangement. Francis Coppola sometimes indicates basic plot developments in short descriptive lines on a large piece of paper, arranging them like a graph to show rising and falling conflict.

Because changes are so simple at this point, there's no need for an anxiety attack. (I sometimes work on Coppola projects at this early stage and joke with him about me having all the fun now—and him doing all the work later.) If you can have a good time with your progress, there's a good chance that others will, too.

Conflict:
The Core of the Storytellers Art

Someone in Hollywood said it long ago: Everything starts with the script! It's the foundation upon which you'll begin to build a construction, using *characters in conflict,* the two critical elements in every story. Without conflict, the events may only be incidents trying desperately to be dramatic. Whether the tale is a romance, a crime caper, a comedy, or a domestic drama, conflict is the glue that holds everything together. It is the single most important element in the storyteller's arsenal and requires a concise understanding before any visual work is attempted.

The success of your finished product depends on your grasp of the story's conflict and how to state it graphically. Before you attempt any visualization, be certain you have a thorough knowledge of that dynamic. Your goal is to express that conflict in every image you generate. The greater your comprehension of it, the more powerful the result will be.

Antivisual Scripts

Words are a writer's weapons and they aren't always wielded in the artist's/filmmaker's favor. By that I mean there are too many long-winded hacks who fail to think pictorially while working in visual mediums. They make an artist look bad, because only a real virtuoso could possibly punch up their scenes with a bravura performance. It can be done, but why should it have to be done? Why should the artist have to struggle to make the imagery endurable, when the writer could have expended a little more thought to make it visual?

Trained to believe in the importance of the word, they tend to overwrite, creating "talky" scenes that lack visual power. I recall having a conversation with Lee Van Cleef (Angel Eyes in *The Good, The Bad, and The Ugly*) about the problem, and he revealed his solution. He'd carefully read through every day's shooting script, redline his dialogue, then confer with the director. He'd suggest that he could deliver the essence of the material (boredom, anticipation, menace, etc.) with a mannerism or an expression. The result was often a series of riveting close-ups, particularly focusing on his hard eyes. . . . Today's comics are riddled with sit-down scenes that go on for pages, essentially talking heads wasting dozens of panels where one would suffice. While those writers are engulfed in the self-celebration of clever

banter, the rest of us are ODing on their numbing, Nytol repartee. These dimbulbs should be grinding out paperbacks, where visuals are not important.

Film scribe Shane Black (*The Last Boy Scout* and the *Lethal Weapon* thrillers) is particularly adept at integrating dialogue and images by writing scenes that work on both levels. An ideal situation exists when the words and pictures are created by the same person. Francis Ford Coppola excels in both areas, as *Apocalypse Now* and *The Godfather* trilogy amply attest. Milton Caniff raised the comic-strip form a notch or two with *Terry and the Pirates* and *Steve Canyon*. I'm not suggesting that those who do one should also do the other. Not every artist is a writer or vice versa. But I am recommending that each learn as much about the other's craft as possible.

My personal note to writers in visual media: Write visually or die!

Visualizing Scene Components

Whether you're creating for film, TV, game animation, or comics, the basic process is the same. The first three utilize storyboards; the latter requires page layouts. Here, one of the essential differences between the formats comes into play: comic panels can change their size throughout the story; the other forms have a static screen or frame that does not change.

All scenes are constructed with three basic shots, which are defined by the distance between the viewer and the elements in the shot, the long shot (LS), the medium shot (MS), and the close-up (CU). The art and science of visual storytelling relates entirely to the selection of these three shots (internal expression) and their narrative orchestration (external expression). The storyteller's objective is to construct a logical sequence of shots, which creates an intellectual or dramatic statement using pictorial continuity—the common factor between film, animation, and comics.

Angles

Not only is the arrangement of elements in a shot subject to great variety, the angles at which they are depicted are equally diverse. This kind of freedom may seem confusing initially, but the application of a few guidelines can help get the situation under control. Essentially, there are four viewpoints to consider:

* *Eye level* is the most common and utilitarian angle. It suggests an equivalence with the subject shown and that the drama could proceed in any direction. While other shots sometimes call attention to themselves—making audiences aware that they're viewing a film—the eye-level shot is the least self-conscious of angles. If eye-level sounds prosaic, remember that Francis Coppola shot every scene in *The Godfather* with this classic approach.

* *High angle* (or bird's-eye view) tends to reduce the importance of the subject (such as the high-angle zoom out of the asylum floor and Olivia DeHavilland in *The Snake Pit*), subordinate it to its surroundings (Dorothy Comingore surrounded by puzzles in *Citizen Kane*), or suggest a sense of desertion (Gary Cooper on the empty street of *High Noon*).

* *Low angle* (or worm's-eye view) on a subject lends a larger-than-life quality to the figure (Arnold Schwarzenegger in *The Terminator*) or an attitude of dominance and superiority (such as that of Sidney Greenstreet in *The Maltese Falcon*). Sometimes, it represents a child's viewpoint (on Ralph Richardson in *The Fallen Idol*) or that of a small animal (*Benji, Stuart Little, Babe*).

* A *tilt shot* can suggest emotional disorientation (such as James Dean watching Jim Backus come down the stairs in *Rebel Without a Cause*), latent tension (Orson Welles on the run in *The Third Man*), erratic consciousness (Jean Reno at the climax of *The Professional*), or spatial turbulence (*Titanic*).

If you find yourself tempted to use numerous angles, remember it's what's *in the frame* that counts—if you need odd angles to make your story interesting, you're in deep trouble!

Viewpoints

Another consideration in determining the kind of imagery necessary in every shot is the basic viewpoint. There are two:

* *The objective view* is the most prevalent because it

places the viewer adjacent to the scene, in a position where all the characters and action can be clearly witnessed. From this position, the viewer becomes a spectator.

* *The subjective view* puts the viewer into the scene, allowing him to see exactly what one of the characters sees in the story, from the character's height and position in the setting.

In the former, the viewer is a witness. In the latter, the viewer is a participant.

In most cases, the subjective view is used like punctuation to refocus the dramatic attention of a scene because it brings the audience into direct confrontation with the other elements as the subject sees them. At the climax of *On the Waterfront,* Brando is beaten by union thugs, but attempts to rally the dockworkers to follow him—if he can walk across the wharf to a warehouse entrance. He staggers along, barely conscious, his eyes rolling up into his head. The subjective shot that follows puts the audience effectively in his place: shambling forward movement showing a mass of staring faces, convulsively zigzagging from side to side and up and down, until reaching the warehouse.

More extreme cinematic examples of the subjective view include the first reel of *Dark Passage* (in which the viewer sees only what the escaped convict sees); *The Eyes of Laura Mars* (in which the audience experiences the killer's murky, unsettling viewpoint just before murders are committed); and *Lady in the Lake* (an experiment gone awry, in which viewers see the entire story from the detective's viewpoint).

These are the exceptions, however, not the rule. Examples of more traditional uses are any Hitchcock film with a car chase (frequently intercut with subjective views) and the climactic operation in *Seconds* (in which Rock Hudson is wheeled down a corridor and subjected to a cranial drill). Boxing films inevitably use a double subjective shot: a gloved fist thrown into the camera, followed by a fighter's head snapping backward. When character A hears a knock on a door and looks up, the next shot will most often be subjective—character B entering the room from A's point of view. The trick is to use the subjective shot logically and dramatically.

Temporal Continuity

All stories manipulate time, except in those rare cases where the telling occurs in "real" time. (*The Incident,* in which Martin Sheen and Tony Musante terrorize a group of late-night travelers, occurs during a long subway ride, which comes close to real time.) There are four essential variations of temporal continuity:

* *Simultaneous coverage,* in which a shot or scene takes place at precisely the same time as the previous shot or scene. Stanley Kubrick used this device in the racetrack heist film *The Killing,* in which various interlocking sequences happen during the same time period. At the picture's climax, the technique is used in a different manner: an airport baggage handler is driving across the tarmac in a cart with Sterling Hayden's suitcase full of stolen money precariously balanced on it. In the following shot, a little poodle is shown jumping from the arms of a woman waiting for the plane. Next, a medium shot shows the driver swerving the steering wheel to avoid the dog (not seen). The suitcase topples to the ground, opens, and spills thousands of dollar bills into the backdraft of a plane, scattering them in a cloud of paper across the runway. The subsequent shot of Hayden's shock follows—but actually reveals his response during, not after, the previous shot.

* *Continuous coverage,* in which Shot B actually occurs after Shot A, such as the baggage-cart driver–dog sequence described above. Sergei Eisenstein's Odessa steps sequence in *Potemkin* is a masterpiece of simultaneous and continuous coverage; Brian DePalma liked it so much, he imitated the scene in *The Untouchables.*

* *Subsequent coverage,* in which Shot B occurs some time after Shot A. This is very common in most stories because it condenses time for practical purposes and is standard syntax to viewers: a character is seen starting her car in New York; in the next shot, she pulls into a parking space in Baltimore.

* *Flashback coverage,* in which a shot or sequence happens considerably before the previous scene. *The Manchurian Candidate*'s brainwashing scenes are all revealed in flashback. In both *The Killers* and *Sunset Boulevard,* almost the entire story is told in flashbacks.

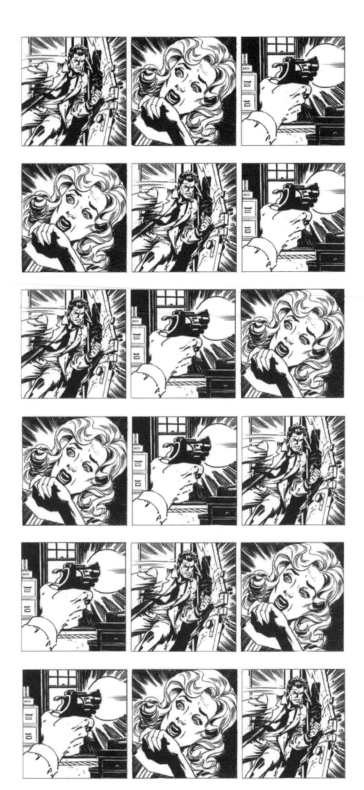

The A/B/C order suggests (1) the man breaks down the door, (2) the woman beyond the door responds fearfully, and (3) she fires a shot at him.

B/A/C order suggests (1) the woman reacts to something menacing, (2) the man breaks down the door as if in response, and (3) he fires a shot (visually reinforced by the similar direction of the action).

A/C/B order suggests (1) the man breaks into the room, (2) fires a shot (visually reinforced by the similar direction of the action), and (3) the woman reacts fearfully.

B/C/A order suggests (1) the woman reacts in fear, (2) she fires a shot at (3) the man breaking into the room.

C/A/B order suggests (1) a shot is fired by (2) the man who breaks down the door (visually reinforced by the similar direction of the action), and (3) the woman reacts in fear.

C/B/A order suggests (1) a gunshot is fired at the woman by an unknown person, (2) she reacts fearfully as (3) the man breaks into the room in response to the shot.

Six Temporal Orchestrations

Unless you opt for a split-screen effect that suggests simultaneous coverage, you'll have to decide on the sequence of shots that is most appropriate for the action—which is not always as apparent as it seems. Let's assume the script calls for: *man breaks into woman's room as a shot is fired.* We'll break down the action into three images (A, B, C) for which there

are six possible configurations, each telling a different story.

Numerous secondary conclusions can also be drawn from the various orchestrations, in addition to those listed above. Note that the hand with the gun always seems to belong to the character in the *preceding panel,* especially due to its subjective viewpoint. Because the gunshot has no preceding panel in C/B/A, it can only relate to the following panel. In

this configuration, the gun points right and the woman looks to the left, tightly relating the two panels. In C/A/B, the panel following the gunshot is of the man, giving the impression he pulled the trigger. Also notice my purposeful deception of showing neither character's right hand, making it impossible to determine who is holding the gun.

Temporal articulation may seem arbitrary to those principally concerned with shot content and composition, but be assured that it is of equal importance to any other aspect in the architectural structure of visual storytelling.

Lighting

As an illustrator, I use a series of elements in every image I create: line, form, mass, texture, pattern, directionals—all of which could be said are the result of certain kinds of lighting. Of course, I'm referring to the lighting in realistic or photographic-type images, not cartoons, which are not necessarily subject to the principles of light and shadow. Although lighting is a major factor in the artistic arrangement of positive and negative areas of pictorial compositions, my concern in this section is more with its dramatic capabilities. Aside from revealing the characters, setting, and props in a scene, there are three basic considerations regarding light that I impose on every shot: atmosphere, character, and depth.

Atmospheric Lighting

Atmospheric lighting expresses the intent of a scene visually and puts the viewer in a frame of mind to accept or at least be comfortable with what they're about to see. For example, if a character enters a dark room with low-level interior light or limited patches of exterior light (daylight with shades drawn), a heightening of suspense occurs (partially due to fear of darkness, partially because we know the syntax of film psychology). More often than not, there is a surprise or shock payoff to satisfy that expectation. (A classic example is in *Psycho,* when Martin Balsam enters the Bates' home, ominous with its dark wood construction, and makes his way up the stairs.) Conversely, fully lit scenes provide comfortable, natural atmosphere. (The friendly, familiar lighting in Woody Allen's apartment puts viewers at ease immediately in *Play it Again, Sam,* giving the actor maximum tranquility for his catastrophic antics when his date arrives.) Diminishing light can create expectation. Increasing light suggests revelation.

Character Lighting

Character lighting helps the storyteller define the attitudes and emotions of the subjects. Sometimes intimacy can be suggested by a low, romantically lit setting and rim light on the character, so that emotion and facial expression are more in the audience's mind than on the screen. Fear, shock, hate, apprehension, and menace are often expressed visually by a light from below the subject's head. Affection, happiness, loyalty, and optimism are emotions that can be easily read in compositions lit for the purpose of showing the character's beauty, appeal, and sensitivity—emphasizing light, minimizing shadow. In mystery movies, characters' faces are often lit from a low angle because it has a distorting and alienating effect on viewers. (No example could be more explicit than that of Tom Neal as he recalls his fated journey in the diner scene in *Detour.*) Overhead light can suggest the presence of divinity (Pat O'Brien as he walks the last mile, praying for Jimmy Cagney in *Angels with Dirty Faces.*) Often character lighting is created independently from the sources of atmospheric lighting.

Depth Lighting

Depth lighting refers to lighting that separates elements within the field of vision and makes them easy to read visually. If the background plane is essentially dark, then the major characters in front of it should be well lit to pull them out of that plane onto one of their own. If dark subjects are called for against a dark background, they would be lit by a rim light that just catches the edges of the figures. A light background would naturally reveal dark figures best. I call the result of this type of illumination *silhouette power* because it enhances the shot's perspective and creates the aspect of deep space by the contrast of overlapping elements lit in alternating fields of light and shadow. Perfect examples of this treatment appear throughout Robert Siodmak's *The Killers,* such as the scene in which Edmond O'Brien is discussing the Swede's murder in the medical examiner's office. Here's another example: against the bright horizon of a Western landscape, several prairie schooners are seen in shadow; silhouettes of Indians on horseback are seen crossing behind them (background); a woman in a light-colored dress carrying a baby in a white blanket is pinned to one of the dark wagons with an arrow through her sleeve, and other pioneers in light clothing

crouch nearby with guns drawn (middle ground); in front of her, a grouping of settlers are crouched in the shadows of a barricade, where their figures are seen shooting rifles at their attackers (foreground); the scene is shot through the spokes of a light-textured wagon wheel (extreme foreground). Every element has been positioned to create maximum depth of field.

Structuring Shots Smoothly

To maximize your initial efforts, I recommend that you treat all your images as naturally as possible and attempt to capture what you would see if you were watching the situation unfold in real life. It's a matter of learning to walk before running. Many veteran filmmakers, including John Ford, Raoul Walsh, Frank Capra, and William Wyler, used this naturalistic approach for their films. Restrain your passion for through-the-birdcage and under-the-toilet shots (sometimes referred to as camera rhetoric) until you thoroughly master the basics.

When I develop narrative passages, I always rely on the story to lead me from one shot to the next. When capturing scenes heavy with exposition or dialogue (sit-down scenes), the character who delivers the line generally is the subject of the shot, whether it's a close-up or a medium two- or three-shot favoring the character. When another character responds, the visual requires an answering shot, similar to the previous one or perhaps over the shoulder of the first character. This is called a *reverse-angle shot.* The character dramatically dominating a scene usually gets the most coverage.

In film, camera set-ups are costly and time-consuming, so developing the appropriate shots quickly is critical. Storyboards can be helpful. With CGI games, experimenting with angles is much less expensive. In animation and comics, one shot is as easy (or difficult) to create as another. Comics have the edge in this respect. When I handled the *S.H.I.E.L.D.* series, I could compete on a certain level with the 007 films by creating a million-dollar set on every page. Eat your heart out, Cubby Broccoli!

Orchestrating shots—whether in writing, storyboards, or comic panels—is similar to the post-production editing process. In animation, all scenes are pre-edited in the planning stages. Many directors, including Alfred Hitchcock and Ridley Scott, shoot from very comprehensive story-boards. Most action scenes in today's films are heavily boarded to minimize costly on-set decisions.

After a series of action and reaction shots, films often re-establish the scene (not necessary in comics). Sometimes, to enliven static scenes, one character will move around in the shot, with the camera following that character or shooting the character through a group of other actors. Director Michael Curtiz does this exceptionally well in *Young Man with a Horn,* as does William Wyler in *Detective Story.* Orson Welles elevated the idea to a leit-motif in the party scene of *The Magnificent Ambersons.*

In the context of scenes, every shot must relate to the one before and after it, particularly in film and animation. Many of these shots demand a spatial (same set, actors, colors, textures, pictorial approach, etc.) and temporal match in some manner to achieve clean continuity. In comics, a skillful and sophisticated storyteller can make all panels on a two-page spread relate to the others, because they are all within the periphery of the reader's vision. This obvious concept is generally ignored or unknown by even the most seasoned pros, yet it can be a major factor in creating scenes with powerhouse cohesion and credibility.

After a while, a creator's natural storytelling inclinations will evolve into personal formulas which will facilitate the orchestration of stock scenes. Unless they become a substitute for the imagination and evolve into clichés, I consider them to be artistic shorthand and, in a sense, the backbone of the creator's style. We all have them. (Ralph Bakshi refers to mine as "Steranko cutting patterns.") Just as a good artist's rendering style is often recognizable, so too may be his or her storytelling techniques.

Remember: every shot should be structured to *advance the storyline,* to create interest, to surprise, to delight, to shock, to deliver emotional responses. All the elements of content—distance, viewpoint, angle, temporal continuity, and camera and subject movement—must be taken into consideration for every shot. Although it may sound time-consuming, practice and experience will help speed the process. Don't rush. Be methodical, thorough, and have fun with the process.

Similarities And Differences

One primary difference between comic books and motion-capable mediums is that the former are controlled at the

reader's speed, while the latter play out in their own time. Consequently, the experience of the comic reader is often more personal or warmer than that with film or animation (although photographic realism, spoken dialogue, musical score, sound effects, and motion are undeniably appealing).

Interactive games combine elements of both mediums to create an enhanced sensory experience. It's appropriate to capitalize on the strengths of the medium in which you're working. For example, in comics, I created many scenes that were rich in interesting detail or complex in dramatic content—sometimes both. Readers would pause to study the art, assimilate the concepts, and attempt to interrelate the elements at a heightened level during which they should have experienced a series of intellectual/emotional responses, from intrigue to stimulation to satisfaction. Those responses, of course, occur in other mediums as well.

In film, we see a form of theatrical reality: real people in three-dimensional environments. In animation and comics, we see renderings of two-dimensional people and environments which attempt to transcend their limitations and engage the reader in realistic confrontation. Literary mediums attempt to invoke reality on a purely intellectual level. Film and animation appeal to two senses (sight and sound) to help suspend disbelief. Comics and literary works address only one.

Film and animation features average about 135,000 individual frames. The average comic book has about 140 to 160 panels. Those panels, however, frequently change in size, unlike the screens of computers, TV sets, and movie theaters. I equate the *size of a comic panel* to the *length of a film shot*. A narrow panel of a hand reaching into a desk drawer, for example, would be similar to a short insert shot in a film. I use a much larger panel for an establishing shot of a room with several people; on screen, that scene would require more time for the audience to absorb the information. The shower scene in *Psycho* would equate to a series of narrow panels in a comic book because it is composed of many close-up shots of very short duration, each expressing a detail of the attack.

Each form has its liabilities and assets and the consummate artist knows them all. The tyranny of the comics page, with its small, silent, static images, should not restrict the imagination of the storyteller any more than the sensory overload of cinema should overwhelm it. The trick is always to exploit the positive elements and minimize the negative aspects. Although there are no panel gutters and margins in real life, readers apparently have few problems with comics syntax. Nevertheless, it is sometimes possible to transcend these limitations. I found panel rules oppressive and looked for ways around that convention. One was in a story set on the Scottish Moors. On the opening double pages, I eliminated *all panel rules* and used the white of the pages—including the book's margins—to represent heavy fog, with just the tops of castle ruins showing. Another goal was to use the staples in the center of the book!

Influences

Everything an artist has experienced with all five senses can influence the artist's work. In my case, they could be cloud formations I saw as a child, the thunder of low-flying airplanes, the smell of summer rain, the bitter taste of blood, bark peeling from birch trees, the howl of an adversary's pain, the haunting quality in the eyes of animals, the sensation of splintered bones, the intimate touch of a woman—all influences that are relived during the act of creation.

Simply reproducing shapes and textures, sounds and sensations, no matter how skillfully done, will rarely transform an aesthetic work into a living experience for an audience. To bring any art to life—music, dance, sculpture, painting—one must lend a personal quality to the effort. It is that quality which transcends the medium and touches audiences. It cannot be taught like mixing paint or playing scales. Nonetheless, artists should be conscious of the shaping forces behind their vision, explore their meaning, and invest them judiciously in their work.

Awareness is a major weapon in every artist's arsenal. The more you know about yourself, the more authority your work will display.

How an artist tells a story is the result of their experience, imagination, judgment, taste, and training. These are also aspects that essentially define the *human personality,* confirming the direct correlation between an artist and the work, the characteristics of which can often be determined by the perceptive observer.

In case there's any doubt, I confess to overtly attempting to invest as much creative insight in my projects as possible. After I accept any job, whether it's for $50 or

$50,000, it goes through the same dialectical process that brings all my experience to bear in discovering an appropriate solution. For example, I was a club musician for twelve years and believe the aesthetic sensibility developed during that period influences my imagery as much as the music I always have playing in the background while I work. In fact, I often tailor that music to the assignment. When I'm painting a Western scene, I'll play an Ennio Morricone film score. If I'm writing a dramatic scene, I'll try Miklos Rozsa. For fantasy, I rely on Russian composers, such as Prokofiev, Mansurian, or Shostakovich, to provide inspiration. When I created my hard-boiled graphic novel *Red Tide,* I played only '40s music—mostly bebop—to evoke the period. I call this aural approach *method music.* (This trick alone is worth the price of the book.)

For most artists, music provides an external or conscious motivation that energizes the creative process. Internally, my collective musical experience invests a certain rhythm to my words, images, designs, and concepts on a subconscious level, in addition to sustaining a unity through those efforts.

If there's a certain theatricality in my work, it could be traced directly back to my performance years. It's a matter of associating data, themes, and continuities with instincts, meanings, and experiences. As a magician, I integrate the psychology of illusion, misdirection, disguise, false revelations, concealment, surprise, stagecraft, and optical effects into certain assignments, but I wouldn't be too surprised if those processes permeated all my efforts in some subtle manner.

These are an artist's real weapons and they should be employed in the same manner in which actors and singers use their emotional history to embellish their best performances. The rule is always true: the more experience you invest in your work or play, the richer the result will be.

Mastering Double-Page Composition

The standard comic book opens to 10 by 14 inches, an area easily viewed in its entirety, no matter where the reader's vision is focusing. Cognitively, the mind absorbs everything on those pages because it's all within the peripheral vision. Consequently, the artist must develop a sense of composition for multipanel double-page spreads. (Writers are usually unaware of this aspect when they script scenes and

often make well-conceived doubles an artistic impossibility. Collaborations at this point may be helpful to both parties and the resulting work.)

The easiest and most practical manner to unify double pages is with the use of a *grid,* a pattern of structural increments upon which panel size and positioning are based. A triple-tier grid is standard for comic-page layout. Some companies, such as EC and Gold Key in the '50s and '60s, rarely deviated from this basic format, which breaks up the page into three equal horizontal areas. The two gutters between the three tiers strongly anchor the pages, so that individual panels may now be plotted.

Of course, there are many other ways to divide double pages besides the triple-tier method, but I suggest that at least one *horizontal, anchoring gutter* always be maintained, wherever it is placed. A rule of thumb might be that the more unconventional the placement of the stabilizing horizontal element, the more demand is made on the artist's layout skills—and the more chance there is of failure.

Keep in mind that numerous compositional solutions must work simultaneously on several levels:

* Each *panel* represents a specific moment in the story and must communicate a maximum amount of information focusing on that moment. In addition to maintaining the integrity of the panel's dramatic intent, the artist should articulate the elements shown in a compelling arrangement that can stand alone as a unit.

* Each *page* features an amalgam of moments, each defining a dramatic high point within a scene, and together creating a kinetic sequence, where the essence of any one panel is *enhanced* by those adjacent to it. The panels also become a collective mosaic of images that should not only have their own unity, but underscore the dynamics of the plot by suggesting movement, opposition, tension, inactivity, menace, whimsy, harmony, discord, and other abstract concepts. For example, in one of my comics that involved the death of Captain America, I designed a page that subliminally suggested a sense of somber lament by using black backgrounds and an arrangement of panels in an arched, cathedral, stained-glass window-type design. Another example would be *S.H.I.E.L.D.'s* Nick Fury who, in a *Strange Tales*

thriller, had penetrated an enemy fortress and was making his way through its labyrinth. To visually underscore his situation, I created a *maze page* that readers had to solve to get from one panel to another.

❋ Each *double page* functions as a collective canvas on which the drama unfolds in fragmented images, yet as a whole creates a powerful narrative that drives readers on an imaginative journey from the upper left corner, through a series of sharp, angular movements, to a conclusion at the lower right. Both pages should complement each other visually and function as a single, evocative unit of smooth, streamlined storytelling.

While the script often dictates how panel arrangements are structured, working from an outline will allow much more latitude in placement. Either way, the artist should consider both pages simultaneously as the tiers are broken into panels. A visual balance should be maintained; for example, if the left-hand page opens with a full-tier establishment shot, the double-page sequence might close with a full-tier climactic shot on the lower right-hand page.

Panels depicting long shots, close-ups, silhouettes, and details should also be placed with a sense of parity. However, I don't recommend perfect symmetry unless it underscores that specific quality in the story. The challenge is to create a kind of weight, texture, and color balance on the pages using various-sized panels and components within them. Black areas and open panels can also be key elements in establishing interesting, unified double-page compositions.

Always keep in mind that the arrangement of panels on single or double pages can enhance the narrative flow of the story by the kinetic quality of their juxtapositions. A series of thin, rectangular panels next to each other create the impression of a steady, inexorable tempo. Increasing or decreasing the width of panels in a sequence creates a sense of *external* tension, which is distinct from the *internal* tension generated by the imagery. Intercutting thin, rectangular panels with larger-volume panels (such as squares) generates still another kind of tension. External tension is almost always secondary to the primary or internal tension of the panels' content and only needs to be considered after the function of the imagery has been clearly established.

Although it is not always possible to create perfect

images in perfect-sized panels, the artist (and writer) should always be aware of passages where that ideal union might be possible and attempt to develop it. The more the technique is exercised, the easier it is to determine when these sequences naturally occur.

It might also be noted that when a certain kind of idiosyncratic narrative sequence is developed (such as a series of decreasing-size panels), it is often reasonable to use similar sequences two or three times in the same story to unify the storytelling approach. A single usage can be a jarring element, while several well-placed sequences could elevate the device to a stylistic entity.

Remember: no matter how interesting or offbeat any panel is, if it doesn't function to enhance the storyline or creates a jarring effect within the page or double-page format, it should probably be recast or replaced.

The Ideal Comics Page

Certainly an "ideal" comics page is a subjective concept, but, for our purpose, a general definition might be a page which not only commands readers' attention, but compels them to continue along a memorable path until a satisfactory conclusion is reached.

There are thousands of ideal pages, some of which break the basic rules, but most of which conform to a common set of standards or a traditional paradigm. I don't mean to suggest that using formulas is the path to superstar success, but comprehending them can be a liberating process and employing them will provide a platform upon which a successful career can be erected. Yes, rules were made to be broken, but first they must be understood and explored to determine the parameters and possibilities inherent within them.

I consider formulas, such as those I've distilled in creating a model of an ideal comics page, nothing more than a shortcut through the complex terrain of storytelling techniques. More appropriately, they represent a starting point at which a multiplicity of variations can be charted. (One of my favorite challenges is to address a cliché or formula and twist it into something new and exciting.)

In the comics world, the Kirbys, Kurtzmans, and Woods were the creative elitists who set the pace for the rest of us to carry on with the traditions they established. Not everyone has their gift of virtuosity. For those who don't, learning sophisticated storytelling techniques will provide

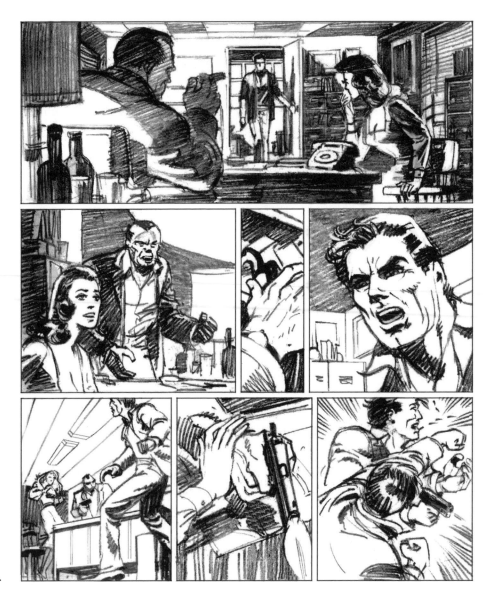

Creating the ideal comics page.

an opportunity for access to the popular competitive arena and applying them will facilitate the production of endless, high-quality ideal pages.

Ignoring the groundwork is an error common with amateurs who believe they can run before they walk. Often the result is a collection of bad habits which cripple them with weak narrative techniques for the life of their careers.

The basic shots and transitions analyzed in the Carter-Risko-Stacy page shown here can easily be applied to cinematic storytelling. What does not apply is the requirement to move the reader's eye from one part of the page to another, although the devices used would certainly be functional in other media. Consider how effective this page would be as a standard storyboard. The page reproduced is not finished art, but simply a rough layout, drawn on the spot dur-

ing a public seminar on storytelling, to illustrate the concepts discussed.

Synopsis

Carter enters Risko's office and finds Stacy there. Risko pulls a gun, but Stacy deflects his aim. Carter punches Risko.

Let's break the action down into visual sections. Remember: the story will always tell you what to show.

Panel 1

The scene should begin with an establishing shot. Where? Risko's office. Who? Carter, Risko, and Stacy. When, What, and Why will be explained in captions and dialogue. But, with the first two elements clearly in mind, I begin determining possible viewpoints and angles. Since I need to

see all three characters, I opt for an objective shot and consider positioning them so that their placement within the frame reveals some of the story. One of the first POVs (points of view) I consider is from behind Carter as he enters the room: his back would be a massive silhouette and the other two characters would be seen on either side of him—a visual metaphor that underscores his interruptive presence by separating them.

That POV, however, makes Carter the dominating presence in the frame. Although he is the hero or protagonist of the story, if he seems to be in control of the situation from the beginning of the scene, then there is no conflict—and without conflict, the story will fall apart. So, I envision the opposite POV, where the villain or antagonist becomes the dominant element in the frame. Putting Risko in the center works well, but eliminates the separation metaphor that tells an important part of the drama. To maintain the device, I move my POV slightly to the right.

My preference for establishing with a third-of-a-page panel (very similar in proportion to a Cinemascope screen) works very well to open this scene. Risko becomes a massive shape on the left (in the Western world, we are trained to observe from left to right because our language reads that way; the Japanese, however, read right to left). The sheer volume of his figure (in addition to his position) makes him the dominating presence in the frame—the dynamic on which I'll build progressive conflict.

Opposite Risko, as a balancing element, I place Stacy. Because she's subordinate to Risko, I make her smaller and less imposing, underscoring her relationship in the drama. But to give her character some tension, I put her in a reaction pose: rising out of her chair and lifting her right hand to her mouth in a gesture of surprise.

Both figures are now in a perfect position to emphasize the action which ignites the scene: Carter's entrance into the room. By placing him in the center, I'm able to express the visual metaphor of splitting the bond between the two figures. Note that I've reinforced that bond by connecting them with the edge of the desk, making them a formidable framing unit around the intruder.

Although Carter is much smaller in volume than either of the other characters, the fact that he's shown in almost full-figure size creates a potent psychological tension in the reader's perception. (The rule is that smaller full figures can compete with larger partial figures because they offer more cognitive information to stimulate the mind.) Carter is in a rather passive pose, further providing an opportunity to build conflict. Had he crashed through the door, that opportunity would be diminished.

A series of other subtleties is now applied to the scene during the layout stage. Carter's emotional isolation is enhanced by putting a box—the doorframe—around him. This also suggests that he's in the act of entering the room; to reinforce that notion, I put his hand on the doorknob and carefully positioned the door itself so there is no doubt that the reader clearly comprehends the situation. (In visual media, it's much more satisfying to show instead of tell; consequently there is no need for a caption here that says, "Carter opens the door to Risko's office and sees him with Stacy. . . .")

The hero's entrance is further enhanced by Risko's position: the figure is leaning in Carter's direction, looking directly at him, and the cigar actually points at Carter's face. Stacy's body English has a similar effect. When I dressed the background, I deliberately made the perspective lines converge toward Carter, further increasing the importance of his appearance. Although the panel is rich with detail, I've made certain that there isn't a line of confusion in it. The reader knows exactly where each of the characters is geographically and the approximate layout of the room, so that subsequent action will be perfectly clear.

Check out the illusion of deep space created by overlapping elements: the whiskey bottles and glasses in the extreme foreground (suggesting an aspect of Risko's character), Risko's chair, Risko, the desk and phone, Stacy, her chair, the office filing cabinets in the middle ground, and the back wall and door, Carter, and finally the far wall behind him in the background, all suggesting a strong quality of depth with a touch of confinement. Often in establishing shots—-such as this one—I use the device of playing out the drama in the foreground, middle ground, and background (most storytellers use only one or two levels), a technique I learned from films lensed by Gregg Toland, particularly *Citizen Kane.*

Also, note the light sources used to create a heightened sense of drama and easy-reading silhouettes: the foreground lamp, the window behind the filing cabinets, an unseen source

to the left, and another in the hall or room behind the hero.

One final point: I attempt to help the reader move through the story and to control the pace of that movement by the nature of my panel compositions and the use of directionals. In this case, I've prompted the reader's eye to focus on the panel's central area and, because it features a strong vertical doorway, the eye is thrust downward after all the information in the frame is absorbed. That downward drift helps the reader get to the middle tier of panels smoothly.

Panel 2

This is a *reverse angle* on Risko and Stacy, a natural *answering shot* to the first panel and one that could easily be subjective (with the reader seeing what Carter sees). But I had another idea, one based on cinematic technique. I moved the angle of the shot a few feet to the hero's left and to about three feet off the floor, similar to that used in the previous panel. The low angle helps enhance Risko's towering presence as he responds to the interruption by standing up and making a fist (nicely silhouetted against the lampshade). He dominates the moment, which is underscored with two graphic devices: I positioned him higher in the frame than Stacy (subordinating her action in the drama) and give him greater spatial volume.

The medium two-shot allows their facial expressions to be easily comprehended. (This shot, by the way, is the basic building block of the visual storyteller's art.) Notice that I adhered strictly to the old cinematic rule of not *crossing the axis* (see The 180 Degree Rule, page 67), which, in this case, is the imaginary line between Carter and Risko/Stacy. In panels 1, 2, 4, and 5, I always stay in the area to Carter's left. If I moved to his right in framing a shot, it would appear that the characters are no longer responding to each other. Not crossing the axis is a simple but important device to facilitate coherent storytelling.

Panel 3

This is a close-up insert on Risko's hand. The fist in the previous panel points to the lower right, helping the reader into panel 3, a tight, subjective shot of a hand reaching into a desk drawer for a gun. Although the panel is very narrow—and silent (no caption required)—it delivers the precise information necessary to drive the plot forward.

Note how the upward trajectory complements the previous panel's downward thrust and leads into the next

panel's down-angled close-up. I believe this down-up-down movement is a kind of *internal visual rhythm* that energizes the narrative on a subconscious level and draws the reader deeper into the story. Check out the up-down-up movement in the lower tier to further experience the concept. Internal rhythm may be among the most sophisticated techniques used in the art of graphic storytelling.

Panel 4

Panel 4 is a close-up reaction shot of Carter challenging Risko's threat. Every comic page needs a close-up to express the high point of the scene's emotional content with clarity and force. Unarmed, Carter defies his adversary with typically heroic courage. (From Tom Mix to Clint Eastwood, actors would sell their souls for close-ups like this one!) Close-ups bring the reader face to face with a character and the character's emotions, and should be used very sparingly. More than one on a page reduces their impact considerably, so if you decide to use more than one, have a very good reason.

Panels 2 and 4 represent an interesting narrative experiment. Generally, panels are created to relate kinetically with those to the right or left of them. (One of the most common failures of the current generation of comic storytellers is that they fail to comprehend—or just dim-wittedly ignore—the symbiotic interchange of information and energy between panels.) Cognitively, the reader absorbs the content/meaning of panel A, then repeats the process with panel B; as the data from both panels is digested, the reader forms a concept—or *third idea*—derived from both panels.

Here, panels 2 and 4 function as if they were adjacent, as though panel 3 didn't exist. Part of this effect works because the panels—the characters in the panels—are facing each other confrontationally, so that panel 3 becomes almost invisible to the reader, like a punctuating note in a harmonic passage. Panels 2 and 4 have a powerful, active quality, while panel 3 is static by comparison. Perhaps the most important reason that readers easily relate the two images is that they have *equal dramatic weight,* even though they are completely different in subject matter, size, and composition.

The three-beat focus of the first tier (Risko, Carter, Stacy) is repeated in the second tier (with three elements in three panels), and again in the third tier (three equal-sized panels) to create a *visual cadence* that locks the page together in a tight, rhythmic sequence not unlike that of many

first-rate films (or third-rate films with first-rate editing).

One consideration in the content of panel 4 was that it needed to lead the reader's eye to the bottom tier, specifically to panel 5. I achieved that goal by the low-angle tilt of the head (although the eyes are looking toward panel 2) and the strong directional line where the wall meets the ceiling (pointing directly to panel 5). The angle of Risko's hand in panel 3 also promotes movement in the same direction (reversing a path previously taken by the reader). Although these devices seem obvious upon explanation, they are completely subliminal to the reader. If they had seemed distracting, I would have replaced them with something less apparent.

Panel 5

Easily the trickiest panel on the page, this image was composed to pick up the directional line from panel 4 and repeat the angle in the perspective lines of the ceiling. The starting point is Carter's head, silhouetted against the ceiling light. Those fixtures carry the eye to Stacy on the opposite side of the frame and down her figure to the desk, where its edge directs the eye to the right, across Risko brandishing the gun, and back to Carter, who overlaps the desk and Risko. The average reader will make the circular path twice (to pick up all the information provided), then move smoothly to the next panel (helped by the directional line of the desktop and the position of Carter's left thigh, not to mention his figure cropping off the right edge).

Carter's domination of the scene in terms of spatial volume carries over from the previous panel. Yet that domination is clearly threatened by the much smaller figure with the gun. Risko, however, becomes more prominent than he might otherwise appear because of the forceful ceiling perspective lines. In this composition, the reader only discovers Risko after comprehending the other two characters—a minor but compelling surprise.

I had several reasons for using a worm's-eye view in this panel. Because I had already used three rather conventional angles, I felt some variety would be appropriate. And because the conflict was reaching its apex, a shot with more *visual tension* was mandatory. I looked over the previous panels to help solve the problem: throughout panels 1, 2, and 4, I progressively moved the angle lower, so that going to floor level in panel 5 is a natural continuation of that movement. Its radical viewpoint nailed the emotional content of

the scene and also provided the compositional solution to moving the eye from panel 4.

Notice how effectively panel 5 fits into the structural corner of the page as a whole, especially with floor level being at the bottom of the page. (Imagine how much less appropriate a floor-level shot would have been in the second tier.)

Panel 6

Risko's right hand has been an element in every panel except 4, so it is not inconsistent to use it again to focus on a dramatic detail: Stacy attempts to deflect Risko's aim just as he fires the weapon. Tension increases because, for a moment, we do not know if Carter has been shot. Note how the thrust of Stacy's hand helps draw the reader's eye from the previous panel into this one. The angle of the automatic and its gunflash would probably push the reader off the bottom of the page—except for the powerful composition of the next panel.

Panel 7

I needed an image that would pull the reader's eye into this panel and created a directional that essentially intersected the end of the gun barrel and drew the eye toward the right at an upward angle (an angle identical to the girl's hand in the previous panel). The violent upward thrust is particularly appropriate and satisfying because of the physical conflict between the characters. If this was a left-hand page, the final panel would move the reader's eye to the right-hand page. If it were a right-hand page, it would encourage the reader to turn to the following page.

Summary

Although very little action occurs on this page until the last few panels, it seems to demand being read. The reason is that it's graphically interesting and rippling with tension. By utilizing sound storytelling techniques, I can pull readers into the scene and keep them there as it unfolds. I render each panel with the belief that I can smell the cigar smoke and hear a radio broadcast from another room. As I draw the characters, I *become* each of them, like an actor with an investment in getting their mannerisms and emotions correct. The result can be a page that comes to life and involves the reader in its drama, in the same way a satisfying novel, TV show, or film does with audiences. It requires

a little strategy, but the result can be worth the effort.

Notice how all the elements on the page keep the reader's eye *inside* of it, rather than leading off the edges or into the opposite page. Look through almost any comic to see how this simple and obvious rule is violated continuously by even the most popular talents—then make it a point not to repeat the error yourself. A shortcut to determining how panels play best after they are orchestrated is to flop them (using tissue overlays or digital scans) and reconsider their positions. David (*Kabuki*) Mack often cuts panels from pages and moves them to other pages to create interesting juxtapositions. His results are often startlingly original and unpredictable.

Study the page as a whole and you'll discover how well it holds together visually, even though each panel defines a separate moment and has been composed to deliver specific information related to that moment. In a storytelling sense, this page is a credible example of *rising conflict,* starting with a very passive establishment shot and escalating to extreme action. If there were a next page, it would probably begin with Risko on the floor (in a passive composition) and build to another dramatic climax.

Note how the solid black areas spotted in various panels give the page weight and visual authority. Milton (*Terry and the Pirates, Steve Canyon*) Caniff and Frank (*Johnny Hazard*) Robbins were superb at spotting blacks in their comic strips, while Jack Kirby, Mort Meskin, and Wally Wood excelled at the technique in comic books.

Fine-Tuning

For the sake of completeness, I'll detail a list of alterations and improvements I'd make on the finished page.

* *Panel 1.* The door is slightly off center. I'd make it symmetrical. Risko's cigar appears to be touching the doorway and should be moved slightly right or left to eliminate "edging."
* *Panel 2.* Risko's right hand should move slightly up or down because it "edges" with the desktop.
* *Panel 3.* No changes, except perhaps to move the panel to the right, so that the right-edge gutter aligns with the bottom-tier gutter below it.
* *Panel 4.* Rough up Carter's hair a bit more to suggest his turbulent state of mind.
* *Panel 5.* Carter's figure could lean forward slightly to heighten the pending conflict.

* *Panel 6.* No changes.
* *Panel 7.* Risko's left hand could be lowered and moved slightly out of the frame to avoid possible confusion. The right hand and the gun could move slightly down and to the right.

The *S.H.I.E.L.D.* Silent Sequence

The narrative strategies utilized in this sequence would require a chapter of their own to fully examine and analyze (I attempted it at one of my infrequent comic-book seminars and was surprised to discover that it required more than two hours), so my commentary will be limited. The pages display a rigorous application of the storytelling devices detailed above, including a sophisticated counterpoint between subjective and objective viewpoints, in addition to polarity-cast passive and active panels, so that the aspect of *visual and intellectual tension* is moderately high.

Starting on the splash and continuing on the following two pages, the sequence represents a memorable, trend-setting experiment that became the prototype for many others that followed. The concept visualized agent Nick Fury penetrating an enemy fortress (in a long shot on the title page) in complete silence. Ordinarily, the panels would be littered with captions and thought balloons in typical Marvel style. Instead, I eliminated them all, even the slightest sound effect, to achieve a *profoundly oppressive silence.*

I was dealing with pure imagery to tell the story, much like the pre-1930 silent movies. (George Miller once told me that he cuts his films, such as the Mad Max trilogy, *without* sound, so that the visuals alone tell a credible story—and the sound, added later, enhances that credibility.) To underscore the height and monolithic quality of the stronghold, I divided each page into eight, identical vertical panels, for a powerhouse 16-panel double-page narrative sequence, the first of its kind in comic history.

Note that each panel is composed to take advantage of the tall, rectangular area (such as vertical movement) and delivers precisely enough information to make a clear—yet sometimes abstract—story point. Each panel also works kinetically with the adjacent images so that the reader can quickly and efficiently fill in the action between the panels. The passage (which could be defined as a kind of early interactive sequence) put a special demand on readers' cognitive skills, one they undoubtedly found satisfying as they completed the process.

The silent sequence was inspired by Jules Dassin's

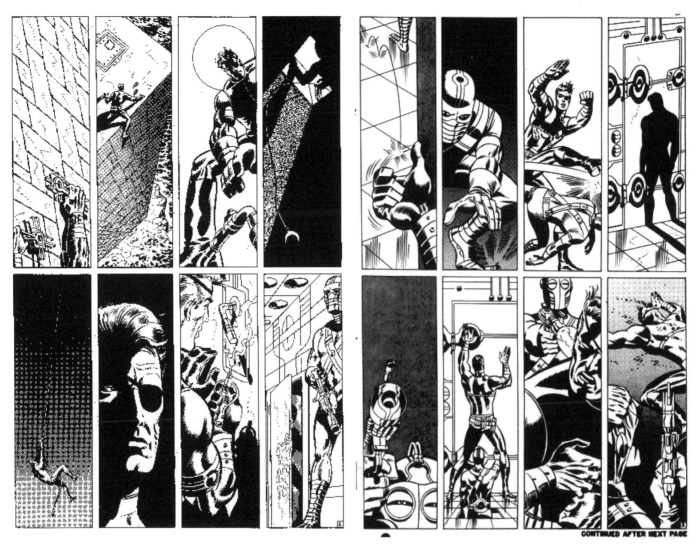

CONTINUED AFTER NEXT PAGE

film *Rififi.* The plot involved a robbery that had to be executed *in silence* because of alarms, so the middle third of the picture had no sound, not even a musical underscore. I was about fifteen when I saw it and the concept left a deep impression on me. Fifteen years later, when I needed Fury to penetrate an enemy stronghold in silence, I felt it would be most effective by eliminating *all words, thoughts, sound effects, and captions*—even the standard title—and attempt to generate an impact similar to that of *Rififi.* It was so effective that it spawned a host of imitations, including several that were hilarious in their misunderstanding of the concept.

The Final Secret

There's one special quality I try to invest in my work. It's difficult to express in words, except perhaps to call it integrity or truth. Maybe it's conviction or authority. Of course, in many cases, I'm not dealing with truth, but fiction—and often outrageous fiction. Nevertheless, somewhere in my text or imagery, I try to find the essence of truth, something of reality, something from my personal experience, something I know about intimately, and capture it in the work. It may have to do with becoming the characters for a while and transmitting them from the imagination to the page or from the heart to the canvas or the soul to the screen.

Ever wonder why you're sometimes attracted to work that is amateurish, crude, or nonprofessional in its execution, rather than other work that is flawlessly produced? This is one of the reasons. Technically perfect works of art, music, dance, design, sculpture, architecture, or literature can, at the same time, be distant or remote, while less accomplished works can be accessible and appealing. It cuts both ways.

There are many rules for visual design and narrative continuity; rules can be taught and skills can be learned. They represent the science of storytelling.

The art of it is ultimately on you.

Index

Abydos Passion Play, 25
Academy flat, 42
Action flow:
 clarity, 66–67
 direction, 141
Action-reaction scenes, 135
 in animation, 70
 classic comics panels, 71, 141
 in film and comics, 69
 knockout punch, 135, 136
Adams, Neal, 142, 145
Adventures of Dolly, 39
Anamorphic scope, 42
Animation, 173
 pre-editing in, 180
 production diagram, 53
 storyboards for, 85
 3D, 85
Anime, 149
Anticipation, 140
Arcs, in proportional charts, 93
Art education, 85
Art-focused storytelling, 57, 159, 160, 161
Asimov, Isaac, 8
Aspect ratio, 42
 academy flat, 42
 anamorphic scope, 42
 "classic," 42
Atmospheric lighting, 179
Aura lines, 147
Aureliani, Franco, 125
Auteur theory, 17, 59
 comics "director," 55
Avenue Productions, 52
Avid Media Composer, 52, 53

Babendererde, "BMAN" Brian, 34, 55
Soul chaser Betty, 32, 38
Balanced double-page composition, 183
Balanced panel composition, 168
Ballhaus, Michael, 105
Baltazar, Art, 125
Banister, Jim, 43
Bayeux Tapestry, 28
Beachum, Mark, 113
Becker, Steven, 35
Bertolucci, Bernardo, 114
Big gun style, 146
Biograph, 39, 112
Birth of a Nation, 39
Black areas:
 in gutter design, 160
 in page design, 167
Book of the Dead, 28
Bohlen, Maggie, 89
Borders, panel, 169–170
Bram Stoker's Dracula, 124
Breaking the panel barrier, 170
Buddy movies, 72
Bullet Time, 134
Burke's Law, 6
Busch, Wilhelm, 29
Byrne, John, 66, 81, 159

Camera angles, 102–103, 176
 point-of-view shot, 8
 bird's-eye view, 102, 176
 down-shot, 103
 eye-level, 102, 176
 extreme, 36, 102
 high-angle, 102, 176
 low-angle, 102, 176
 up-shot, 102
 worm's-eye view, 102, 176
 See also Point of view; Shot composition
Camera movement, 104
 in *The Conversation,* 10
 dolly shots, 104
 tracking shots, 104
Cameron, James, 41
Cameron, Julia, 144
Cassavetes, John, 18
CGI, 40, 41, 51
 See also Computer graphics
Character lighting, 179
Characters, developing, 164
Church, Doug, 43
Citizen Kane, 19, 104, 185
Clarity:
 action flow, 65, 66, 67, 68, 69
 continuity, 77–79
 See also Continuity; Temporal continuity
 establishing shots as tool, 65
 lack of, in comics panels, 65
 lack of, in IGs, 65
Close-up, 101
Collaboration, 50, 55, 57
Color:
 black and red, in Steranko covers, 119
 computer-generated, 118
 Indiana Jones concept art, 123
 *The Last Emperor,*114
 light and, 114–115
 reflected, 117
Comics:
 as active (participatory) medium, 30, 173, 180
 double-page composition, 182–183
 dynamic motion in, 40, 136
 eye path, 36–37, 136
 manga style, 149
 "motion capture" in comics,76
 panel to panel, 35
 reading sequence, 35, 138
 slowing/speeding the reader's pace, 137
 speciality line work, 147–149
 thumbnails to detailed penciling, 54
 western style, 35, 149
 See also Panel design; Page design
Computer graphics:
 in art education, 85
 CGI, 40, 41, 51
 digital special effects, 40
 Lord of the Rings: The Fellowship of the Ring, 81
 The Mummy Returns, 81

Star Wars Episode II, 51
Conflict:
 action-reaction panels, 136
 classical plot structure, 72
 core of storyteller's art, 175
 lighting as enhancement, 129
 rising conflict, in page design, 188
 timing and pace, 133, 136, 141
Connolly, Cyril, 21
Continuity, 77–79
 reference points, 78
 temporal, 78, 177, 180
The Conversation, 9–10
Continuous coverage continuity, 177
Coppola, Francis Ford, 9, 16, 124
The Country Doctor, 39
Court, Catherine, 57, 64
Creativity:
 and intuition, 64
 and technology, 41
Croft, Lara, 43, 44, 45
Cropping dos and don'ts, 152
Cross-pollination among media, 46, 52
Cut scenes, 45, 59–60
 Resident Evil, Code: Veronica X, 65–66

Death of a Salesman, 21
Depth lighting, 179
Depth of field, 74, 104–105
Design, purpose-driven, 165
Dimensionality:
 in comics, 74
 foreground, middle ground, and background, 152, 154
 3D illusions in 2D media, 74
Directors:
 auteur theory, 17, 59
 comics directors, 55
 as writers, 18–19
Dirks, Rudolph, 29
Dixon, Chuck, 36
Dolly shot, 104
DOOM, 41
Double-page composition, 182–183
Down-shot, 103
Dual-focus (words/pictures) storytelling, 159
Durston, Bat, 16
Dynamic Duo Studio, 170
Dynamism, 75
 dynamic vs. static media, 76
 exaggeration, 77
 "motion capture" in comics, 76
 2D art and 3D modeling, 75
Editing:
 Avid Media Composer, 52
 nonlinear, 54
Eisner, Will, 159
Ellison, Harlan, 6–21, 145
 auteur theory, 59
Establishing shot, 65, 99

Exaggeration, 77
 big gun style, 146
 camera angles, 102, 146
 forced perspective, 145
 foreshortening, 142, 145
 of physique, 145
Explosion lines, 147, 148
Extreme close-up, 101, 155
Extrinsic perception, 173
Eye path, 36–37, 141
 focusing viewer's attention, 36
 page design and, 136
 panel borders and, 170
Fade-in, 106, 139
Fade-out, 106, 139
Ferren, Bran, 26
Figure drawing:
Flashback continuity, 177
Film:
 directors as writers, 18–19
 history, 39
 illlustrating for, 122–124
 jump cuts, 134–135
 lighting, 129
 realism in, 172, 181
 silent, 30
 slow motion, 124
 storyboards, importance of, 180
 talkies,31
 temporal continuity, 177
 timing, 141
 See also Camera angles, Shot composition
First-person IGs, 44–45
Flash, 150
Forced perspective, 145
Foreshortening, 142, 145, 146
Fox, Todd, 36
Frames, 34
 frame within a frame, 37
 within panels, 38, 151
 sequence of, 34, 38
 See also Camera angles, Shot composition
Free-form page layout, 166
Frost, Portrait of a Vampire, 46
Galaxy magazine, 16
Gammill, Kerry, 52, 75
Gertie the Dinosaur, 87
Goodfellas, 104–105
The Great Train Robbery, 39
Grid page layout, 166
Griffith, D. W., 39
 lighting techniques, 112
Gutter design, 160, 170, 182
Half-life, 44
Hanna, Wayne, 41, 84, 85
Hergé, 46
Hitchcock, Alfred, 73
Hogarth, Burne, 114
Holkan Bible Picture Book, 29
Horizon line, in achieving correct proportion, 94, 95
Hot spots in IGs, 60, 61
Hunter: the Reckoning, 44, 116

Illinois Institute of Art, 85
Illuminated manuscripts,

28–29
Impact lines, 147, 148
Indiana Jones, 42
Infantino, Carmine, 150
Interactive games, 31, 41, 43, 57–61, 172
 "abdicating authorship," 43
 art-focused collaboration in, 57, 59
 cut scenes, 45
 early, 41
 environmental details in, 43, 87
 first-person, 44
 interactive script, 57, 59, 60
 as "lean-forward" experience, 31
 lighting, 129
 player-affected course of action, 34, 44, 47
 role-playing, 47
 Software Requirements Specification, 58–59
 third-person, 44
 timing, 133, 144
 word-picture mix, 159
Interdependent (words/pictures) storytelling, 159, 161
Intrinsic perception, 173
Intuition:
 vs. analytical approach, 81, 173
 and creativity, 64
Inverse square law, 113
Iwecks, Ub, 125

Jackson, Peter, 51–52
Japanese animation, 149

Kael, Pauline, 20
Kaney, Terry, 52
The Katzenjammer Kids, 29
Kirby Krackle, 148
Kober, Alisa, 98

L shape, in panel design, 154
Langlois, Daniel, 57
Lara Croft Tomb Raider: The Angel of Darkness, 44
Layouts, 162
 designing from a script, 162
 rough layout to finished page (from), 163, 170–171
Lee, Stan, 72, 74
Lenardo and Blandine, 29
Lighting, 110–114
 ambient, 114
 atmospheric lighting, 179
 back-lighting, 112, 127
 character lighting, 179
 and color, 114, 117
 comparison of film, comics, and 3D, 129
 depth lighting, 179
 dual-source, 112, 114
 expressionistic, 114
 inverse square law, 113
 Loomis's 12 lighting sources
 moonlight, 114
 planes and light, 126–129
 point, 114
 radiosity, 116
 real-world vs. storytelling,

112, 114, 115, 129
sculptural, 114
single-source, 112, 114, 127
spot, 114
stage lighting, 111, 127
3D modeling, 128
2D vs. 3D, 116
uplighting, 111
Lines:
importance of, 90–91
Kirby Krackle, 148
speciality line work, 147–149
Literature, 173
Lock, Vincent, 90
Long shot, 99
Loomis, Andrew, 91–95
The Lord of the Rings, 51–52
Luhrmann, Baz, 134
Lundgren, Ulf, 76, 87

The Maltese Falcon, (extreme up-shot), 102
Manga, 38
Manikkin frame, 93
Mankiewicz, Herman, 19
Manyen, Mark, 57
Master scenes, 17
The Matrix, 75, 134
McCloud, Scott, 31, 35, 84
McKay, Winsor, 87
Medium close-up, 101
Medium long shot, 100
Medium shot, 100
Mise-en-scene, 158, 165
Miyamoto, Shigeru, 125
Montage, 158, 165
Moore, Terry, 79, 80, 125, 160
Morphing, 150
Motion capture:
in comics, 76
3D modeling, 88
Motion theater, 81
Movement, camera (*See* Camera movement)
Multiple images, 150

Negative space, in page layout, 167
Nilsen, Vladimir, 40
Nonlinear editing, 52, 54

Objective point of view, 176–177
Off-camera action, 106
180-degree rule, 67–68, 186
BONE, 68
Outlines and plot points, 174–175
Over-the-shoulder shot, 106

Pace:
in film, 16
timing and pace, 132–141
See also Timing
Page design and composition:
asymmetrical vs. symmetrical layout, 166–167
eye path, 36–37, 136, 167
free-form layout, 156, 166, 167
geometric shapes in, 148
grid layout, 166
"ideal" comics page

(Steranko), 183–188
layout, 166–167
mastering double-page composition (Steranko), 182–183
reader pace and, 133, 138–139
silent sequences, 160, 188–189
Panel design:
balanced vs. unbalanced, 168–169
borders as a design element, 169–170
cropping, 152
focusing viewer's attention, 36
framing, 36
importance of, 182
size, 36
splash panels, 156
as timing device, 38, 133, 144
Panel sequence, orchestrating for effect, 178, 182
Parallel (words/pictures) focus, 159
Patrick the Wolf Boy, 90, 125
Perspective:
horizon line and, 95
Loomis charts, 94
vanishing point, 94
Picture-word mix, 159–161
Plagiarism, 88
PlayStation, 59
Plot structure:
character development and, 72
classical, 72
free-form, 72
Point of view:
eye level, 102
power of, 8, 9
choice of, for maximum effect, 185
Polygons, in 3D modeling, 89
Pong, 41
Porter, Edwin S., 39
Production processes, 51–54
animation, 53
comics, 54
film, 51
interactive games, 57–60
Proportion, 91–95
arcs and head units, 93
heads in proportion, 92
horizon line (using), 95
ideal male, 92
Loomis proportional charts, 91–92
and perspective, 94
relative proportion, 94
Props, 164

Quake, 41, 44, 45
Raiders of the Lost Ark, 122–123
Raimi, Sam, 46
Reading a comics spread, Western style vs. manga style, 38
Realism, 72–73

dramatic realism (Jim Steranko), 119
Lee, Stan, 72, 74
using reference, 87–88
Red Eye Studios, 88, 89
Reference:
continuity and, 78
realism, using to achieve, 87
reference points:
setting up, 69
visual, 174
Relative proportion, 94
Resident Evil 3:Nemesis, 44
Reverse-angle shot, 180, 186
Rififi, 189
Rodriguez, Robert, 50, 54, 64
Role-playing games, 47, 159
Rust, 82
Schumer, Arlen, 170
Scott, George C., 17–18
Scripts:
construction of, for film, 20
designing from, 160, 174–175
treatments, 15
Secondary illumination, 116
Septerra Core, 47, 57
and realism (Maya's death), 73
script, 60, 61
storyboards, 45
2D lighting, 116
Sequencing shots, 162
Serial Box Studios, 85
Setup and payoff, 69, 140
The Shadow, Steranko covers, 119
Sherlock Holmes: Consulting Detective, 44
S.H.I.E.L.D.: designing for multiple markets, 174
silent sequence (the), 188–189
Simultaneous coverage continuity, 177
Shot composition, 176–177:
camera angles (*see* Camera angles)
close-up, 101, 160
depth of field, 74
distance, 66, 99
dynamic,76
establishing shot, 99
extreme close-up, 101, 155
long shot, 99, 160
medium close-up, 101
medium long shot, 100
medium shot, 100
reverse angle, 180
viewpoints, 176–177
Silent films, 30–31
Silhouette, 125, 127, 154, 155
Sit-back scenes, 175, 180
"Sit-back" media, 31
Slow motion, 134
Smith, Jeff, 26, 140
Smith, Tom, 55
Smylie, Mark, 37, 137
Artesia (mise-en-scene), 38
Soul Chaser Betty, 32, 38

Speed lines, 149
Spider-Man, 46, 71
Spurlock, J. David, 46
Staake, Bob, 27, 164
Star Ocean: The Second Story, 44
Star Wars Episode II, 51
Steranko, Jim:
big gun style, 146
Bram Stoker's Dracula, 124
cover art gallery, 119–122
dramatic realism, 119
film illustration, 122–124
the "ideal" comics page, 183–188
influences on, 181–182
Raiders of the Lost Ark, 122–123
S.H.I.E.L.D., 174, 188–189
The Shadow, 119
temporal panel orchestration, 178–179
Storato, Vittorio, 114
Storyboards, 52
for animation, 70, 85
digital (nonlinear) storyboarding, 52, 54
for film, 39
for cut scenes,, 45
for television scripts, 164
video, 50
Style, 74, 86, 90
big foot, 90
little foot, 90
Subjective point of view, 177
Superimposition, 106, 107

"Talkies," 31
Technology and art, 85
Temporal continuity, 78, 177, 180
Teleplay, Harlan Ellison rules for, 10–13
Tezuka, Osamu, 125
Theater of Dionysus, 25
Theater:
evolution of, 25
lighting, 11, 127
Third-person IG, 44
Three-dimensional lighting, 116
Three-dimensional modeling, 57, 75, 87
Time-lag (subsequent coverage) continuity, 177
Thumbnails, 56, 162
word balloons, 37
Tilt:
camera angle, 176
of comics panels, 151
Timing:
in comics, 133, 136, 137, 138–139
in film, 133
jump cuts, 134–135
in interactive games, 140
slow motion, 134
Tintin, 46
Titanic, 41, 87
Toland, Gregg, 104, 185
Tomb Raider, 43, 45
Total immersion, 80–81

Tracking shot:
comics, 105
film, 104
Trapnell, Coles, 19
Treatment, 15
Tucker, Diane, 41

Unbalanced panel composition, 168
The Unquiet Grave, 21

Van Cleef, Lee, 175
Van Hook, Kevin, 40, 46
Vanishing point, 94
Vicon motion capture, 88–89
Villigran, Enrique, 36
Vincent, Tom, 117
Virtua Fighter (Softimage), 48
Visual media, 7:
interactive, 31
"lean forward," 31
linear, 31
scene treatment, 15, 19–20
"sit back," 31
teleplays, 9, 11–13
visual storytelling continuum, 29
writing for, 7, 8
Visual storytelling:
in comics, 55–56
continuum, 29
definition, 26
in interactive games, 57–61
media,29–31
plot points, 175–176
scene structure, 175
Voiceovers, 8
von Goez, Josef Franz, 29

Walt Disney Imaginering, 26
"War of the Worlds (Welles's broadcast), 28
Welles, Orson, 19, 28, 41, 64, 104
Western style comics, 38
WETA Limited, 52
Wipe, in comics, 107
Wolfgang, Sherri, 170
Woo, John, 134
Wood, Wally, 153–155
framing techniques, 37
24 panels that always work, 153
Word balloons, 37–38
Word-dominated storytelling, 159
Word-picture mix, 159–161
Writers Guild of America, West, 21
Written By (WGAw), 21

Xbox, 59
Xtreme techniques (*see* Exaggeration)

The Yellow Kid, 29, 35

Zoom shots:
comics, 96
film, 104
Zork, 41

Biographies

Tony C. Caputo has a 30-year history in the world of visual storytelling, as publisher (Caputo Publishing Inc. and NOW Entertainment Corporation, whose critically acclaimed premiere issues of *The Green Hornet, Twilight Zone,* and *Mr. T and the T-Force* series each sold over 250,000 copies); artist (*Fright Night, Vespers,* and *Supercops,* among many others); writer of fiction (*Speed Racer, The Terminator*) and nonfiction (*How to Self-Publish Your Own Comic Book,* 1997, and the forthcoming *Build Your Own Server: The Ultimate Tech Guide to Building Your Dream System*); and screenwriter. Mr. Caputo is currently senior manager and consultant for Intellisys Technology, LLC, a technology-consulting firm with offices in the United States, Australia, Singapore, and India.

Harlan Ellison's accomplishments are legion and legendary. Hailed by *The Los Angeles Times* as the "20th Century Lewis Carroll," Ellison has won the Hugo Award for achievement in science fiction $8\frac{1}{2}$ times, the Nebula Award (given by the Science Fiction and Fantasy Writers of America) 3 times, The Edgar Allan Poe Award of the Mystery Writers of America twice; the Writers Guild of America award for Most Outstanding Teleplay an unprecedented 4 times for solo writing; and others too numerous to list. He has written or edited 75 books, as well as more than 1700 short stories, essays, and newspaper columns. Among his best known works are the short stories "I Have No Mouth, and I Must Scream" (also an interactive game created by the author, and one of the most widely reprinted stories in the English language) and "'Repent Harlequin!' Said The Ticktockman"; the collections *Slippage, Deathbird Stories, Angry Candy, Mind Fields,* and the legendary anthology *Dangerous Visions* (recently reissued in a 35th anniversary deluxe edition); the novella *Mefisto in Onyx;* and the autobiographical *Memos from Purgatory.* One highly regarded Ellison work, *Spider Kiss,* was called by music critic Greil Marcus "the finest novel about the world of rock in the last quarter century."

In 2000, Mr. Ellison was host of the series *2000ˣ: Tales of the Next Millennia,* a project consisting of 40 hour-long dramatized radio adaptations of famous science fiction stories for National Public Radio. A Grammy-nominated Spoken Word narrator, Mr. Ellison's *Voice from the Edge* albums are currently available on CD and audiocassette from Fantastic Audio.

In 2001, Mr. Ellison signed with Miramax's Dimension Films to develop his award-winning *Outer Limits* script, *Demon with a Glass Hand,* as a theatrical feature to be directed by David Twohy. Also in 2001, Morpheus International published *The Essential Ellison: A 50-Year Retrospective,* a treasure-trove both for long-time fans and a rare treat for those who are reading him for the first time.

More than any of his contemporaries, Jim Steranko brought the *noir* sensibility to comics: heroes and villains alike driven by alienation and psychotic obsession; narrative themes dominated by eroticism, tragic irony, and fatalism; and a visual style characterized by chiaroscuro, montage, symbolism, and expressionism. As more than one critic has suggested, he transferred the experiences of his troubled early life—including sideshow performer, escape artist, magician, photographer, ad agency art director, and rock and roll and jazz musician—to the page, treating it as a forum for self-expression that resulted in numerous graphic *tours de force.* In 1965 he began a collaboration with Stan Lee at Marvel Comics, one ground-breaking result of which was Nick Fury, agent of *S.H.I.E.L.D.,* a series which rocked the comics world with a revolutionary approach that combined such cinematic techniques as dynamic symmetry, visual metaphors, symbolic montage, point-of-view angle shots, and match-dissolve transitions.

Among the characters that have been brought to life in Steranko's inimitable visual style are Spider-Man, Conan, Mike Hammer, Sherlock Holmes, Sam Spade, the Green Hornet, The Shadow (30 covers!), and many others. His work has been exhibited at galleries all over the world, including the Louvre.

In 1968, he parlayed his extensive pop-culture knowledge and graphic arts experience into two volumes of *The Steranko History of Comics,* which have sold more than 100,000 copies each and are still considered a definitive resource. He followed with the popular entertainment magazine *PREVUE,* whose 25-year lifespan created the model for today's entertainment-related magazines.

Recent projects include an uncensored, rewritten, and redrawn version of his hard-boiled graphic novel *RED TIDE* for Dark Horse Comics (due out in March 2003); a Web site (steranko.com) he promises will be bristling with technological FX and imagery; and a new film project, his third with director Francis Ford Coppola.